Praise for *Tracing Time*

"Childs brings refreshing humility . . . Readers might find here, along with a soul-saving historical perspective, a place of calm amid our noise."

—*BOOKLIST*

"In *Tracing Time*, Craig Childs invites us to join him on a journey to visit, experience, and try to understand the ancient rock writings scattered throughout the storied northern Southwest—a journey that includes many colorful components and even more colorful characters. This is not an investigation, in the typical and tiresome sense, but a meditation. Punctuated with reflections on Childs's own experience and insights shared with him by descendant knowledge-keepers, *Tracing Time* is an engaging glimpse into a world both fascinating and fundamentally unknowable to those who aren't born into it."

—R. E. BURRILLO, author of
Behind the Bears Ears

"In a beautifully written new book, Craig Childs climbs desert boulders to find meaning inscribed in the rock, but finds instead mystery. He treks through redrock canyons to see rock art, but is surprised to find himself listening instead, as the artists' voices echo through deep time. As refreshing as a desert storm, *Tracing Time* is a welcome invitation into the continuities and conundrums of time."

—KATHLEEN DEAN MOORE, author of
Earth's Wild Music

"The enigma of rock art of the American Southwest has puzzled archaeologists and amateurs for decades. In *Tracing Time*, Craig

Childs adds to our knowledge by listening to the elders as he travels to hundreds of sites, yet the sense of mystery and imagination still swells."

—ANDY NETTELL, Back of Beyond Books

Tracing Time

Tracing Time

Seasons of Rock Art on the Colorado Plateau

craig childs

TORREY HOUSE PRESS

Salt Lake City • Torrey

First Torrey House Press Edition, April 2022
Copyright © 2022 by Craig Childs

Published by Torrey House Press
Salt Lake City, Utah
www.torreyhouse.org

International Standard Book Number: 978-1-948814-57-7
E-book ISBN: 978-1-948814-58-4
Library of Congress Control Number: 2021941552

Cover photo by Jonathan T. Bailey
Cover design by Kathleen Metcalf
Interior art by Gary Gackstatter
Interior design by Rachel Buck-Cockayne
Distributed to the trade by Consortium Book Sales and Distribution

Torrey House Press offices in Salt Lake City sit on the homelands of Ute, Goshute, Shoshone, and Paiute nations. Offices in Torrey are on the homelands of Southern Paiute, Ute, and Navajo nations.

For Daiva

who led me there

Acknowledgments

I couldn't have thought up this book or claimed these stories by myself. I'm grateful to those who offered insights or showed the way through brush and canyons to some hidden image. Thank you Polly Schaafsma, Jim Enote, Micah Loma'omvaya, Carol Patterson, Laurie Webster, Chris Lewis, Chuck LaRue, Kelley Hays-Gilpin, Scott Thybony, Joe Pachak, Rory Tyler, Garry and Ming Adams, and Kristen and Matt Redd.

Much appreciation goes to my editor, Kirsten Johanna Allen, who recognized the importance of this book, and to the passionate, skilled crew at Torrey House Press. Susan Markley's assistance helped get this project off the ground, and her reads ushered it along. Tim Goncharoff was always there for a quick read and feedback when ideas started tripping over themselves.

To Gary Gackstatter, great thanks for the quill pen and ink illustrations, more than I could have ever asked for.

Thank you to the Tozer brothers, Rex running cattle for the Ute, and Don farming green chiles on the Colorado side of the Four Corners. When I visited you in McElmo Canyon, you told me you wanted more pages than the last book. Here you go.

Contents

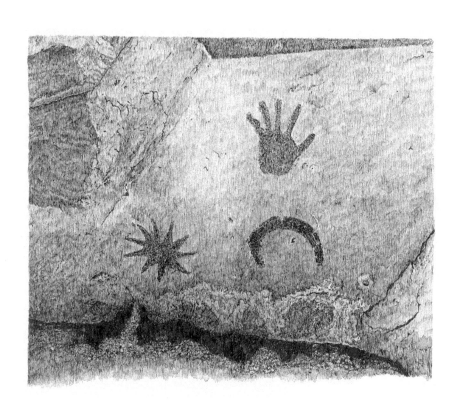

Time moves in one direction, memory another. We are the strange species that constructs artifacts intended to counter the natural flow of forgetting.

—*William Gibson*

Do you sense them there, the ones
Who invented art, who saw that we might see?

—*N. Scott Momaday*

Introduction

Rock art is a practice in stillness. Finding it requires movement. For a spiral pecked into sandstone or a red phantom painted on a rockface a thousand years ago, time is different than it is for you or me. To them, we must buzz like flies, never landing long enough to say anything of use.

I am westbound on the California Zephyr somewhere in Nevada, Polly Schaafsma's tome *Indian Rock Art of the Southwest* open in my lap. It's 1994 or '95, hard to keep track when you live by seasons. The desert flashes by and I'm turning through pages of interconnected spirals and head-dressed artwork, historic photos, black-and-white sketches. Sometimes I look out the window at horizons shifting like swimmers at different paces, blue hulks of mountains turning slowly, rock outcrops streaking past. I wonder what I'm not seeing. If I were on foot, these distances would be crossed over weeks. I would stop and take in a warm breeze, searching for the smell of rain. My eye goes to the sky, blue as a polished stone, not a cloud in sight.

These years, my time is spent between guiding, writing, and pouring through the desert, journals loaded with sketches of bugs, plants, bones, and ancient imagery I'd find on rock. I am what you'd call a dirtbag. It's a variety of people consisting of poor climbers, alpinists, skiers, or other outdoor folks who live cheaply, without normal employment, and with few amenities, which allows them to focus as much time as possible on their sport. My sport is seeing. I walk long distances through undulating terrain, snow and rock ledges, waterless expanses, for no other purpose than to see.

I tote Schaafsma along because what I've seen has made me want to know more. I've found ghost eyes peering out of holes as if through masks. Elaborate regalia sprung from heads of anthropomorphs with arms, legs, eyes, and genitals. Rock art is all over the desert Southwest and I'd been rolling in it.

Most of my life has been in the close company of these images. They are everywhere. Anyplace in the world you could say the same. You'll find bedrock riverbanks nibbled with petroglyphs, or an overhang of spider webs and hanging moss faintly painted with handprints and designs. The period from hunter-gatherers up to early agriculturalists is globally rich with imagery put to stone, no part of the habitable world left undecorated. It's a passage we go through as an early civilization, hands busy painting and etching dances, ceremonies, hunts, and scenes of the day. Whether with dogsleds, masonry pueblos, stone henges, or pyramids, your people, too, went through this era. In the arid, bony Southwest, the work stands out as if electrified. Everywhere is a canvas, a boulder, a protected cliff. In my home metropolis of Tempe, Arizona, mountains and buttes are pecked around their crowns with chains of symbols. As a kid I scrambled up summits, finding snake images, spirals, concentric circles, and rough anthropomorphs. In the eastern part of Arizona where creeks flow through basalt, I explored petroglyphs of bear paws and butterflies, imagery tied to modern Hopi and Zuni people. The desert was not empty, wilderness not vacated. Though I seek solitude, I've never believed I was alone.

The train hums and rocks on its rails and something out the window catches my eye. It's fast enough my head whips up. I imagine we are traveling at seventy miles per hour, coming into what seems to have been gray, rough rock, though it might be brown. The details fly by too swiftly. What I saw was rock art, I'm certain of it. An entire panel blurred past. An older, quicker part of my brain must have caught it. What had it been, rainbows and

stickmen, horned figures with dashes for eyes, a bear, a bird, a human track, a handprint?

Before I can think, it's gone. I am so surprised by what I saw, and how irretrievable it is, I look around at heads of scattered Amtrak travelers, and almost, just almost, say something. I want to ask out loud if anybody saw what just flew by. It was only that I couldn't find the words that I kept quiet and remained seated. Who wants to involve the conductor?

I immediately justify the sighting. Highways and train tracks are often set along rock art corridors. We've been traveling the same routes for a long time. There are highways where you remember to let off the accelerator, craning into the windshield to see petroglyphs of box-men and bighorn sheep sailing by. Outside of Shiprock in New Mexico, try not to cause an accident looking up into mustard-colored alcoves above the highway. They hold pictographs that are looking down over the right-of-way fence and guardrail not at you, but at the unimaginable blur of you.

I close Schaafsma's book and peer out the window, looking for more.

◆

I don't know how many galleries and painted or pecked rock-faces I've seen over the years, thousands I'd guess. I know people who fill files and ledgers with dates for the countless images they've seen, people whom I call rock art obsessives. I might be one, but I'm less organized. I note sites in a journal from time to time, snap some pictures, spend several minutes, or an hour, or a day or two, then move on. After a while, the journal hangs by your side, parted by your thumb where you are supposed to be writing. Pen and paper feel useless when all you can do is stare.

The Colorado Plateau has been a focal point for Indigenous artists and storytellers since the end of the Ice Age. Most of the work comes from a thousand or two years ago, the age of

Basketmaker and Fremont, the earliest corn growers bridging the gap between agriculture and deeply animistic hunter-gatherer ways. I've heard that back then, these artists were more of a single people, not divided into names like Ute, Navajo, Paiute, and Pueblo, as if cut up on a butcher's table. This I've been told by archaeologists, ethnographers, and Indigenous people speaking of their own ancestry. I've heard that even earlier, in a mythical time, humans were more like fish or frogs, some with tails and webbed hands. The earth is said to have been soft, and tracks were left easily. This is how rock art came to exist, imagination making impressions on hardening boulders and cliffs. Whatever people did left a mark.

Now, I felt the world becoming soft again as if reforming. The first year of the pandemic, I was acutely aware of how easily a great eraser could take out all that civilization has accomplished. I also saw how stories can last in detail for thousands of years, countless images pecked into soaring cliffs, not as bright as they'd been on day one, but still conveying their messages.

For many years I had little to say about rock art. I saw plenty of it and heard questions asked as if they were being pulled from a hat: Is that symbol a comet, are these people fighting, is that a corn plant? This is our most basic response to visual representation, questions, which are where the conversation begins. After long enough, though, I began to find threads and follow them. It has taken decades till I felt I had a place from which to speak.

What I've written here is based on a little more than a year of intensive study during lockdowns and reopening. During those seasons, I spent more time with pecked and painted images than with living people. In southwest Colorado, I live in a nest of petroglyphs and pictographs extending hundreds of miles around me. Taking shelter from the sun or rain below an undercut boulder or rock overhang, I find painted people with upstretched arms, rows of spirit figures, zigzag designs climbing a wall onto the ceiling. There are spidering heads and insect

people, scenes of hunting and warfare, armed figures holding up human scalps, and women squatting in childbirth. Histories are written here, footprints, handprints, bows and arrows, atlatls, spears, shields. Flute players are in rows, some on their backs playing upward, some seated, some moving in processions, their penises raised like flags.

I am not offering a guidebook to places, but a guidebook to context, meaning, and ways of seeing. There are no maps or directions in this book. Exact locations are not deemed important. Particular sites you may already know, or you'll be a hundred canyons off. Some are glaringly obvious, right above the highway, and others take days on foot to reach, sometimes with the aid of rope. If you were hoping for photographs, I recommend the work of dedicated photographers like Bruce Hucko, Garry and Ming Adams, Jonathan T. Bailey, Dave Manley, and Ekkehart Malotki. For my part, I bounced around the blob-shaped island of the Colorado Plateau across four states, Utah, Colorado, New Mexico, and Arizona, looking for patterns in the imagery, narrowing my study to a catalogue of motifs. Instead of photographs, I use words, experiences, conversations, and the reflections of people following these ancient narratives.

I define rock art as cultural imagery put to stone, not the gripes and scrawls of graffiti, which I call vandalism. What's the difference? Read the book.

There are two basic kinds of rock art. Petroglyphs are made by pecking, scratching, or rubbing the rock. These are images put *into* the rock, breaking through the darker outside patina, which is a natural varnish of iron or manganese, exposing much brighter rock underneath. The contrast can stand out like neon. Pictographs, on the other hand, are made with pigments mixed with a binder such as blood, urine, or egg white. They are painted *onto* the rock, most often red, sometimes white, yellow, or blue. Why one technique or the other was used, hammerstone and bone chisel or fingers and paintbrush, depends on the kind of

rock, the tendency to weather, and if color was needed. Pictographs, being more friable, tend to be more protected. A pictograph will be a red bird man haunting the back wall of a rock shelter like a ghost. Petroglyphs you'll find on the blackened face of a boulder turned to the sky, pecked-in tracks of deer, wolf, and mountain lion beside humanlike bodies shaped like ladders.

Some see mystery in these peckings and paintings, and others see identity. Jim Enote, a Zuni farmer born of the Corn Clan, a basket-maker and soil scientist from northern New Mexico, sees relatives. When I spoke with Enote, his pueblo was closed off in the pandemic, while I was restricted to travel within my own county in Colorado. He told me on-screen that when he encounters rock art, he greets it as if the images are living people. If it's morning, he says good morning, if it's midday, he says good afternoon. Enote said, "If there are writings, very likely somebody has lived nearby, and if somebody has lived nearby, there may also be somebody buried nearby." He asks the images, how was your day, and how did your night pass? He does not see them as only markings on rock. "In the way that you would talk about life and death, those people are not completely gone," he said. "If you were to remember their face and say their name, they are there. If you see their mark, they are there. I see them, I greet them, I acknowledge them. They've dissolved; their bones and flesh have dissolved, their oils, their fats have dissolved into the soil. They are part of the soil. The soil has brought nutrients, has helped these grasses and these trees to grow. They are here."

Rock art is not an artifact. It is an action still happening.

When I see petroglyphs and pictographs, basic questions come to mind. What do these figures and symbols convey to me now, what did they say to people in their time, and how do they fit with other sites and repeated motifs, stories being told across distances? The entire Colorado Plateau, around 250,000 square miles of mostly exposed rock, is an open book. The questions move on from what am I reading to where am I on the land?

How did I get here, and how did they get here? What are the flute players playing? A resplendent person depicted holding a snake by one outstretched arm means what?

I am drawn to Polly Schaafsma's research because of how she applies archaeological rigor to rock art, a subject mostly left out of academic disciplines. Potsherds and architecture can be sampled and dated, their purpose intrinsically functional, but rock art is liminal. Its function was to communicate, commemorate, or just to give hands something to do. It could have been made for countless elusive reasons, original meanings as fleeting as the artists who made them. But it is definable, Schaafsma found. She linked styles and motifs across an arid, geographically complex part of the continent, finding that starbursts, bighorn sheep, plumed serpents, spirals, and the rest of the pantheon were not floating randomly like alphabet soup, but were part of a bigger narrative. The book of the Colorado Plateau can be read.

Decades after I first picked up her work, I spoke with Polly Schaafsma, an octogenarian PhD with a lifelong career spent studying pictographs and petroglyphs in the Southwest. With a wonderful imagination firmly grounded in science, I think of her as the Ursula K. Le Guin of ancient imagery. When she talks, tiny figures seem to fly out of her, birds and animals, designs she's seen in the field. "You put things on rocks that aren't just everyday things," she said. "You might represent some kind of spiritual being, compelling it to be there. In other words, these images are perceived as powerful and they can command spirits."

The images she describes are not objects on shelves ready to decipher, but are portrayals of lives and visions. They are a window into ancient dreaming. Schaafsma told me, "When rock art is made, it sits there and is open to interactions for centuries and centuries and centuries. It is not static. That's what's so exciting about it, it's alive in the sense that people come and put meaning onto it continuously."

Is it art? I've been urged to find a more accurate or sensitive term. The use of "rock art" rubs some people wrong, relegating it to leisure and impressionism when these ancient images can look like a pictographically written language, or symbols imbued with prayers. Some of it is counting, some remembering, some pointing to combat or hunts, some to fertility. You could call it a ledger, a palimpsest, or a dry-erase board that takes millennia to clear itself. It is a gallery, a church, a portal into an earlier time when the earth was soft.

Kelley Hays-Gilpin, archaeology faculty at Northern Arizona University and a researcher at the Museum of Northern Arizona in Flagstaff, told me, "We don't know what it means, but we know it was meaningful. That's kind of all we need to know as archaeologists."

Hays-Gilpin learned scientific field techniques as a kid, growing up with a father who was a research chemist and an avocational archaeologist. She specializes in ancestral iconography and she freely uses the word *art*. She said, "A commercialized individual Western concept is not what art means. Are you saying Indigenous people don't have art? That's inflammatory. Art is something meant to invoke an aesthetic response. It's an interchange between the creator and the viewer or audience. It's deeper than just communicating simple information."

One of the more flexible words in the English language, *art* is defined as a human creative skill, doing something as a result of knowledge and practice. It is the mind's eye rendered in visual form.

"Everybody has art," Hays-Gilpin said. "This is what it means to be human. It's your response to nature, it's your response to another person, it's your response to an image, then your reinterpretation of that experience for others. If that's not art, what is the word for it?"

◆

Along the San Juan River, not far from the intersection of Arizona, Utah, Colorado, and New Mexico in the Four Corners, I've been going over the same walls for decades. Crowded with petroglyphs, the walls chatter and shout, and sometimes I've stared and stared and nothing comes out. In the summer, blood-colored sandstone turns silver with hot light, petroglyphs burned like film exposed in the sun. During the fall, the angle softens and cliffs turn gold, foot-lit by changing cottonwood leaves. Every kind of light alters what you see. I've come in moonlight on a summer night, hands in pockets, seeing each tiny blow from the artist's stroke, blue shadows gathered to form antenna-headed figures, or people standing like acrobats on the backs of bighorn sheep.

Thousands of figures appear on canvases of rock over several miles along canyon walls. You'll see spear throwers, ant-like people, and a bighorn sheep standing on its hind legs playing a flute. About ten miles north of here is a cave painted with handprints. East by twenty miles, boulders are big enough to crush houses, strewn below a high-capped mesa, their faces meticulously articulated into petroglyphs. Thirty miles south are walls upon walls of triangle-men. Between them is more. Beyond them is more. They are everywhere.

By five o'clock on a December evening near the winter solstice, light picks up speed toward sunset. Along the river, cliffs fall into shadow while others grow coppery and bright. As one figure appears in the last quickening glimpses of the day, another goes out. This is my favorite time of day for viewing. Two huge feet, shoe-size-fifty, lose their sun, five toes and visibly rendered bunions slipping into shadow. Nearby, a humanlike form the size of my torso holds the last light before slipping over to shade, as if gathering the last sun into itself. This figure would be called an anthropomorph, trapezoidal body, stick for a neck, and a circle for a head, with hair bobs or ear ornaments pictured to either side. *Anthro* because it looks human, and *morph* because

it appears more than human. The figure's left hand is held up as if waving to the audience, which, for now, is us. Shadows cup into every strike mark making up its body, causing the figure to pop. A dark sharp line, terminus of the sunset, descends across it, beginning at the right elbow, moving to the shoulder, the head. The left hand is lifted as if to touch the last light, and you can see every pecked joint. The petroglyph of a tiny person stands on the anthropomorph's shoulder, next to its ear. What is it whispering?

You hear the river behind you rippling over cobbles. Ice cracks and shifts. The petroglyphs are silent, but you can hear them, and they sound like a long, deep breath. They sound like the pause before something said.

I am writing this book for you, whomever you are standing with me at the foot of this cliff, watching light fill this mysterious figure and the companion on its shoulder. You've got drinking water in a pack, and a warm coat, gloves, and a hat for nightfall. It will get cold. A headlamp is in a pocket for when you leave.

When the light changes swiftly at the end of the day, take a moment to watch. Let your eye go where it wishes. In this last sunlight, become as human as possible, the one you were before paved highways and the skies plastered with contrails. Feel the shape of boulders with red grit blown between them. Cold river air drifts through willow copses, sweet with the smell of fallen and rotting leaves. Follow the warmth, the last light, as it climbs the rock and pinches out overhead, turning all the petroglyphs gray. Stay until the last glow depletes and the night opens wide. The bow of the Milky Way stretches over the river, the sky frozen and moonlessly bright. Slushbergs hiss as they slide past each other on their way to the dark vaults of Lake Powell. Your eyes strain to make out the boldest representations on the cliff, but it's more what you feel than what you see. The images have presence. They were never merely markings on rock. They have life, wisdom, memory. This is them telling their story.

◆ 1 ◆

Handprints

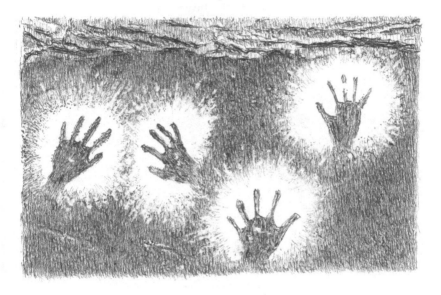

Perched on the imaginary crosshairs of the Four Cor-
ners, the high desert is salted with caves. They are not deep,
cramped, and lightless, but yawning holes, like moons risen
inside the rock. They come in shapes like skulls and empty eye
sockets. If you walk inside, human skeletons may be under your
feet, chest cavities feeling your weight. Be careful where you
step.

The mummy of a baby in its cradleboard was found in one
cave, a handful of necklaces with turquoise beads and polished
bone disks in another. A soaring alcove shaped like the inside of
a clamshell revealed a rattle made from a beavertail sewed closed
and sinewed onto a stick. The small, leathery purse came out of
peach-colored dust mixed with corn cobs and little black pills of

woodrat droppings. It is now in a museum drawer, climate controlled, its fired-clay balls rattling inside when you put on cotton gloves and softly turn it from side to side.

To reach the cave where the beavertail rattle was dug up, take a lone highway that crosses Utah and Arizona, and turn off to the west at an unmarked ranch gate. Close the gate behind you with a twist of wire and follow a two-track across sage and sand. In some places the sand will be deep enough you won't want to let off the accelerator, and then the road will be made of rock and a few miles per hour is not too slow. Park where the road ends and walk down into a canyon, passing grinding holes in bedrock, and open-mouth caves, one that held a baby mummy, and another that once bore beads and disks. Looking back at these two caves, the rock they are in seems amphibious, a sandstone head of a frog the size of Godzilla. There will be rock art along the way, petroglyphs of corn plants and snakes. A piece of cliff fell recently, its boulders thrown across the floor like meteorites, flattening sagebrush and Mormon tea. This will help give you a sense of time, how fast or slow this landscape moves and falls apart, the range of catastrophe always waiting.

If you shout along the canyon, in some places your echo will come back startlingly clear. All you have to do is talk at a conversational tone and you'll hear yourself from a few hundred feet away. This, I'm told, is one way to find rock art. Walk around clapping and when you hear a good echo, go look.

Past the clearest echo, turn into a side canyon and you'll notice the gaping oval of a cave. It is the shape of a hollow shell, a bivalve the size of a lecture hall. I went with a small group into this cave on an early spring afternoon, finding the ground inside jackhammered with old looter's holes. Brittle and hard corncobs from centuries ago lay in the dust, requiring careful steps, coming over the notation of cricket tracks and rodent dimples. This is where the rattle was found. Weather doesn't reach far inside and the ground is as dry as powdered bone. Drop anything in

here and it could remain for centuries. A pen would survive ice ages.

Jonathan Till, archaeologist and curator at the Edge of the Cedars State Park Museum in Blanding, Utah, oversees the collection holding this rattle. He was with us in the cave and told me, "The sound of the rattle evokes the pattering sound of rain, of course. One can't help but observe that beaver is a water animal. Potentially powerful water associations with that artifact."

As if in an empty bandshell, our voices bounced around us, the laughter and conversation of explorers with daypacks and water bottles. We were one of the last outfits to launch before lockdown, mid-March 2020, our trip billed as an archaeological field course, sleeping on the ground, waking with sunrise. Forehead temperatures were checked and we'd been thrown in a van, sent into the backcountry for a week, told if we didn't pull out of the parking lot immediately the trip would be canceled. The virus was spreading quickly. An archaeologist from the Greasewood Clan at Hopi was supposed to be working alongside me, offering a needed perspective as a direct descendent of the people who lived here a thousand years ago, but the Hopi mesas in Arizona had already closed, everyone called home. We'd made it in under the wire, moving day by day from canyon to mesa to canyon, lining up archaeological sites on the map and checking skies for contrails, looking for news that the machine of civilization was still chugging.

Around the back end of this vast stone room hollowed by erosion, big enough to park a fleet of RVs, were profusions of painted handprints, two hundred of them at least. The display looked like a colorful census, hands of different pigments, red, yellow, white, and green, seeming to say, *We are here. These are our numbers and our clans. Be aware of us.*

Each painted handprint had been an action, an arm outstretched, contact made with the rock. Pigment had been painted onto the flat space of the hand and fingers, the color of cherry

or butternut squash, each planted on the wall, most at eye level. Some went high, placed by crack climbers on the curving ceiling. Some were barely visible, as if the impressions were falling asleep, only flecks of pigment remaining, and others were crisp, almost wet, paint puckered where the hand had lifted away.

These were not the marks of generic lives or of gods in legends, but individuals with names and faces, each a different person, a crowd, a room of applause. Holding up your own hand to compare sizes is involuntary. Without touching, for the paint is too delicate, the grain of the rock exposed and exfoliating, you see that the people were on average smaller than us. Smaller, but the fingers and thumbs, the slight wells inside palms, are no different from our own. In some places, where handprints are in direct sunlight, a shadow can be cast for a clean comparison, matching how they held their fingers, narrowed together, or spread out as if holding up the wall.

In grade school we traced our hands on sheets of paper and decorated them with glue and glitter. I carved one into a woodblock, which I ink and stamp for book signings. When people ask what the hand means, I kind of shrug, not sure myself, explaining it means this book was written by me, by a human being. I, like you, like anyone, carry memory of our earliest days, like an epigenetic dream. In the beginning, I see a handprint. One gesture made us stand out among the other creatures, something uniquely ours. When the shower stall steams up, I press my hand against tile or glass and I leave a print.

In Manhattan, I was staying with the writer Ginger Strand when the side of her building, which had been a vivid gallery of street art, was whitewashed without warning. As a longtime resident, she was incensed and insisted we start it up again that very night. We knocked back cocktails and went down to the parking lot, where I had this idea to stencil our handprints onto the wall. I told her that in the rock art world, this was the proper thing to do. We wrapped our hands in cellophane and sprayed black

paint across them. If we'd had more time, I would have had us blow pigment through a reed, but this was the best I could come up with. The art was rough, a little drippy, but clearly two hands. Within weeks, someone pasted a constellation of gold stars at the tips of the fingers, and soon tags began going up, colorful bulbs and zags of letters and moon shapes, ladders taking the gallery up to the second story as the wall filled again. The wall is currently curated behind a mechanical multistory car garage, where you will find at the start of the graffiti, like a seed, our two handprints.

The late anthropologist Florence Hawley Ellis wrote in 1968, "Tracing one's hand on the wall of a sacred place brings a blessing into one's self, like 'taking the breath' from any sacred object." Ellis, who did much of her work in Arizona, described the completion of a ceremony where a leader paints his hand white and presses it against the kiva or cave wall to signify that he has carried out his religious duty. Growing up in both Sonora, Mexico, and central Arizona, Ellis's knowledge was earned from time spent with Indigenous people descended from these pictograph makers. She saw handprints as drawing supernatural forces to a point, so that spirits that have been called will know where to direct their blessings.

They are small windows, or keys that turn in locks. From what Ellis learned, they could be markers of a job done, where the power is not in the thing left behind, but in the doing of the thing.

◆

Representations of handprints are known worldwide from the Pleistocene onward. Either applied as a painted hand pressed to the rock or stenciled by blowing pigment around a hand through a reed or bone tube, they show the most frequently symbolized part of the human body. The oldest documented prints are stenciled in an Indonesian cave where people used a hematite-based

pigment forty thousand years ago. The stencil is made by holding a hand against the rock and spattering it with blown, sprayed pigment. When the hand lifts away, its outline remains. In Indonesia, they look like red trees with fingers for canopies. Their meanings are mired in speculation, but on the surface they are gestures of presence, a wave hello, a mark that cannot be mistaken. Children's hand and foot prints 200,000 years old were recently found pressed into sediment in Tibet. Arranged in a mosaic pattern, these appear to be the oldest known human art. In this Utah cave, the prints likely date to pre-ceramic Basketmaker culture, fifteen hundred to two thousand years old, a developmental stage that mixed agriculture with earlier hunter-gatherer ways. The people of that time probably spanned multiple languages and ethnicities, leaving artwork across the Colorado Plateau. Whatever their tongue, Uto-Aztecan, Keresan, or early Zuni, the shape is the same, the hand something we all know.

This is where we stopped for a quick lecture, gathered for a moment under a vaulted stone ceiling, the time of masks not yet begun. We weren't standing far enough apart, because we didn't know better. Numbers had been rising exponentially before we left, news changing by the hour, but words like lockdown and social distancing were not being spoken. We figured whatever it was, we were best off in the backcountry.

Stenciled hands outlined in paint, I told the twelve-or-so of us, tend to come later during the Pueblo era, the time of multistory room blocks and masonry villages. For a stencil, pigment was sprayed around the hand leaving a negative impression on the rock. I held up my hand and drew around it in the air. Fully painted handprints where people brushed on pigment or dipped into it and then pressed skin to wall, tend to be earlier, dating back to the Basketmaker period. This cave held the latter technique, fully painted hands.

We'd been going through cliff dwelling architecture and hills

of fallen villages over the last few days and in this cave, we had a chance to talk about rock art. Hard to date and challenging to decipher, it is not a written language but a narrative one. I told them that archaeologists tend to prefer potsherds, architecture, and perishable remains like baskets and blankets found stuffed into caves. Rock art has long been treated as a minor character in the discipline, while I find it contains the most vivid views of human life and how these people experienced the world. More than any other testimony, this is a window onto their animated lives.

The first question that may come up is, what does it mean? After sitting with a site for longer, you'll wonder, instead, what does it express? Questions eventually turn to who made it, who was meant to see it, and where do you stand between these two? For Hopi, in Arizona, a people who coalesced from across the ancient Southwest, the guardian of the world, Màasaw, told them to leave footprints as they migrated. Footprints are the images left on rocks. These marks can be seen by anyone who passes through, and they help people to identify their own ancestry on the land. A handprint may seem like a sheer human expression, but to the right eye, it is far more detailed. What color was used? What design was placed in the palm? In numbers, how were they arranged on the wall?

These may not have been done for us or anyone else to see, but instead were a byproduct of a ceremony, handprints put up as part of an event, marking a passage, not necessarily for public consumption. They are markers of ancestry, like anything left in this cave, crystallized by drought. If you fished with your fingers in the sand, you'd find snips of braided cordage, part of an arrow shaft with sinew wrapped around it, or the hard stem of a gourd, which everyone knew at this point not to do, not to brush the surface with their hands looking for archaeological goodies. To remove a piece would shrink the memory of this place. Memory exists for a reason. Jim Enote from Zuni said that when he comes

on images in stone, he sees genetic lineage, faces he might have recognized, names he might have known. "Brown skin," he told me. "These people had brown skin."

Enote feels that rock art can be healing to the Indigenous soul, ancient depictions left not by some far-flung, inscrutable people, but from blood relations. He is concerned about how people find their group, what deeper roots they connect to. "When I see these rock art messages, they illuminate my identity," he said. "I am Zuni. I am of this place. I am a descendent of these people."

I am of this place, but from other blood, and my language did not evolve here. If the Hopi scholar hadn't been called home, he would have taken this differently than me, knowing a great-uncle a thousand years removed would have known someone who knew someone else who put handprints on a wall like this. We, in this group, were of this place because we were here living and breathing right now. Our relationship to the rock art was that it proliferated in front of us. How could we not see it rising over our heads, hands raised as if in prayer or elation? You wouldn't look away.

◆

I reached out to Jim Enote during the heart of the pandemic. He was at his home at the Zuni Pueblo and I was home in Colorado. We chatted by screens, meeting in person being out of the question. Roads into Zuni were barricaded, and my county mandated a two-week quarantine for anyone coming home. He sat at a desk and talked about the value of rock art to him, what he sees in it, what evokes deeper responses. His darkly rooted and silvering hair was pulled back into a black tail folded into a club. A few weeks after we talked, he would cut the tail off, saying it was a part of him grown tired by a year of unease and loss. Elders were dying around him in the pandemic. He cut it off with the intention of flourishing again.

Enote grew up living in a household at Zuni with great-grand-parents who themselves grew up in the 1800s, the last of them passing when he was seventeen years old. Now in his sixties, becoming an elder himself, Enote said, "It was enough time with them, and enough for me to get a good appreciation of a world before our carbon-based economy. Not to romanticize it, but it was a world unencumbered with the knowledges we have now."

"Knowledges, plural," he said. "You're constantly mediating different knowledges."

Enote told me there are entirely different ways of witnessing the world, the Zuni ontology naturally on another track from the Anglo. Science, he said, is one knowledge system, and his traditions are another, and he stands in both. "I can tell you about soils and geomorphology, felsite porphyritic with apha-nitic textures. I can also tell you about *danaya sowe*, a certain kind of organic soil that is under Gambel oak trees."

Enote has the voice of a gentle storyteller, spaces thoughtfully positioned between words. He rounds his vowels back inside his mouth, his accent coming from Zuni as a first language, English second. Behind him, half a wall of packed bookshelves rose above his head. Coiled baskets he'd woven were stacked atop a file cabinet, and a carved katsina effigy sat at the edge with legs hanging over, as if sitting on a rooftop at a dance. A framed painting on the wall showed three of the first gods in the world, masked and wearing Zuni kilts, climbing up from a kiva ladder, storm clouds growing behind them. Wearing sensible glasses and a denim button-down, sleeves rolled up, Enote looked like a man of manual labor, a farmer, which he is. As a scientist, he has headed the tribe's Department of Natural Resources, and as a curator, directed the A:shiwi A:wan Museum and Heritage Center at Zuni. He is now leading the Colorado Plateau Foundation, a Native organization that funnels philanthropic money toward Native groups on the plateau.

I came to Enote for his balancing of science and traditional knowledge, what he describes as riding two different horses at the same time. When he approaches rock art, he first acknowledges imagery with a hello, then frames how he is going to listen, how he hears what they have to say. "I go through stages," he said. "Like, how you would appreciate the brushstrokes on a painting, the technical aspects, the combinations of colors. I look at the shape of the bird or the fish or the turtle or the spiral and I think, wow, that's really well done. What comes next is how they are evocative. That's a perfect, beautiful spiral, but they're talking about movement, migration, moving from one place to another."

You look into this imagery and see beyond the skill it took to make it, understanding that volumes are being spoken. Myself, I'll say hello, but mostly I'm quiet, as if not sure what to say. I can be awkward, the way I sometimes am among strangers, hands in my pockets, then back out, then back in. I make eye contact, and look away. What right do I have to be here? is a question that often goes through my head. Is this mine to see? I feel like a sympathy card sent out after a genocide. I'm the back end of an invading army, the cleanup crew trying to fit broken pieces together. The land I am exploring is stolen, not mine by any bloodless right, while senior rights are written in the rock. I come to these markings with curiosity, as if we just met, talking about the weather and asking each other where we're from.

◆

After the lecture in the handprint cave, when notebooks went back in pockets and packs, we were left to wander. I toured the handprints and watched where people went, pairing off or walking alone out of the alcove into daylight. I saw the slowness of their steps, one crouching at a corn cob, another on tiptoes to study the paint-dabbed whorls of fingerprints.

The rock is a coarse sandpaper the color of rose tea, its

surface mildly uneven where pictographs come in profusions, like fireworks. You can see the center of the burst, handprints set head-on in the middle, while those around them flare to the sides, radiating outward, making the placement seem like a single event. Hand after hand went up, people waiting turns, creating a sum that was more than the parts.

I passed by a dragonfly painted just above eye level, and slid on my reading glasses to see it up close. It was a simple, red-painted emblem, four lines representing wings, one line for the body. Nothing but a dragonfly looks like this. I didn't know much about this figure in the art other than what appears across the Colorado Plateau, much the same at every site with a dragonfly, a bit of geometry that your eye recognizes. It was put here for a reason. If I knew more, I would have added it to the lecture, but I felt fine seeing a dragonfly and not knowing. The knowing takes longer.

At the sonic focal point of this cavernous ceiling lies a cluster of boulders smoothed into grinding dishes. You can imagine the sounds the grinding would have made, people scratching back and forth with stone manos, polishing so deeply the dishes were made slick. I counted thirty-five ovoid basins, some nearly overlapping and feeding into each other. The dishes are so smooth the boulders look like salt licks in a field of cows, and pigment would have been swept from one into the next as if on a mixing palette.

Carol Patterson, a Four Corners scholar and ethnohistorian, has visited these grinders and tells me they are paint pots. Grinding corn, she notes, requires a rectangular trough, deeper, wider and sometimes with peck marks in the bottom for breaking up the corn kernels. Sometimes stone or mud-and-dowel bins will be nearby for parsing meal. The grinding holes in the cave have smooth, almost glassed bottoms, and are relatively small, not meant for the industrious work of crushing corn. Seeing handprints all around, and recognizing pigment dishes, Patterson

believes these were made for pulverizing minerals to be mixed with water and a fixative. This would have been where paint was made for going up on the walls. The blue-greens are all the same blue-greens, yellows all the same yellows, reds all the same reds. Preparing pigment is a science.

Ute elder Clifford Duncan once told Patterson that small ovoid basins like these were used at "paint parties" staged inside gaping, acoustic caves. Duncan, who passed in 2014, was with Patterson inside a similar alcove in the Henry Mountains of southern Utah. She was a follower of his over the years, an attentive ethnohistorian taking careful note. He explained to her that the depressions on a large flat slab of fallen rock in front of them had been an important gathering place for these paint parties. One group living in the area would invite young girls from several different villages to come for a few days and grind paint together. "They would sing songs as they did this," Patterson later wrote. "After they ground the different color mineral paints, they would give the colored powder to medicine men for their ceremonies. The medicine men, in gratitude, would give each girl a little bit to take back to their village."

Patterson told me she imagines girls with bags of differently colored rocks to grind. She sees three or four crouching on each boulder around the pots, the rock slick from their work. "I get singing in my head," she said. She hears grinding songs, young girls with soft voices giggling together. They get a rhythm going, singing songs to rain and songs to flowers.

The way the alcove is shaped, arcing a good thirty feet overhead, the sound of grinding would have rained down on them, and I can hear the giggle because we did the same when we first came in, laughing to hear our own voices. You can come to these places with courteous silence, steps as quiet as a cat burglar's, or with talking and hearing your playful echoes, a humanness that carries its own brand of respect.

I was glad for the easy sound of my group. Being alone in

a chamber like this can feel off, all the handprints on the wall hushed as if waiting for someone to speak. Instead, I listened to postulations, questions, how old, what languages, which mineral pigment? A conversation two hundred feet away, across the cave's parabolic arch, sounded as if it were in my ear. The handprint-makers had listened here, too. Who wouldn't? We are human.

The day was getting on. With a walk still ahead to a road and a camp, we couldn't linger much longer. As everyone left the cave, a line of us dropped down the slope and out to the canyon. I stayed back, holding up the end, waiting until voices were far away, words no longer distinct, enunciation softened. They sounded like anyone, any language, their tones mixing in this yawning chamber, reduced to our most basic selves, the five-fingered people.

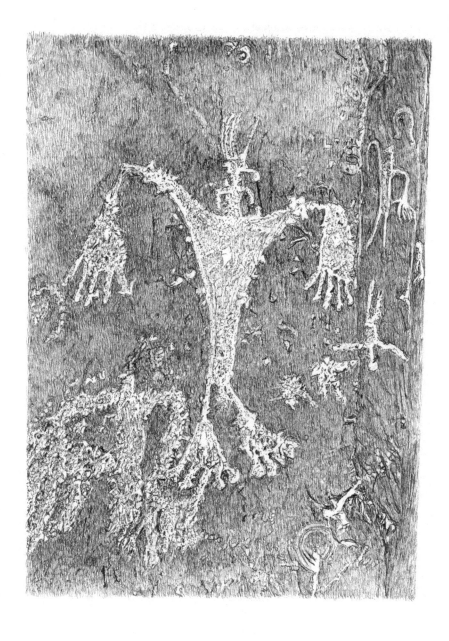

◆2◆

Floating People

The year of the pandemic I mostly stayed close to home, sticking around salt valleys that ribbon across the Colorado-Utah border. An ancient almost-volcano sticks up like a widow's peak straddling the state line, a compass point on the horizon. Below the mountains on all sides are throngs of canyons and broken-open basins. Redrock explosions have cracked the earth. Cliffs stand all around. I used to come out here in my twenties on days off from work, taking the twisted thread of a two-lane where I'd pick anywhere to pull off and start walking. Along a river, I found a boulder marked with petroglyphs of bighorn sheep. Over the years I spotted them here and there and none made particular sense to me. It was like finding a piece of newspaper in an unfamiliar language. I knew they were depictions of animals or people or lines, and that was all. Ancient, to be sure, the rock art seemed dropped from space. I'd crouch and study a scribble on a rock, repeating it in my journal, thinking myself a mapmaker, not thinking that I was the one dropped from space.

Decades after I moved away and had a family, I moved back to this part of Colorado as a single father, now with two kids entering teenage-hood. A woman named Daiva whom I started dating asked if I wanted to see some rock art. I said of course. It was our first walk together. She and her climbing buddies had found a site years back and she thought I'd enjoy seeing it. I knew rock art in the area from when I used to live here, some wavy lines and circles, mostly rough renderings. I said yes, mostly interested in being with her, and always up for a little rock art.

Up through boulder fields and animal trails, her body sprang above me as she called out this view or that. A basin dropped below us and I could see the rims of farther regions, a few lonely mountain ranges here and there, places familiar to me but from years ago. I knew those mountains, had climbed them when I was younger, learning my homeland one horizon after the next. Where was she taking me? Her route went behind a dragon's tooth of a cliff and up to a wall where she presented a row of tall, pecked figures. I'd been thinking she'd show me stickmen and more bighorn sheep, but here were full bodies chiseled with sharpened bone that must have dulled, snapped, and been replaced a number of times. Tens of thousands of peck marks gathered on a panel the size of a bedroom wall. I saw not a nick of graffiti or rough treatment. The main stage consisted of several figures, the tallest almost four feet head to toe. They were humanlike, anthropomorphs, with heads and shoulders. Their hands and feet appeared to be inflated, oversized, hanging down as if these depictions of people were floating. Many smaller petroglyphs surrounded the bodies and heads, bird-people flying, falling. These looked almost identical to elaborate Basketmaker panels I knew from the San Juan River in Utah, lifted up, carried more than a hundred miles, and dropped not far into Colorado. I had no idea this kind of rock art was here.

Daiva's tendinous climber's hand slipped into mine and she smiled. I asked her, You've known about these for how long?

I returned to this panel again and again, in every season, snow-swept and rippled in summer heat. My kids were younger, one still hoisted on my shoulders, and both were quickly old enough to run ahead carrying their own gear, giving me a hand as we climbed. Each light and mood changed how I saw the petroglyphs. I took my joys and sadnesses to them, or talked about the weather with them. Mostly I sat on a nearby boulder saying nothing, letting the day come and go.

Four years after she first took me there, Daiva and I came with my mom and stepdad in their mid-seventies, a hard day's huff on a clear, wind-blasted November afternoon. We went hand over hand, spotting each other through splintered cliffs and slopes of boulders. Their two little schnauzers scrambled and hopped across rock cracks. Sitting on a boulder in front of the petroglyphs, and after asking several questions, my mom braced herself with her trekking pole and cradled her head against her open hand where she fell asleep. She seemed to fit in below the main petroglyph figure, the four-foot-tall anthropomorph. My mom wasn't one of the dead, or the elevated, being on this side of the rockface, out here with the rest of us. Still, she seemed part of the tableau. I took pictures to show her later around the dinner table, but also to study the way her body cupped into the inset boulders like she belonged there. It's a trait I appreciate in my mother, her ability to find a piece of ground and fit herself into it.

Not far beyond her, opposite direction from the rock art, were remnants of industrial work, getting electricity out to a mine in the desert. Cables had been suspended above the ground, leaving grooves in the rock where they'd been dragged. I wondered if workers who dug lines and screwed anchors into rock several decades ago saw the panel over here. Did they walk to it on a lunch break, cables and tools left behind? If they did, no one pulled out a pocketknife to scratch a name or a date. They had to have seen it, had to have stood here. The petroglyphs are so clean, as if done with a straight edge, and the workers would have seen these as rare and beautiful. Maybe that's why no one marked up the rock. Or maybe someone said not to, the older guy on the crew who shook his head and said, These are haunted, leave them alone.

They look haunted. It's their suspension and the exaggerated hands and feet. The figures barely have legs or arms, torsos as big and spread as manta rays, heads small, some unadorned,

some with a bob or a feather on top, a water-gathering headdress meant to pierce the clouds.

Similarly evocative floating figures like these can be seen on the walls of Canyon de Chelly in northeast Arizona, white and red painted bodies, yin and yang for eyes, penises hanging down, and chests dotted with color. On a darkened boulder at Bandelier in northern New Mexico, a box-shouldered man had been endowed with the same hanging feet and hands. They hover in Grand Gulch and Comb Ridge in Utah, and are all along the San Juan River near the Four Corners.

Carol Patterson said I have them all wrong thinking they are people, at least in the way I think of people. Her study is in Native mythology and ethnography as it applies to rock art. Her dissertation from 2003 is on postures and gestures displayed in anthropomorphs, or what rock art people were doing with their hands and feet, and how they presented their bodies, and what the positions imply. Her home in Bluff, Utah, is a library, every room stocked and stacked, books toothy with sticky notes. By poring over ethnography interviews and monographs from the last century, she has made herself into a storehouse of knowledge. She told me that human figures rendered upside down, as if plummeting toward the ground, represent actual dead people, not just spiritual figures, but the no-longer-breathing. These upright drifting figures, however, are beyond death, possibly immortal. "Hands are neutralized, feet are not walking," she said. "These guys have transformed into spirit." The term she gave them was cloud beings.

I hear from other ethnographic scholars and Indigenous voices that personifications of floating people with enlarged feet and hands may indicate they are dead, but the word "dead" is too final, sounding like a nail driven flush to its head. I've heard these forms also called a shaman's vision or a dream of the supernatural, people who have passed beyond ordinary life.

Polly Schaafsma told me that hands and feet blown up like

balloons, hanging as if suspended, are not representations of living, everyday people. She said, "They are people who have become something other than human."

Micah Loma'omvaya, an archaeologist and anthropologist, member of the Bear Clan at Hopi, has a similar angle. When we spoke in Arizona, Loma'omvaya told me that these were holy people, those in contact with the supernatural. "Whenever you see hands this way," he said, holding his hands downward, "it is knowledge, the knowledge of how to create life."

Loma'omvaya, who was born at Songoopovi on Second Mesa, a Hopi village dating to the twelfth century, sees knowledge in rock art. Images contain information, what a person might need to know to survive and thrive in the world.

As he and I wandered among petroglyph boulders near the dustbowl of Tuba City in northern Arizona, I asked him about this word, *knowledge*. Loma'omvaya is a forty-seven-year-old researcher who balances science with his ceremonial roles. He has obsidian-black hair pulled back into a ponytail. He said the way a Hopi person thinks of knowledge may not be the way I think about the word. It is about truly knowing something, comprehending it, something you can do with esoteric knowledge that the Hopi do not publicly share. Knowledge comes from more than simply witnessing something, but from being taught its layers of meaning. "What I fear is that there will be knowledge, like facts, but not understanding," he said. "We could end up learning our tradition from books, not from living."

I side with Loma'omvaya, where understanding does not come from books as much as it does from walking and talking in fields of rock art. It comes from being there, receiving a place with your senses and from the perspectives of others. Being here is the cleanest way for me to come to understanding. Looking at these floating figures, you don't have to be told by scientists and scholars that they are beyond human. You feel it.

Chris Lewis, a farmer, weaver, and keeper of stories from

Zuni Pueblo, called these figures *spirit beings*, and said the Zuni word for *spirit* translates into English as the word *raw*. "They are raw beings," he told me. "When you're born, you're raw, and when you're dying, you're raw. That's when you sense and know the spirit world. After we're born, when we're our age, we're not raw anymore. We're cooked."

The floating ghostmen Daiva showed me were uncooked, unjaded, made of pure spirit. They appeared to be rising, and I wondered if it was a trance or an ecstatic state. I once felt something like this for an instant in strict Buddhist meditation, the seventh day seated in silence, no speaking, no eye contact. At the end of a night in a meditation hall, hours and hours of listening to chants, aware of every breath, I began to buzz. I couldn't feel where I began or ended. I had lifted off the wooden floor and existed in stars, unwilling to think, to move, knowing if I did, I would fall back into my body. Everyone else stood from their positions at the end of the chants and left their mats, while I remained. I didn't open my eyes until the meditation leader came to me, laid a hand on my shoulder, and said, "Take rest."

We are not always ordinary people. Sometimes we fly.

Following these buoyant figures back in time, you'll find older versions of them from the Desert Archaic age, predating Basketmaker culture by another thousand years or more. Bodies are painted high on the walls, often in many colors. These earlier people left polychrome expressions of life-sized figures, bright-eyed, skull-headed, dressed and decorated, eerily human and at the same time not.

A local Utah variant of these Archaic figures is called Barrier Canyon, a style of hunter-gatherer imagery from before corn, dating back possibly five thousand years. In canyons south of the town of Green River in Utah, they are gathered along echoing walls as if in covens. Pictographs show ancestral spirits or bodies wrapped in adornments, blankets or robes, only arms showing, if that. There are no legs or feet. Their torsos taper like water.

Schaafsma describes them as supernatural, calling these color-ful pictographs, "abstracted, elongated silhouette shapes, lacking limbs, but harboring human likeness, thereby evoking a power-ful sense of awe and otherworldliness."

When I see rock art displaying people with feet flat as if standing on a surface, I think of them as less powerful, more mundane. They are we, the average, the earth-bound, while these floaters have powers.

◆

On Christmas Eve, the first winter of the pandemic, I came alone to this familiar wall of petroglyphs. A flight of steps made of geology hundreds of feet tall took me up the side of a desert valley rimmed with cliffs and scraps of snow. You wouldn't call this place lush unless you consider boulders lifeforms. Sheaves of cliff were either still standing or long ago collapsed, leaving rubble and blocks the size of buildings. The sun stood a few fists above setting, maybe two in the afternoon. Winter light cut low across the broad valley that stretched more miles around me every hundred feet I climbed. As the valley became wider and longer, I could see its tectonic buckles and depressions, a roller coaster of uplift broken down by erosion. The boulders must have numbered in the tens of thousands.

I climbed through the shattered talus of salmon-colored sandstone thinking Basketmaker people came this way, too. They'd grabbed the same holds in the rock and pulled themselves up. Twisted, hairy-barked junipers grow from cracks like ogres, each living a few hundred to a thousand years, not old enough to have been around when early Indigenous agrarians were here, but old enough to remember a thing or two. Those people would have had their own junipers, using exposed roots and branches as rungs and steps. Along a bench of sandstone I found a mark, a sign of humans, something I hadn't seen before. Several inches long and worn into the rock, it was a single groove no wider than

a pencil, probably made with a bone tip or harder stone rubbed back and forth. Simple imprints like this are common across the Colorado Plateau, signs that you are in a place people frequented. I've most often heard them called arrow shaft straighteners, though I find the name erroneous. No one straightened arrows this way. More likely, it was an act of gathering sand from a sacred or important place, scratching it out of bedrock and putting it into a pouch. Sand was picked and rubbed from the rock and carried as medicine, a custom widely known and still talked about.

The first panel I came to, a palate cleanser from the climb, was composed of three humanlike figures pecked into the foot of a cliff, one with a drunken, almost comical headdress, another wearing a turban that expanded like a rising sun, and a third a stick figure of a person with a penis. On each I could count fingers and toes, appendages pronounced and drawn downward. The turbaned figure bore six toes on one foot, a polydactyl symbol known across the Southwest, found in rock art as far south as the Atacama Desert in South America. Six toes is a hemispheric motif, an American sign. If enlarged hands and feet imply power or knowledge, a sixth finger or toe is even more. I paused, said hello to the three figures, a nod of a greeting, and continued up to the next higher stack of cliffs where the ghostmen stand.

Their position looks across the valley and its dendritic fingers of dry washes, so high the petroglyphs cannot be seen from the valley floor. Looking up from the bottom of the basin, you can make them out if you try, fitting them onto the head of a pin. Up close, they are much larger, the tallest measuring exactly a meter top to bottom, head to hanging feet. It looks as if it is coming out of the wall, drifting forward to meet you.

These were clearly not made with steel tools, which would leave straight lines and strokes. They had been eyeballed and struck precisely with a bone awl and hammerstone, each peck

leaving a dimple the size of a BB. Shoulder leaned into the rock, the maker had flecked out dust between blows, maybe a few thousand pecks for each ghostman, slow and tedious work. I sat on a boulder nearby to watch, sun now two fists above the horizon, two hours from sunset.

Slowing down is what I recommend. If you can take an hour at a rock art panel, take an hour. It may astonish you how they unpack themselves. If you've got four days, take them. I've heard that if two strangers stare silently into each other's eyes for four straight minutes, they will fall in love. You do the math.

The most telling moments at any panel are the still ones, after questions fade and your eyes have traced horned people and hunting scenes again and again. Distinct stories have been isolated, a man playing flute to a round woman squatted down. What song is he playing? This is what meets your eye, but it's only the start. How are the figures positioned among each other? Is it an intentional constellation or are they barely related? Is there a sequence of events on the rock, a sense of distance or dimension between figures, an intensity or urgency, a sense of the artist's emotion? Are the larger figures closer, the smaller ones farther away, giving a sense of depth? You are not so much deciphering rock art as letting it in.

Inquiries are like tiny pebbles. Eventually they all spill out. You'll no longer take mental notes, as if looking at rock art had been a game of solitaire, figures flipped each time you see them. You pick at your finger. You look at the sky, and glance back to the rock, which has changed in that short time. A face has turned slightly, sunlight pivoting through a thousand peck marks of a petroglyph. These figures are in motion all day, walking with the sun.

Around the ghostmen, I noticed small elements I hadn't seen before, something about the light or my wandering eye looking for something new. A small pecked figure rose up the side of one of the larger figures. Maybe I'd mistaken it for a smudge in

the past, but this time as I came closer, right up underneath it, I could see I'd made an amateur's error. It was no smudge, but a rendition of a small bird. From its position, beak up, body vertical, wings straight out, I convinced myself it was a hummingbird. I've seen them in the older Barrier Canyon polychromes, often painted in red, feathers and wings rendered with two-hair yucca brushes. They are often depicted around the bodies of the dead or the holy, whomever these wafting bodies were.

How did I miss this hummingbird before? How many tens of hours have I looked at this one frame of rock and not spotted such a simple form? You'll ask yourself the same thing, clocking hours at a rock art site, lifting binoculars and putting them back down, and suddenly you notice a bird you hadn't seen before, or a petroglyph of what looks like a beetle or a kissing bug down in the corner.

Micah Loma'omvaya told me people miss a lot when they look at only the boldest features. "They'll get stuck on one symbol," he said. "It may mean something very different depending on what's around it. If you show me where it was placed, I might be able to say something."

For this reason, I have problems with photography. The frame treats rock art purely as an aesthetic, picking out the finest-looking piece or angle, capturing the sky or bringing in shadows. When I take a picture of a rock art panel, I'm both frustrated that I can't include everything and glad I can't, because where would it end?

I have the same challenge with the journal in my hand as I enter words about the hummingbird and the bodies around it, trying to take in the waning afternoon and the broad shotgun of this valley. Writing may be able to encompass a larger spectrum than photography, but it is still a frame. Most of the pieces are left out. I see only the basic picture, something ancient on a wall, perhaps sleepers, dreamers, portrayals of the dead from a people I scarcely know. This is the nature of a colonist, a person in

unfamiliar land. No matter how many marriages and births occurred in my family line, I've barely arrived. I am stepping foot on my own home ground in a land that is not mine. I plant the flag of my body at a row of ghostmen where later, after sunset, I'll take my flag back down and go home.

◆

Jim Enote from Zuni told me that a clean, precise panel like these ghostmen heartens him. The work artists put into it took concentration and mastery, making him think of prosperous times. When he sees rougher petroglyphs and slapdash pictographs, he is saddened. They seem to have come from hurried hands, as if shaking in the cold.

"Rock art panels are also about circumstance," Enote said. "It was a good growing year or a deep contemplative year. I can look and see some of these things. Sometimes if I look long enough, I can say, *Oh, I'm so sorry, that was a hard time.* I can look at others and see their marks were strong and bold and this was a time of flourishing."

I told Enote I'd always imaged sloppy or ill-made petroglyphs came from children practicing their art and he said he didn't think so. He saw little rain and shriveled crops, game animals hard to find. At an unfinished petroglyph, a partly done rendering of an animal, I now think, *There would have been legs, but I had mouths to feed. The spiral would have had more turns and tighter curves, but baskets needed mending. I would have finished this symbol, but I am bleeding from a wound and this is my last act.*

The ghostmen look like a healthy occasion, a big panel with crisp pecking. Making art like this, you couldn't be too pressed for time.

Their finest hour is winter just before sunset. Colors become saturated. Sunlight casts through wind disturbances and the day's atmospheric dust on the horizon, scattering light into its

full spectrum. A slight redshift complements the red in the rock. Light becomes music, the root note striking the wall, next note up bouncing back with eroded iron in the rock, the third note your eye taking it in. A panel becomes chord.

I saw more on that Christmas Eve than any day before. I'd seen the single track of a deer on the panel, represented by hooves and a dewclaw, but then I saw three of them, as if the other two sprang from nowhere. How had I missed these? The tracks were now in a line, the direction of an animal walking. I couldn't sit still, moving from rock to rock. An hour from sunset, one of the ghostmen fell into shade. It somehow seemed brighter, clearer, illuminated by the encompassing glow of the desert.

Figures still in the light turned a blushing bronze where I read stories as fast as they came, piecing together a small person with wings repeated in different places, one turned upside-down like Icarus plummeting along a natural groove in the rock. I've seen humans becoming birds elsewhere, winged people flying like ochre angels. Scott Thybony, an Arizona writer and ethno-historian, told me about a site where painted bird-people are mixed with fossil dinosaur tracks. Along a cliff that runs a hundred miles from Arizona into Utah is a short trackway of Jurassic prints belonging to a three-toed predatory *Dilophosaurus*. Four, maybe five of its true prints clearly show its direction of travel across a horizontal plane of exposed limestone. The prints break off at the edge of the cliff where it appears that this creature walked to the lip and took flight. Thybony said, "I can see the origins of a mythic bird that among the Hopi is called *Kwaatoko*, this man-bird, war-bird that intervenes at the moment of their distress. You can see where the kernel of this might have begun, trying to make sense of tracks like these."

The earth is said to have been soft at the beginning of time. That would explain how the ground recorded the footprints of the first beings. In a geologic sense, this is exactly how it happened. The dinosaur that left the tracks was twenty feet long and

weighed nearly a thousand pounds. It had walked through soft sediment, a muddy lens, and its tracks were preserved. The mud turned to stone over tens of millions of years. This cliff was not present at the time. Instead, this rock was buried beneath sand dunes and sea floors, and when it came back into daylight, tectonics broke it into palisades. These tracks happen to come to the edge, what in the Jurassic was no edge at all. The tracks are *Dilophosaurus*, or, in legends told across Indigenous cultures of the Colorado Plateau, they are a giant, monstrous bird, both true. Thybony believes people would have interpreted these fossil tracks as evidence that this bird existed, proof of a story they'd already conceptualized.

A hundred feet below the trackway are pictographs of people becoming birds, or birds becoming people, as if they'd leapt from the rim and laced the air like giant swifts and swallows. These transforming pictographs are gathered around a single rendering of a three-toed track, a clear association with the fossil. This seems to be a depiction of the Hopi *Kwaatoko*, or what the Navajo call *Tsé Nináhálééh*, the monster bird. If such a creature lived long ago when the earth was soft, and it had wings to fly, jumping unflinchingly off the edge of a cliff, you would have told stories about it.

At the ghost panel, I couldn't tell if the flying people were monsters or rain spirits who are said to fly among the clouds. I thought these scattered bird-people showed events that happened here and that continue to happen, as if time were not moving just one direction, but swirling. They could have jumped off the cliff above, diving around this rockface, leaving shadows of themselves in flight. Around them, spirit beings stood tall, or hovered, and a hummingbird floated. A deer came through leaving petroglyphs for tracks, dewclaws like quotation marks. These were left at a time when the earth is said to still be hardening.

On one side of this timeline was an era of flying people and monster birds, and on the other archaeology and paleontology.

The two sides leaked into each other as I watched the day close. Shadows advanced half inches at a time as figures in the light became bolder. One, two, three, four, five toes sprung from one foot after another. On the shady side, you see the panel warts and all, every scratch, rub, and blemish. You see where people leaned to study the figures, not recent people, but faint, bald patches of patina worn over centuries from visitors long ago. Some may have been curious, not sure whose legends they were seeing. Athabaskan travelers coming down from the north a millennia ago, speakers of an Arctic tongue, would have encountered petroglyphs of people they may have heard of but didn't know. They may have leaned into this wall wondering who they were going to meet, what descendants were here. The questions haven't changed much since then.

Two fingers of sun became one, and then the light left all the ghostmen. Cliffs lost their blaze. For several minutes a pinkness remained in the rock as the images flattened out, no figure greater or brighter than any other.

It was time to start back. We'd be having eggnog and pickled herring by oil lamps, and Daiva would put handfuls of dry, wild grasses under our placemats, a Christmas Eve custom brought to this country by her family from Lithuania. I found a long stick and scribbled my tracks from the dirt as I backed away.

·3·

Spirals & Concentric Circles

Tattooed on my back are four interlocked spirals spinning one direction and the other. They help remind me where I am when everything is in motion, like a compass that never leaves. The composition, which I designed on a scrap of paper and slid across to a tattoo artist years ago, is the size of a dinner plate. I positioned spirals in four corners around the image of a sea turtle, a navigator, star-watcher. This is my way of grounding myself inside of movement, dazzled by the whirling architecture of the world.

You can't be in the Southwest without the spiral imprinting on your imagination. Santa Fe is rife with them on signs and lawn ornaments. I imagine people naturally doodle them onto corners of paper regardless of where they're from, but in the Southwest, they hold unique significance.

Everything here moves, not just the ephemeral rise of grasses and trees, but the basement of the earth grinding and snapping. Every boulder came from somewhere. River gorges and their entrenched meanders have been cutting down for millions of years. You don't need to be a geologist to see it happening. Rock is active and writhing, while droughts weave in and out over decades. People could never stay still, dryland farmers having to pull up stakes if precipitation dropped by an inch in one year. Even the nomadic hunter-gatherers that preceded agriculture had to follow rains, watching the horizon for storm clouds drawn to distant mountain ranges or mesas. The land, weather, climate, people, and animals are constantly pushed and pulled.

If the Southwest is spiral country, the Colorado Plateau is

its epicenter. You hardly find a rock art panel without the representation of one. I once asked a Hopi man what the spiral represents and he laughed, asking me where to begin. They come in pictographs and petroglyphs, as big as an arm's reach from fingertip to fingertip, or they are as small as saucers. Depending on who you talk with, they can depict many things, wind, water, or the migration of people encircling the Colorado Plateau. They describe anything that goes round and round.

◆

A whirlwind blustered through the middle of a conversation, interrupting a group of scholars and field archaeologists sitting on a dusty hillside on a warm spring day. Half were masked, and the other half, sitting at the edges, weren't. Vaccinations were just coming out, allowing us to come in closer together, an important moment considering that most of these scholars had come by plane or a long drive from distant institutions. We were becoming used to asking where people were from, and stepping back a little farther when distances were involved.

A PhD researcher from Skidmore College in New York was talking about human bone assemblages she'd studied from sites below a ridge that rose behind her, on the other side of a reservoir. That's when a swift column of air careened over the water's surface. We were camped with trucks and recording gear, discussing a site most people here had worked on or studied, a cluster of ninth-century pit houses that had been excavated before the reservoir filled. Sixty miles from the Four Corners into Colorado, we were at a confluence of ridges and piñon-juniper woodlands. The wind had unleashed from far off, a top whirling faster and faster. The glass of the reservoir turned into spinning, bright shards. Mist scraped off and gyrated upward. On late spring days like this, dust devils are common, some spinning close enough to give you pause.

By the time it hit land not fifty feet from us, we were staring

at it and the sound guy wearing headphones signaled to the researcher from Skidmore to stop. Her voice was being drowned out. She turned to see what we were looking at as the whirlwind collided with a wild hedge of shore willow, ripping and sawing at the air. Feathery branches clattered wildly. Past the willows, the whirlwind entered a patch of dried thistles and seemed to linger as if relishing the fodder, whipping papery skeletons into the air, yanking them out of the ground and sending them end over end.

The warm season is when tight, violent winds like this begin to rise, little tornadoes formed on clear days between heating earth and cooler sky. Air shoots up fast enough it becomes water down a drain in reverse, reeling a mile or more into the sky. It is a coil, a spiral, a spring made of air. The wind spins inward, forming what is called a cyclostrophic balance where the inward pressure balances the outward centrifugal force, effectively keeping a column of air intact. Anything captured and carried by it spins inside and the column occasionally throws out a rock or a branch.

This, I've been told, is also what a spiral represents. In rock art, you see them, circular or squared, lines curved around each other or bent sharply as if on an Etch A Sketch. Some are coiled snakes, the curl in the center bearing a diamond-shaped head. They are starbursts and labyrinths. Whirling across water and onto land, they are the shape of wind.

You'll hear that whirlwinds and dust devils are ancestors passing by. It might be your father or grandmother, or the spirit of somebody who lived in the place. Under this reservoir, bones used to stick up from the ground, the remains of burials and battles, some skeletons with grave goods and some without, some arranged neatly as if sleeping and others shattered and broken, stabbed and stuck by arrows. Every watered valley or decent mesa around the Four Corners carries a similar story. The dead have been poured into the ground, given to the soil until the land and the people are blood relatives.

I asked Micah Loma'omvaya to interpret spirals in rock art and he said, "I don't really consider it interpretation, I consider it understanding." To interpret means to translate, and much can be lost in translation. He said he's found water in the desert by following spiral petroglyphs as if they were instructions, describing going behind a boulder marked with a spiral to find a spring.

Loma'omvaya balled a fist to show his thumb circled around his tucked forefinger, left hand turning clockwise, right hand counter-clockwise. This, he said, is how you learn to read spirals and which way they are turning, followed from the outside in.

Spirals are the high verb of rock art. They are the trappings of motion, like stepping into a planetarium with stars and planets swiveling around a domed ceiling. Often, they'll have some form of astronomical alignment, positioned to relate to certain seasons and sunrises. In the middle of Chaco Canyon, on the observatory-shaped head of Fajada Butte in northwest New Mexico, a large, clockwise spiral is struck through the middle on summer solstice by a dagger of sunlight. At the height of winter, first sun frames the spiral with two daggers on either size. Equinox puts a single sundial just right of center, as if the people who made it were aware of their latitude, marking their angle off the plane of the ecliptic. The site at Chaco is also aligned with lunar cycles that return every eighteen and a half years, arranging specific lines of moonlight on the petroglyphs. You'd think of this spiral as a calendar, telling when to plant or harvest, yet it might simply be a visible recognition of order and return.

When I come to a spiral, I'll turn around to see its horizon, noting where the sun would rise at certain times of the year. It might come over cliff tops or through fallen boulders where first light breaks into fingers addressing the rock art directly. On Fajada Butte, light comes through an upright sheave of three flat boulders that may have been positioned by hands and tools, the slots between them casting sun daggers that track the seasons.

Once you think of the spiral not as stationary but rotating, rock art begins to move. These wound-up circles become gears turning in an elaborate and elemental machine. The Neolithic spirals of Britain and Serpent Mound in Ohio, with its massive clockwise tail, are set to celestial patterns. The spiral's tracking of the heavens is a human motif among early, animistic agrarians worldwide, people who lived by seasons.

Jim Enote said he heard about spirals from his grandparents and great-grandparents, who told him that they represent things that move. Enote said, "Whether you're watching the water go down a gopher hole or you're seeing a whirlwind, or you're seeing anything spiraling, there's a center to it. That center is where things slow down." The spiral makes him think of his hitchhiking days in his youth, taking jobs along the way where he thought he might end up being a logger or a carpenter, a gas station attendant, a musician, an educator. For him, these were choices along the curve of a spiral that is a person's life. He said, "You may be one of those things, but at some point, through life and experiences, you spiral into your truth and find your center."

Chris Lewis, also from Zuni, told me he sees spirals as migration symbols. We talked by phone since half the alphabet was being allowed out of Zuni at a time, with only three hours to pick up supplies and return through a checkpoint. There was no seeing each other. He said that you can tell how many years people lived at a site by counting the number of rings from one side to another. Lewis is frequently tapped by archaeologists and ethnohistorians studying rock art, coming out not to give set-in-stone interpretations, but to convey stories he finds relevant to the images.

Lewis and I both found that most of the spirals we see, counted from one side to the other, have about eight or ten or thirteen rings. He said, "People lived in one area, then moved to another, then they came back. Ten or thirteen years may have been enough to deplete nutrients in the soil."

Lewis sees spirals as information. To him, they tell which way people came from and which way they were going. Some unravel into a tail that can be traced across a rockface to where the line comes out of a small divot pecked into the rock. That divot is an emergence place or a destination, the line and the spiral being the journey taken once you've stepped foot in the world. He said that linked spirals, which look like disks of converging or departing galaxies, show communities either splitting or coming together. He told me what they portray depends on where the spirals are placed, clockwise facing north, or counter-clockwise facing south. Variables of possible placements and directions are as numerous as stories of migration among Pueblo people. Movement is written into the foundation of these people. Over their history, their journeys might look like a turning, changing circle, a constant search for a center-place, every bend honing inward.

The same could be said for this whirlwind raking across dry grass up the hillside toward a gnarled grandmother juniper. It was turning and whipping swifter than any culture or lifetime. It had our full attention, carrying mist and dust and cartwheeling thistles. It crested a hill and went down the other side. As it left earshot, the Skidmore scholar gathered herself and began speaking again about bones.

◆

A younger man named Aaron O'Brien, who'd been on the dig crew for these ninth-century pit houses, took me aside to show me pictures on his phone. He'd been tracking astronomical alignments in his spare time and had some good leads on spirals and concentric circles. O'Brien told me he'd noticed that concentric circles often interact with the sun, and he'd found one that represents to him where to stand at a particular sunrise. "I used the app," he said. "It feels a little like cheating." The app being one that shows where the sun rises for your latitude on any given day.

When he spotted a possible alignment for summer solstice, he came back at the height of summer to ground-truth it.

"Here's sunrise on equinox" he said, showing me a photo of the circumference of the sun as it rolled up from the horizon, and a natural rock tower stabbed directly through its middle. The photo looked like a needle piercing the yolk of a boiled egg. Swiping to the next picture, he said, "Here's where you're standing to see it."

This was the pictograph of a hematite bull's-eye, not the windmill of a spiral but a geometric stamp, perfect, singular symmetry. Stand here, it said.

This concentric-circle pictograph was on a ledge along a red-faced cliff, canyon bottom dropping away below. Someone a thousand years ago climbed with pecking tools and left one circle within another. The rock tower it denominates is miles off, too far away to cast a shadow on the wall. The way to see the alignment is to turn away from the petroglyph and watch. It says: *This is one of those places.*

◆

A canyon south of Green River, Utah, has the highest concentration of polychrome pictographs on the Colorado Plateau. Most of the painted wraiths are Archaic in age, at least a few thousand years old, before the advent of agriculture and pottery. I've noticed not as many spirals or concentric circles during that age. There are some, of course. An Archaic humanlike figure in red ochre holds a snake in an outstretched hand, and rings of concentric circles are painted in its chest. Perhaps people were on their way to becoming themselves that long ago, their relationship with the Colorado Plateau beginning to form. Without farming, they may not have needed to codify their relationship with time and cover their rocks with circles of astronomical alignments. After corn, however, seasons were broken down to planting, tending, harvesting, feasting, and storing. Circular

rock art, signs of motion and positions within seasons, became abundant.

Seen as a symbol for the sun, the circle, or circles within circles, may also portray a weather event. Preceding rain, the sun will often be surrounded by a halo in the atmosphere, light passing through a layer of high ice crystals. Sometimes you see double or triple halos, a sign that precipitation is nearby. In arid country, a portentous sky like this would have been welcome, possibly called upon and prayed to. It is the sun making rain.

This is why the Hopi man I spoke with laughed when I asked what the spiral, or the concentric circle, means. These do not come down to one circumstance or one representation.

A route drops into this canyon of polychromes, several hundred feet of boulder jams and gaping alcoves. One of the alcoves, big enough it feels as if you are under the saucer of a starship, holds a pool of water in the middle, a disk gathered from rain. Footers of masonry structures stand in the back along the seam between ceiling and a sloping floor, ruins of buildings once used for storage or dwelling. The people who lived here must have marveled at the cavern around them, constructing in this place not just for its shelter, but for its echoing enclosure. I used this route on a day when the sun entered the alcove and cast a mirror image of the pool against the high, vaulted ceiling. A near-perfect circle of light was projected, framed in the back by raw remnants of rock and mortar walls. Any breeze shimmered the reflection, the focus so tight I could see each ripple on the ceiling like a fine-toothed comb. I picked up a chunk of sandstone, weighed it in my hand, and pitched it to the center of the pool.

A deep-throated gulp echoed in the heights. A bright circle grew into this dome of a stone sky. It turned into rings that fanned outward, bounced off edges, and fell back in, a star growing, collapsing, and growing again. I believed I had discovered one of the first concentric circles, a birth of light and time, an ignition of rainwater settled beneath a deep sandstone archway.

I had created a transient form of rock art. This had to have been done before. Maybe people occupied this alcove because of the bright concentric circles they could make. As simple an act as throwing a rock into a pool could set the world into motion.

◆4◆

Conflict

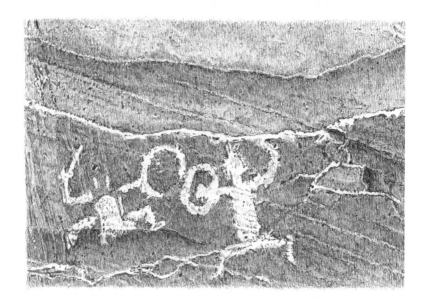

I know a warrior's shield pecked in stone like a glowing mandala. You can tell a shield figure because of its circle, and often you see the head and legs of a person standing behind it, sometimes with a weapon sticking out. This one is big enough you could swipe it off the wall to deflect a flying projectile. Its surface is intricately decorated with pecked lines and smaller circles, representing the design that would have been painted on the shield.

After you've become lost in its detail, your eye will drift to the start of a second shield just next to it. This one was begun with full intention of being completed, but it never was. The first few curves had been added deeply into the rock with a sharp

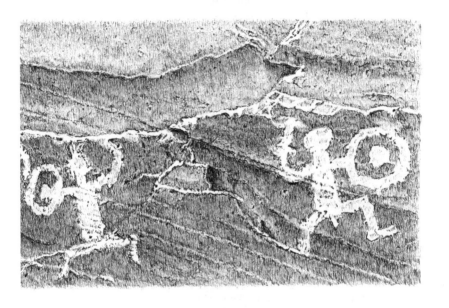

eye, a sharp tool, peck marks so close together you can barely separate them. You can see how a large petroglyph would have been started, a handful of small pecks outlining where the rest of the circle would go. Started with confidence but clearly unfinished, you wonder why the work stopped. Perhaps the maker passed on, or a commission wasn't paid, protection not given. Or the reason they were putting up shield petroglyphs, conveying a warrior's stance, a readiness to fight, suddenly came home to roost and no one was left to finish it.

Some villages burned while they were still being lived in. Canyons went empty overnight, their cliff dwellings smoldering. In the Kayenta region of northeast Arizona, where shield

figures are common, tree-ring dates from cliff dwellings show that some were built and occupied for only a decade. They had shields painted up high, bright white for all to see, bold circles and weapon-wielders announcing that this place would not be easily taken. With masonry structures and timbered roofs, they seemed to be in for the long haul. Within ten years of final construction, they were gone.

A boulder outside of Moab popularly called the Birthing Scene has an image of a claw-handed woman giving birth, surrounded by an array of other petroglyphs. This has long been talked about as a women's boulder, a place of fertility, but when Chris Lewis from Zuni traveled to see it with his nephew, it looked more to him like a battle going on. He and his nephew sat at the panel for an hour and a half, picking out its details, talking back and forth. They found images of combat and weaponry hidden in the scene. "I don't think this is an umbilical cord," he said. "I think it's blood flowing from a warrior who is defending the woman giving birth."

The warrior, he pointed out, standing tall as if protecting the woman, has an atlatl projectile sticking out of his side. Another figure, he noted, has an intentionally severed arm. A third has a raised shield and what might be an axe in one hand.

Whether this depicts a mythic battle, the birth of a hero who then goes to war and is struck by a projectile, or it represents a raid and combat while a woman is giving birth, there's an argument for shields. Bad things happen and you don't want to be caught defenseless.

◆

In January, the emptiest time of year, I went to the high shield figure and its unfinished counterpart. The creek below mumbled under ice. Cottonwood trees stood bare. Frigid air roamed downhill, a stillness the canyon seems to be drifting into like a ship through fog. My perch was slickrock, my gloved hands

wrapped around binoculars waiting to be used, for the day to come. I was here for dawn and sunrise, watching the last stars drift out and an inkling of light seep into cottonwoods below. I prefer this time of day, or at least this pace of waiting. The rest of the time is so much grind and go, a civilization screaming at you to stay on the ball, while here the light comes as slowly as cold molasses. A crescent moon sliced the glowing sky. Petroglyphs above me, around me, stood out through a thin broth of light, and I didn't want to lift my binoculars to focus on them. I watched the canyon instead, eyes drawn into a gray frosting of snow and trees. Nothing moved along the snowbound creek, not an owl or fox, no breeze to stir the unfallen leaves.

Most bends of this canyon, less than a hundred miles from the Four Corners into southeast Utah, are marked with rock art. Overlooks and ground-level panels are detailed with handprints, birth mothers, flute players, snakes, hunts, and spirals. The shield above me is an ornate circle inscribed with gridded lines, curves, smaller circles, and dots. This is how shields were once decorated, in colors and patterns. Polly Schaafsma in her study on shields wrote, "The Pueblo war shield was much more than just a material protective device, but was believed to be animated by spirits and to possess magic power derived from its design that was, in turn, transmitted to its owner."

She said that the painting on a shield, designed to blind and confuse the enemy, was more about the supernatural assistance, "deemed more important than the shield's physical protective qualities."

The disk above me hid the body of a standing person, two legs and feet showing, a head adorned in two pointed triangles for ears, what looks like a mountain lion head. What could be a billy club or a stone hand ax is wielded from behind. At the same time, what I call a weapon could have been a feathered prayer stick raised in a dance. Being a shield figure doesn't automatically mean it was used in combat. A famed red, white, and blue

shield was painted inside a sandstone declivity maybe fifteen miles from here, named All-American Man for its coloration. Carol Patterson told me it is not necessarily a war image, but is a cloud figure in the form of a shield. Patterson says the pictograph is a rain figure called *Sun Youth*, known in Acoma as *Oshach Paiyatiuma*, the one who carries the sun shield across the sky and arouses clouds from four directions, bringing them together to make rain. In that sense, it is not a war figure, but one with a more particular and storied past.

It's no small thing to come to a shield panel. Even if the image were magical or narrative, not about combat, somewhere in its history, this object was wielded in conflict. I stuffed my gloved hands into my coat pockets, feeling in one pocket a wadded-up mask, a sign of the times. Two days before, a mob had stormed the US Capitol to stop the presidential election and five were dead. Shields had been shattered. Tensions in my own country were as high as I'd ever felt in my life. People and violence are not easily parted.

The shield above me seemed proud, pecked into a panel of patina as dark as burnt toast. The figure's feet were spread as if standing on solid ground, not hanging like ghosts, but firmly planted. This was a real person in my mind, not a particular god, but someone ready to kill, ready to die.

Shields like this show up in rock art as far north of here as Montana, and out to the Great Plains where these sorts of warrior figures extend into Kansas and Oklahoma, and north to Canada. They are circles, often with a head sticking up, a pair of legs out from under, maybe showing a spear or ax. On the Colorado Plateau, the range of their designs in pictographs and petroglyphs suggests that they were painted in spirals, crosses, polka-dots, moons, suns, split-levels, and animals. Everyone had their own shield art and style of manufacture. Some may have been made of skin, while many that have surfaced from diggings around the Four Corners suggest they were woven like tight baskets, stiffer

and stronger than framed leather, fair protection against an atlatl whistling at you. A basketry shield was excavated from an eleventh-century great house in northwest New Mexico, its front painted in blue-green concentric circles. Another woven shield came out of Canyon de Chelly, decorated with the painting of a frog-like figure, the center of the woven coil meeting the center of the figure's body.

The shield petroglyph above me this morning is part of a cluster of figures pecked onto different facets of a broken-up cliff, some high above, some far below. Petroglyphs are well dressed in head ornaments and baubles hanging around their necks. They all look over arable land below as if watching for their people. They are best viewed not from up close but several rows back, down at the bottom of these staggered cliffs where you can take them all in. I'd come up to be part of the grouping, joining the gallery waiting for sunrise.

Who was behind the shield? Was it the idea of a person or an actual warrior, someone feared or relied upon? I sent pictures back and forth over email with Laurie Webster, a textiles specialist working with archaeological collections from around the Four Corners. She sent a black-and-white taken in the late 1800s of what she called a mountain lion cap, a sewn skin skullcap that would have descended down near the shoulders, once stitched with a fringe. The head had two pointed skin ears sewn onto it, and Webster believed it was made to look like a mountain lion's head, a decoration worn in battle or for the hunt. In turn, I sent a picture I took of this shield figure, the head sticking up behind it sporting a distinctive pair of pointed cat ears. We had a match. Webster's skin cap came from an excavation in the cliff dwellings of Mesa Verde in Colorado and my shield petroglyph came from this canyon in southeast Utah, the two about eighty miles apart, a distance that could be crossed on foot in a few days. The dates she had were from around the 1200s, a time of drought, migration, and widespread conflict. She thought it might be akin to

skin jaguar masks with heads and ears she's seen in collections from southern Mexico, warrior garb. The petroglyph was probably from the same period. I take it as a fighter's uniform, what you'd put on to either intimidate an enemy or take on powers, the countenance of the most effective predator in the land. This, to me, is the sign of an actual person. Behind this shield stood a figure in a mountain lion cap, a physical item that may have ended up in a cave at Mesa Verde.

The only other combat imagery I know in the vicinity is miles upstream at the head of this canyon. A Fremont figure with a trapezoidal body and stick-figure antenna, perhaps antlers, stands high on a busy petroglyph panel. Its one arm is outstretched, holding up a long weapon, what looks to be a leaf-shaped stone, a blade of some sort. Beside it is a petroglyph of what appears to be a severed head or a human scalp. There's no question that this is a firm statement to watch your step. Below the figure is an engrossing congregation of rock art spanning two thousand years. Its position, higher than the other images numbering more than six hundred, by far the highest on the wall where a ladder would have been needed to reach it, suggests this is the one you pay attention to most. More darkly patinated than the rest, it is likely one of the oldest, if not the first. You wouldn't have been able to pass through this canyon without seeing it, as if it were saying, *You can enter, but don't expect welcome.*

Depictions of warriors with weapons and detached human heads or scalps are found across the plateau, one of the more common motifs. They appear as if from a collective legend like Perseus holding up Medusa's head, or they are from domestic killings that happened often enough to record with grisly frequency and detail. One panel in Utah shows two pecked people holding up shields and projectiles, what look like spears. One of the spears is midair, flying toward a shielded person wearing horns and standing on the other side of a dotted line. The spear is about to strike the person in the shoulder or neck. Another

Utah petroglyph shows someone wearing a skirt, a Pueblo kilt, standing on a rock ledge with a large, shell-like pendant on the chest. In one hand is what appears to be a severed head and the other holds a long sharp blade, the dagger that assumably did the cutting. Decapitated heads in rock art are shown with loops on top for carrying or hanging. These were trophies, fodder for ritual, the destruction of an enemy.

None of this do I find shocking. Which human society has not drawn blood, and plenty of it? The fact that it is so well represented in the art is par for the rest of the world. However much we may hold hands and sing kumbaya, other forces are rumbling.

◆

A reservoir built in southwest Colorado inundated a valley of ninth-century AD occupation, at the time one of the largest human aggregations on the plateau. Archaeologists and diggers were sent in for reclamation before waters rose. They removed ancient burials for repatriation and mapped what sites they had time for. Work intensified when they uncovered a couple buried pit houses full of dead people. These weren't funerary circumstances, no fine wares laid to rest with them, no jewelry spread out on their chests. They'd been cut to pieces, butchered like game animals, thirty-three people chopped into more than 14,880 bone fragments. The bloody mess had been heaved into what were once residential chambers and covered over. Victims ranged from eighteen months to fifty years old, what looks like an entire community including four neatly dismembered dogs. From what could be pieced together, researchers found evidence of weapon use on skulls, ax blows and scalping marks, and blows to the forearms indicative of people defending themselves, covering their heads as they were bludgeoned.

When dust devils blow through this valley, you pause and take stock. Some of the spirits here are deeply unsettled. You lower your head and let them pass.

Anna Osterholtz, a bioarchaeologist out of Mississippi State University, led the lab work for this site, calling what her team found "extreme processing." She and I visited the inundated valley together, serene with water and sun, so calm and pastoral you'd never guess its history. "The actual violence would have been over quickly," Osterholtz said. "The processing took far, far longer. There was a formula, how you take apart a shoulder joint, how you disassemble a skull."

She'd found no remains of hands or feet from the thirty-three people. Those had been picked out and taken elsewhere, their aim unknown.

Osterholtz saw skeletons from this assemblage cut up in the same way every time, jaw bones sawed loose from one side of the face and wrenched out by hand. She calls this "performative violence," which is violence that takes place in front of an audience. That audience may have been survivors of the massacre singled out to witness the butchering so they could return and tell what they saw, and I can only imagine their stuttering, sobbing voices. Those are the ones I pray for, even twelve centuries later. This kind of pain does not quickly depart.

"This creates in-group and out-group identity," Osterholtz said. "These people were definitely out-group."

Osterholtz spoke of violence with a scientific calm I found both alluring and troubling. She called violence a means of control, a functioning part of a social structure, a way of keeping order. "It is essentially a leveling mechanism," she said. I asked her about the children and the horror of what that must have been. She said I should pay attention to the other forms of violence and conflict represented in the archaeological record, evidence on skeletons, often females of low burial status, that bear repeat injuries to the head and upper body, healed fractures, signs of domestic abuse. She pointed to what is known as Cave 7 in Utah with ninety dead Basketmaker people buried inside, many showing violent ends, signs of hand-to-hand

combat with broken limbs and skulls stoved in, and weapons lodged in bones, stone points, bone awls, and the tips or blades of obsidian knives. They weren't buried all at once, not a mass killing, but had been interred over time, a sign of ongoing deaths at the hands of others.

With this kind of violence on the table, you can see why shields would go up. No one wants to be controlled in such a way. The question I've often heard is who was perpetrating the violence, but this is moot. Marauding invaders or next-door neighbors, does it matter?

Shield imagery is common along a boundary that crosses Utah between Pueblo groups in the south and the more northern Fremont culture, evidence of friction between the two. We like to think it's someone else, and no corn-loving Anasazi would ever do such a thing, but violence routinely comes from within. When one group turns on another, some of us have the capacity to become monsters. Knowing that, and with tensions rising, weapons manufactured at a quickening pace, and posters going up of shields on rockfaces, you'd have defense in mind.

◆

The sun was taking its time, stars gone, sky changed from purple to blue. If I had a watch, I'd be checking it. Sunrise was scheduled for 7:33 a.m. It felt like 6:30, or 6:45 if I were lucky. The thin sail of a moon was the only thing moving, slowly tipping from left to right across the sky.

I think of this bend in the canyon as a summer home. Winter is too cold. Warmer, sunnier parts of the desert are nearby, better for waiting out the dark season. A scout may have been left this time of year, someone sitting on a ledge, maybe this ledge, blending into petroglyphs, eyes not on the rock art but on the canyon below. A scout would have watched for anything to move, an invader sneaking in.

Two days before this, I walked with Rory Tyler, an old friend

and rock art obsessive. We went to see rows of shield figures pecked into an overhang not far from Interstate 70 spanning across Utah under the long, sharp palisade of the Book Cliffs. We hiked through a plain of greasewood and ankle-deep snow crystallized into hoarfrost. Waves of ice crystals washed ahead of our steps. Seventy years old, walking with a pole because of a bum leg, Tyler took me out to a place he knew, a congregation of shields he believed had been a warfare boundary between late Basketmakers in the south and the Fremont culture in the north.

Tyler, a roughly hewn character from around Moab, has been talking about rock art for the twenty-five years I've known him. At times, we used to career through this desert, climbing into cliffs and cracks looking for whatever we might find. Between us, we didn't talk that much, poking around boulders, out of shouting range. He sometimes spouted his theories and we'd argue. I was into the mythic Anasazi, a fan of cliff dwellings and ceramics, and he was a Basketmaker guy, telling me I should get off this Anasazi kick. The earlier Basketmaker people, he'd say, were doing all the great rock art for thousands of years, and Anasazi was the late flash in the pan with its defensive sites and last-minute shields, what he called a Mesoamerican incursion from the south. I'd eventually come to agree with him, but it would take decades.

Employing a lisp like a speaking tool, Tyler unraveled the history of this place as we walked, comparing what happened here to early chapters in the Bible, what he calls an anthropological text. "It's the inter-tribal squabbling of a bunch of Bronze Age hillbillies," he said. "I think about the Basketmakers and how long they were here and those inter-tribal squabbles. One area is dominant when another area goes down. Let's move here, let's move over there. It's very dynamic."

Tyler wore plain-soled leather shoes, not sensible for walking through snow and arroyos, but eccentricity is a prerequisite

for his kind of work. Tyler, well-grayed with an Edward Abbey-esque appearance, catalogues rock art sites, cross-referencing motifs that he picks up like a clue game, bighorn sheep in running position or standing, or the ones he calls "spirit sheep," who hover overhead like a watermark. He finds bighorns shown with backward heads or heads up on ridiculous giraffe necks, which he believes, because of where they are located, conveyed to hunters that bighorn sheep can see over the horizon, or they are watching their backs.

Tyler's grasp of rock art in the Moab area, where he's been most of his life, is encyclopedic. He doesn't work for an institution, a man after Groucho Marx's heart, refusing to join a club that would have him as a member. His findings are on thumb drives, which he carries around in a satchel, handing them out to anyone who takes an interest. You probably have one. When Eddie McStiff's was still in Moab, you'd find him at the bar ready to turn to you talking a mile a minute about rock art no matter who you are. Sometimes he's polite, he waits for a beat after asking how you're doing, then grabs your hand and takes you into the caverns of his knowledge, canyons galleried with images where you push through brush and scabrous tamarisk branches, opening onto a petroglyph of two deer with their rumps fused together into eight legs, two heads, and two sets of antlers. "What do you make of that?" he says.

Based on combing through canyons and mesas, Tyler's got a theory that at least some of the combat at the time was staged. He's compiled images of warriors, or at least people geared up to fight, with weapon sashes, atlatls, spears, shields, and projectiles. Some are represented inside of circles or divided by lines, and they are hurling projectiles at each other. Some would have been struck in their hips or legs, turning to run from an atlatl dart or bending down to pick one up to hurl back at their opponents. These sorts of injuries show up on human skeletons from the time, enough to say this kind of combat was common.

The fighting scenarios he describes are shown between people with northern-style head ornaments and those portrayed with ducks on their heads, common south of Moab, closer to the Four Corners. He sees these as two distinct cultural groups dressed up for combat. "They are all near big flat spaces with high sides, so they would make good amphitheaters," he said. "If you see guys throwing spears at each other, look for a big flat place right next to it."

Tyler told me, "I think a lot of the time, combat was people just throwing spears at each other to see who could dodge them, who could chuck them, and who got hit."

"You see it as performance?" I asked.

"It's competition," he said. "Could be bloody."

This would have been a different kind of violence than slaughters and raids, a controlled competition as a way of limiting the number of those killed, maimed, or scarred for life. He sees rock art evidence of fighting played out in ritual fashion with spectators watching fighters in twos, threes, and fours armed with atlatls, facing off from a distance. The panel we were going to, he said, was different. This, he thought, looked like war.

The land is tipped this way and that, ridges and salt basins wrapping around each other just south of I-70. We could hear the steady hum of vehicles in the distance, beads of color streaming one direction and the other. Tyler led me along the foot of a ridge sticking out of the earth like the fin of a 1959 Chrysler.

He took me into a ragged overhang filled with petroglyphs of at least forty shield-bearers, some pecked and then painted red, some with long spears. Shields were mostly no bigger around than the mouth of a coffee cup, most decorated with crosses and lines. Stacked in rows, phalanxes, they looked like maneuvers planned out on a strategy map. One line displayed twenty shields one after the next, impenetrable.

"Spears," Tyler noted. "Not bow and arrow."

With no bows and arrows, the site dated to before 800 AD in

my mind, exactly in the time Fremont and Basketmaker cultures would have been facing off.

"It has a definite martial character, doesn't it?" Tyler said.

"This is almost entirely shields," I said.

"Yep," he said, watching my reaction, seeing me counting, never having come upon so many shield-bearers in one place. Elsewhere, I've seen them in lines, some actively posed, people behind shields holding out weapons, legs spread as if ready for action, but no more than five or six at a time. Forty was a barrage.

"What was this about, huh?" Tyler asked. "What was going on here?"

"And painted red inside," I said.

"Important," he said. "This was some sort of a fortress where you could put up an outlook and repel invaders from the north. You can hear them getting ready up here, psyching themselves up, pounding spears on their shields."

Knowing this, it felt like we were cheating by being here, hardly a care in the world on this bright winter day. Hearts must have raced. Young warriors would have known this was it, their lives could be over by the end of the day. Severed heads on panels they'd seen could be their own, or they would triumphantly hold up the scalp of an enemy, posing for a petroglyph, added to the roster of who killed whom.

This shield site lies within a corral of tilted rock scarps, a visually protected enclosure, a hundred acres of flatland basin guarded by rock. Barricades of geologic uplifts allow views through widening gaps where you are able to see out, but not in. I'd later do a reconnaissance of the area, walking its ridges, piecing together views and obstructions. Satellite images make it look like a sunburnt tectonic circus, the earth ruptured into slabs and ridges forming a strategic landscape. I returned in the spring when the snow was gone, and found the ground blanketed for miles in flaked rock, signs of manufacture of weapons, spear points, and tools. How many tasted enemy blood?

To look back down on the site from miles away, I climbed to the top of the Book Cliffs due north. From there I could see the reason for the panel's specific placement. The Book Cliffs run for 240 miles from Utah into Colorado, one of the longest continuous escarpments in the world. They stand like a palisade against the desert, protecting the high, forested Tavaputs Plateau in the north. These cliffs, situated atop slopes of ash-colored geologic rubble, are marked up with rock art like spray paint along what was once the Berlin Wall. How could these rocks not be dressed in imagery?

To the north of this wall is Fremont territory, where life was more meat and skins than seeds and fruit. Corn does not easily grow in that direction, too cold, too high. Fremont rock art you find up there is embellished with antlered headdress, atlatls, and eventually bows and arrows. Nine Mile Canyon, north of the Book Cliffs, bears thousands of petroglyphs, a Fremont reliquary, some of the finest rock art on the plateau. Go up to Vernal, Utah, to the red northward canyons a hundred miles from here and anything Fremont rivals the complexity and imagination of Basketmaker. Northwest Colorado, the trailing edge of the plateau, is swamped in Fremont rock art. This was a formidable neighbor to the Basketmakers in the south, who wore ducks on their heads and created some of the most stunning, flamboyant rock art the Southwest has ever seen. A line between the two was the Book Cliffs. This was Tyler's line, a boundary between what he saw as warring peoples. Shields had been planted where the two meet.

Plenty of trade came through here. Glassy tool stones traveled north, where rock resources are scarce, as game went south. Bloodlines and languages would have drifted back and forth. Inevitably, conflict would have arisen. There would have been misunderstandings, violations, raids, and bodies left with blunt trauma, skeletons peppered with stone weapons, projectiles buried in spines, hips, and legs. I perched on the high edge of

these butter-colored cliffs looking across a big pie slice of the Colorado Plateau. Three isolated mountain ranges anchored the horizons like paperweights on a map, the La Sals in the east, the Abajos in the south blue-white with late winter snow, and the Henry Mountains in the west, bison-shaped peaks frosted and obscured by a passing storm. Between these ranges sprawled five thousand square miles of Basketmaker canyons and broken-tooth buttes.

On this same lichenous, cream-colored bolt of sandstone, a Fremont scout must have looked across this view, knowing it as other people's land, warmer than the north, better for growing, winters easier to eke out. Below these cliffs, down a slope of boulders waning into lobes and valleys of collapsed salt formations, miles across greasewood plains, the scout would have picked out the hook of land where Tyler took me to the shield images. If it weren't so blasted windy at the high edge of this escarpment, I could have heard Basketmaker war chants coming from their alcove as feet pounded the earth and fighters readied themselves for blood.

◆

A problem with Tyler's take may be a quibble, but physical remains of shields don't show up in collections from the Basketmaker age. They appear later in the Pueblo period, around 1200 AD, a time of later social upheaval. This was several hundred years after Basketmaker. Tyler is right, I believe, that these images portrayed warfare along a significant cultural and geographic boundary. His timing may be off, but shields were ultimately raised.

He and I were at the forty-shield panel the same moment as the siege on the US Capitol, January 6, 2021, when lunatics, politicians, and agitators broke through police lines and entered the seat of the country's government. Around noon in Utah, two in Washington, DC, the mob entered the capitol building

smashing windows and breaking though doors, while we sat on a boulder large enough to crush a bulldozer. I'd get back that day to find my phone lit up with images and videos of pepper spray and flagpoles used as weapons. Police held clear plastic riot shields, which were soon in the hands of rioters who used one to break through a window and others paraded inside the capital using them to protect themselves. The *Washington Post* put up a photo of a man wearing a combat helmet and a gas mask. In one hand he held an American flag and in the other a metal trash can lid, a circular shield, much like those displayed on rock art panels. This is one way of feeling your way along the string of history, stopping at each knot, an era where shields were drawn and civility flew out the window. I searched for plenty of other knots, births, initiations, or prayers, but conflict was on my mind for those few winter days.

Two days after the siege, I sat waiting for the sun to rise in an icy canyon. It was so much quieter here. The rest of the world seemed to be roaring, while this canyon was as still as death, the creek burbling through ice and echoing in the rocks above.

Direct light touched the tops of cliffs and I stood. The sunrise may have been at 7:33, but how long it takes to reach into the canyon is a different measure of time. It seemed to speed up and slow down at once, orange light extending through cataracts and broken shadows, the horizon dipped and towered. The shield figure above me was for the moment another cold being like me, the combat drained out of it. The shield was held up the way I held my binoculars, unused, both of us looking to the line of sunlight coming for us, the warrior in its mountain lion cap, me in a wool hat. For that moment, it felt as if we were standing beside each other as if at a subway station, our eyes fixed on the same point waiting for the light to arrive.

We have reason to be estranged, the shield figure and me. I am a twenty-first-century descendant of colonists, hardly a century ago moved to the Southwest, my family line reaching the

Eastern Seaboard by the time of the Revolutionary War. People of my surname built the first fired brick house in Jamestown in the English colony of Virginia and would soon be throwing English tea into Boston Harbor, soon parading westward with unmatched weaponry and a blanket of massacres and displacements, clearing the land. I imagine it takes centuries to get the paperwork started for naturalization on a new continent. How long till my lines become indigenous is hardly worth talking about, not something that ever happens. I'm thinking many thousands of years, but that might be a stretch. Coming to this panel might be a way of asking permission, standing with a shield figure at sunrise, bearing the same cold, the same expectation for sunrise.

A golden band crossed the head of the petroglyph, first landing on the two sharp tips of cat ears. It then touched me. The first few minutes were a little warmer, no longer the crack of dawn. I unzipped a layer, then two, and watched light creep toward the canyon floor.

A highway comes through the canyon and I heard a hiss from upstream, first car of the morning. The sound wandered for half a mile before the car finally appeared, headlights showing through a dim brume settled into the canyon bottom. This is how easy it is to get through these once-guarded gates, I thought, speeding past the petroglyph of a warrior raising a lance-shaped weapon next to a human scalp, past panels hidden behind trees, and those out for all to see. Families of giant box-people look down from a hundred feet overhead. A windshield makes it hard to see anything above the visor line, and with the heater turned on, music bumping, how would you know what galleries were passing around you? Sun was still to rise down there. Dawn hung in the cottonwoods like a dream. The shield bearer kept watching daylight and I started to think about breakfast and other mortal interests. The car disappeared downstream, engine drone retreating like the tail of a snake.

◆5◆

Horses

We keep a horse skull on a fence post along the drive down to our house, found it on a nearby hillside where it was probably dumped when it died. I come across rusted metal horseshoes around the property, and peg nails crooked from hammering. One of the horseshoes has grown into the arm of a tree, hooked around it a century ago. These came from Euro-American homesteaders and occasional Japanese work gangs, all riding waves of manifest destiny across the continent, their horses coming with them. In the 1800s, steam engines were in use, and it was horses that hauled the boilers and gears into place. They are civilization-makers, another phase of development we seem to go through around the world, humans and horses rising together. The first domesticated and ridden horse may have been in central Asia several thousand years ago, a leap in our relationship with the animal.

The Americas had horses to start with, a blocky Pleistocene species especially populous from the Midwest to Alaska. If they were ever ridden is unclear, but during the Ice Age, along with sloths, mammoths, and elk, they were hunted and eaten by humans, just like they were on the Ice Age Russian Plain and in the valleys of southern France. Horses were herd animals, meat and skins.

At the close of the Ice Age, pressured by climate changes and increased predation, the horse in the Americas became extinct. On the other side of the world, however, they survived and were eventually bred for riding and labor. When Spanish conquistadors and colonists arrived in the Americas in the 1500s, horses

came with them. Many were domesticated and some ran wild, and are still running wild in a landscape they carry in some ancient genetic memory as home. The original American horse from the Ice Age, *Equus lambei*, is the genetic equivalent of *Equus caballus*, the wild horse that lives here now. The horse that started in the Americas has returned.

You don't see them in the older rock art because they weren't here, still taking their ten-thousand-year sabbatical on the other side of the world. Then, *flash-bang*, they arrived.

On a ribbon of a cliff spooling out for miles in southeast Utah are hundreds upon hundreds of figures dating back a couple thousand years. In one corner, near the mouth of an incoming canyon, people are shown riding the backs of bighorn sheep. You might see them and immediately think Ute or Navajo, after the introduction of Spanish horses. But these are not portrayals of horses. It appears to be a game, a sport. Riding, or standing, on a wild bighorn sheep must have been a bucking, furious, dangerous mess. In the petroglyphs, it looks as if people commandeered a herd. The people look like Minoan bull-leapers, perched and spring-legged like acrobats about to jump.

The horses are farther along the cliff, and from much later. To get there, you have to wade through galleries of Basketmaker and early Pueblo petroglyphs, and linear, skeletal figures of Archaic age. Heads and manes of horses appear behind saltbush where you have to reach out and move thin, grassy branches aside. They look Navajo, as if scratched in an artist's portfolio, manes as wispy as cirrus.

Farther along the wall, a collapsed wooden fence leads up to the cliff through a slope of boulders, and the wood is gray, sway-backed, replaced at some point with green metal fence posts rusting into the color of rock. What remains of this cattle fence meets the wall at an unusual collection of petroglyphs. As tidily pecked as any of the older petroglyphs around it are depictions of two people wearing brimmed cowboy hats, legs apart

as if bracing, rifles held up and aimed. Another wears the same sort of hat and what appears to be boots, holding up a bow and arrow, the arrow aimed straight and ready to fly. On the other side of the scene, two figures without cowboy hats hold up bows and arrows, aiming at the three facing them. One is tethered to a horse that seems to stand in disinterest, head down as if contemplating nothing. On the cowboy side of this cowboys-and-Indians scene, a fourth person is laid flat with a line through the head, in one side and out the other, suggesting a direct arrow strike. The person's hat is off to the side on the ground where it must have landed.

Time jumps when you see this grouping. You've hurdled ahead to where the pecking is brighter, less time to oxidize and darken. You've come through European pandemics and armored Spanish horses, lance riders and musket carriers. The saddle shown on this horse petroglyph, with its horn as high as a serpent's head, and the cantle in the back almost as high and straight, is classic nineteenth-century Native American design. It would have been made of wood and dressed in skins.

Once you get past the temporal bump, adjusting millennia, you can see this shootout in action. They must have taken cover, jumping behind boulders or splashing into the river below. Or it was out in the open like the petroglyphs show, an old-fashioned, made-for-TV shootout. At least one person died. The saddle on the horse looks almost Mongolian, not European, and I'd guess the bow-and-arrow figure holding its reins is Navajo, could be Ute, both in the area at the time.

When the horse arrived, Indigenous people took to it as if carrying a blessing out of the flames. American colonization, with its disease, relocation, and planned extinctions, laid waste to the people, but the horse came through. With painted faces, handprints and moons on their rumps, they became part of the Native pantheon.

◆

When I see horses in rock art, the portrayals are usually not alone. They sit inside fields of older imagery, adding the next layer of time to the roster. In a cove of canyons about ten miles from the Utah-Colorado border, rockfaces, boulders, and overhangs hold numerous petroglyphs, placed as if around the bowl of a theater. Among images of duck-headed atlatl-throwers and spirals turning the direction of ancient migrations, I found two Ute horses. They were rendered full-bodied, shown from the side like a big stamp, a chop, a mark of a new age.

A few centuries old at the most, these two horses had been meticulously knapped with bone or antler, pecked as cleanly as anything of Basketmaker age. They'd been made on a canvas of mud-red sandstone, the one farthest left given special attention, its lines sharp, form impeccable. On its rump and shoulder it bears what looks to represent a pair of brands or painted circles, perhaps moons of different phases. These were pronouncements about the horse, its rider, or the people it represented. If I had the right eye, I could read it like a badge. Two or three hundred years ago you would have seen these markings and known exactly who made them, who rode these horses.

Regina Lopez-Whiteskunk, a friend and a member of the Ute Mountain Ute Tribe, rolls her eyes at horse art when it comes up. She said her people aren't really horse people, even though horses are widely pictured in their rock art. She thinks back to sturdier hunter-gatherer days, before horses, the older history of Ute people, before the European invasion. Lopez-Whiteskunk was staying at our house, and over morning coffee she gestured out the kitchen window to shallow platforms of mesas greened with piñon and juniper trees. She said what we could see out there was sovereign Ute hunting land. Hunting rights had been granted to the tribe in 1874 on parts of federal land that were ancestral hunting grounds. The rights are still officially recognized. Those grounds, she said, go back long before horses.

Among the Ute people, horses were stolen, traded, won, and ridden for their utility, their power, their ability to cross hundreds of miles in short order. Their place in the people's eye had been imbued into stone, a unique, post-colonial style expressive to both a Native and European sensibility. I've seen these representations all across the Southwest, Navajo horses etched or painted in the backs of alcoves, Apache horses on canyon walls. Once it entered the lexicon, the horse became a rock art favorite.

◆

My mom is an artist, and when she was a kid in New Mexico she'd draw horses in a Southwestern style, delicately curved bodies and with a jaunty spring in their step. On her yellowed sketchbook pages lifted from the bottom of a box, they took on the art of Navajo, Acoma, or Zuni, renderings she picked up in fourth grade. While researching New Mexican history for her fourth-grade class, thumbing through magazines to study the art of the day, she saw styles she liked. Who it was, she can't remember. It may have been Potawatomi artist Woody Crumbo, from Oklahoma, who lived from 1912 to 1989, his horses electrified, suppleness and strength turned into a spring-loaded, vividly colored powerhouse of an animal. Or it may have been Navajo studio artist Gerald Nailor, 1917 to 1952, from New Mexico, who worked in Santa Fe where my mom lived during her elementary school years, before the family moved to the southern part of the state. The horses these artists made were powerful, as if filled with spirit. With colored pencils, she copied them out of magazines.

The art has a Bambi-like quality, a cuteness employed by Disney in the forties. Disney likely took their style from Native artist Pop Chalee, whose slender deer and enchanted forest paintings first went on exhibit in 1936, the year before brush touched paper in the making of *Bambi*. Chalee, who may have been the one my mother studied, was a student of Dorothy

Dunn, an Anglo art teacher who created the Studio School at the Santa Fe Indian School in 1932. The school produced a number of famed Native artists from the era. Dunn taught a simple "flatstyle" painting with solid color fields, minimal backgrounds, and little shading or perspective. It was a technique that spread among Native American artists, becoming a mainstay. Dunn, in turn, came up with the style while teaching at the New Mexico pueblos. She saw it in rock art, picking up on what people had rendered centuries before her, when the horse was spreading among hunting peoples like wildfire. From one artist to the next, white and Native alike, the form that ended up in my mother's illustrations can be traced back to rock art.

Maybe in the 1950s, every young girl in New Mexico drew the same horses springing across art deco yuccas and tufts of grass, fetlocks flashing, hooves flying. This is how styles and ideas move ahead, my mom in bobby socks sitting atop her bedcovers shading notebook pages, pulling rock art images into the future without ever knowing.

The two Ute horse petroglyphs I found matched my mother's drawings. Her rendition was art for its own sake, something like doodling, daydreaming, while the petroglyphs were a message, an announcement. My mom's art went into a box, kept as a family heirloom, while the petroglyphs stand where they were made in the curve of a canyon.

When I drove home from seeing these Ute horse petroglyphs, I crested the gravel road above our house. Two horses that are usually in the field at the top of the hill stood out against the sunset. Side by side, one dark, one blond, they'd come to the electric-wire fence when I brought an apple to cut in half. We'd reach across the wire to each other. Their owner, our neighbor, said not to tell them the electric fence isn't always on.

Bodies branded the sky, these were the same *Equus* my mother drew as a kid, sway-backed and bold, long-legged, knobs for knees. They were the same as the petroglyphs placed in the

desert. I don't always want to bridge this gap between the ancient past and now. I go back to older rock art as if not wanting to cross into the present. I don't want to dirty my hands with what has happened, but I am already up to my elbows, already swimming in it. At Arizona State University, I gave a tag-team lecture with Rick Chavolla, a Kumeyaay cultural historian. The subject was apocalypse, based on a book I wrote some years ago. I was telling students that there may be no such thing, no world-ending flash. Change is a longer, slower process, I said, one most people may not even notice. Chavolla corrected me. He said it happened to Native America, that their world stopped on a dime and has never been close to the same.

That is the line in history I shy away from. I spend my time with the much longer dead, and the wars, famines, and flourishing that went on for thousands of years before now. They lie safely beyond the grasp of me and my time, our time. The horse is what carries me over that line.

The nimble figures I drove past were hewn into the horizon. They stood motionless, manes combed to one side, tail hairs drifting in the breeze. They were the horses I'd seen in the petroglyphs, moon-rumped and painted, their shapes turned into icons by evening light.

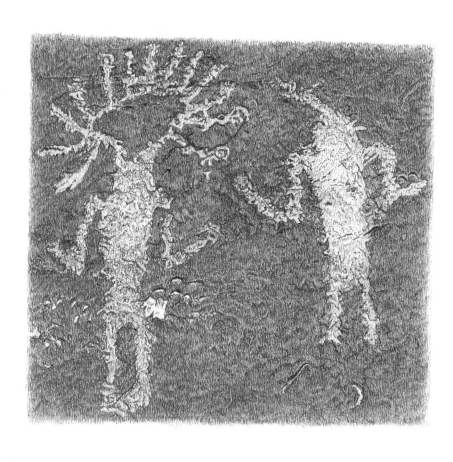

• 6 •

Adornment

Backpacking with friends in Utah, late winter, we carried gear through snow crusts and canyons, stopping to rest on occasion, clumped together in patches of light and shade. We shared bags of nuts and water bottles. This was before masks, before warnings. By the time we'd reemerge, early March 2020, news would be spreading about a virus overseas reaching our shores. It was little concern of ours. We came to peel off from the outside world. Dressed in the garb of wilderness travelers, packs and belts and boots, the spacemen of our time, we marched through red and white strokes of sandstone, bedrock canyons spreading like octopi, fossils of amoebas the size of cities made out of 280-million-year-old sandstone.

Rock art began to trickle in at the sound of running water. Springs turned to creek, cattails crowded with willows. Handprints appeared in an overhang, marking where bedrock brings the water table to the surface.

At night, we walked from our camp through winter sage and moonlight, around a great house of a boulder, its edges giving enough shelter to get out from under weather. Tonight, there was no weather, waxing crescent moon clear in the sky. We had no need for headlamps, the night a faint blue bath, high scattered clouds drifting past. Not until we came into a pitch black enclosure were lights fished out, clicked on. We stood with cups of whiskey and hot chocolate, tea for the fainter of heart, looking up at a masonry ruin and its open doorway. The rock alcove wasn't a huge place, a family could live here, maybe two. The ruin was backdropped by triangle-shouldered pictographs, bust, and

heads of people, or deities, or spirits painted against the wall. Red, white, and green—probably red, white, and blue before pigment oxidized—they looked like a bedecked royal portrait, or at least a Fremont family album stamped with painted handprints.

I could see exactly where each person's gaze fell, white circles branded onto rock, headlamps moving from one armless, legless figure to the next. Jeremy Collins, a climber and artist, father of a young son and daughter, came in below the rendering of four faces and bodies. He was not so close that his breath brushed the wall, but near enough to see detail. He moved his light over the handprints of children planted above him. I asked what he saw. He said family. Not his family, he knew that much, but, because he had one, he could see himself in the lineup.

Collins is athletic, an efficient build, gray showing at his temples and in his trim beard. He pointed out the two larger anthropomorphs on the outside and called them parents, both with slotted eggs for eyes, one wearing lightning in its chest, the other dressed in simple, elegant lines with a pendant hanging at the throat. The two in the middle, he said, were the kids, a daughter and a son, displayed with ornaments and embellished attire. One, he said, was a little cocky.

He was seeing in these figures a story that he knew. I trusted his gut more than most because he has an artist's mind. It is how he makes his living. Buildings are decked with his murals, T-shirts printed with his sketches and icon-shapes of faces, mountains, and rivers. He makes maps and books, and I've watched him onstage paint a canvas taller than himself, completing an entire scene before a live audience. He thinks fast and intuitively.

Biases can be tools for understanding, whittling out a truth that might escape most others. Outlier thoughts might not be correct, but who am I to say these four painted faces are not people who were buried here, and the handprints aren't those of their children or young siblings, their descendants, making this

into a family portrait? I saw Collins and his kids up there. He was going through a sticky divorce and they were on his mind. The handful of nights we'd been together traveling by foot, he'd been talking about his kids and we'd been thoughtful listeners, a group of friends, some of us going way back. This is how we see ourselves in rock art. It is impossible, I think, to separate what imagery means from what you mean. Collins says you can't, you shouldn't, that we are each constantly changing works of art.

◆

Carol Patterson knows this site of four painted faces. At her kitchen table we looked at photographs of similar anthropomorphs spread like decks of cards, their heads sprouting stacks of parallel lines or painted objects that looked like crowns. She said these kinds of figures were cloud people, and the pictographs I'd visited with Collins and our crew were, in particular, Cloud Women. She said she could tell by what they were wearing, and lightning coming out from under them.

I mentioned what they appeared to be wearing on their heads. I knew to be careful with my words. Patterson is a stickler for ethnographic detail.

"If you're going to go on with headdresses, I'll show you the door," she said. "There's nothing in the archaeological record that shows a headdress like that."

What I was seeing as ensembles worn by people, she saw as the enhancements of spirits, maybe akin to a halo, a sign that these are more than people wearing headdresses. She described these humanlike pictographs as part of a narrative, a cosmological mythology. She said I had to stop looking at rock art as purely representational, and she asked me to please stop using that word, *art*.

Patterson's voice is like a stern lecture given with affection. She plays with sweet, higher tones, and nails down every word, making sure you're listening. When I presented her with a

picture of the four faces I'd seen with my friends, she said, "They are all part of a rainmaking tradition. You can see the lightning coming down from one. It's like prayer. You amplify power, and you get it to happen. It brings the rain, or brings the animals, or brings the corn."

Patterson told me that instead of thinking of clouds in the sky as inanimate, I should see them as other people, not human, but members of the supernatural who can be cared for or appealed to. Personifications of different kinds of clouds would come with unique faces, adornments, what I was calling headdresses. The paintings we saw in the alcove that night, in her view, were how the people saw clouds. Patterson called them *koshari*, a Keresan word from New Mexican pueblos that refers to a clown, who is also a mediator between earth and sun, a spirit carrying and relaying prayers for rain. She said he looks like a fool in the dances but is the most powerful medicine man. "He was sent to live with the sun, but will engage with people if their prayers are sincere and they really need his help," she said. These paintings are akin to modern katsinas, she believes, are embodiments of natural elements or forces, seen in historic practices among Hopi, Zuni, and some of the Rio Grande pueblos in New Mexico. Most familiar are katsina effigies carved out of cottonwood and painted resplendently, rendered with faces like masks and elaborate headdresses. Jim Enote has a couple sitting in the back of his office, the size of dolls. They bear clothing and body ornamentation that identifies them as spirits that move between humans and deities, each with its own name and role. Some carry paraphernalia in their hands, feathers, small baskets, crookneck staffs. They also appear in live dances with the same regalia as the effigies, each dancer said to lose his personal identity, becoming the persona of a katsina.

Patterson described a summer thunderstorm, pure white billows of clouds rocketing into a turquoise sky, and you are on

the ground desperate for a storm to come and unload its rain. "What would those clouds look like if you expressed them, if you put them in rock art?" she asked. "You need them to come, so how are you going to talk to them? How would they hear you? You start calling them by name and giving them attributes that build a relationship."

In Patterson's world, many of the anthropomorphic figures are an expression of clouds with rain, thunder, and lightning that she sees wherever she looks. In some of the stories, the children of the cloud people are said to shoot little bows and arrows, creating far-off lightning and rumbling thunder, like kindling to the fire. In this way, Patterson and my friend Jeremy Collins could be considered in accord. In the panel of four painted heads and torsos, we may have been looking at a family of cloud people. Two parents were throwing lightning across the roof of a dwelling, while their kids in between stirred up thunder. Collins knew exactly what he was seeing.

◆

Another in our crew was Renan Ozturk, a global mountaineer and filmmaker who joined this backpack in southeast Utah as a form of vacation. He'd just gotten back from climbing side-routes beneath the summit of Everest looking for the body of Sandy Irvine, a photographer who died on the mountain in 1924. He was taking a week with us to shake himself out.

A tall and stoically delightful man, Ozturk is, like Collins, an accomplished artist. Every morning the two painted and sketched, opening notebooks, pulling out brushes and pens. The day after our evening with the four faces, Ozturk and Collins sat atop the great house boulder with a single canvas rolled out on its surface, replicating a view of our horizon, swollen cliffs and rock towers. They framed the top of the canvas with white painted triangles like teeth, a pictograph motif we'd been seeing in these decorated canyons. Arms reached over arms as they

painted together, coming in close with ink to outline rounded boulders and biscuit-shaped heads of cliffs.

Israeli artist Yaacov Agam wrote, "There are two distinct languages. There is the verbal, which separates people…and there is the visual that is understood by everybody." Watching my two friends paint, I felt like this was a human need going back to the beginning. I saw in them an outgrowth of crosshatches in a South African cave seventy-three thousand years ago where a crayon of naturally forming red ochre had been applied to a rock wall in uniform, inventive patterns. Handprints went up forty thousand years ago in Indonesia, and three thousand years after that in Spain, and soon there were stylized mammoths, horses, early wild pigs, and aurochs in painted and pecked form. Figures were depicted as half animal and half human, a deer-dancing shaman in Paleolithic France. From there, rock imagery worked its way out, springing into a global menagerie of signs, symbols, flairs, and markers, some like each other, many not. Collins and Ozturk were part of the most recent wave, working on a single rolled-out canvas together.

Collins said he needed some kind of earthy, local red and I went down to the muddy wash of the canyon bottom. I came back with dripping red silt in my hands as if carrying a fresh heart.

While they painted, I returned to the four faces nearby, seeing them now in daytime shade. They'd been painted in red, not unlike the color I'd carried up to Collins, along with faded signs of white, maybe green. How much was missing was hard to tell. They'd been far more elaborate to begin with and time had worn them down, leaving a skeletal blueprint of what they once were, Patterson's cloud people.

Dancers could have dressed this way, I thought. It would make sense knowing how today dancers dress as ritualized katsinas. They would have worn what the clouds were wearing.

In rock art, you see objects and adornments in the ways they

were originally meant to be seen. Digging up a burial and sending its offerings of atlatl shafts and ropes of necklaces to collection drawers doesn't show ancient objects as they were employed or imagined. On one hand, objects are chock-full of data, and on the other, they are inert. For all the life and memory they carry, they are not serving their animated function, baskets empty, tools slid into collection drawers, clouds with names lost. Rock art holds the animation. You see hair bobs, chest adornment, fending sticks, snakes in hand, atlatls mid-air, running sashes, implements used for fighting or farming or carrying sacred water from place to place. Crookneck staffs, waving wands, feathered pahos, clouds on heads, shells on ankles, sandals on feet. These were a decorated people.

The expert on perishable objects from this region is Laurie Webster, a researcher in her early seventies who has pored through museum collections around the country, bringing in troops of PhD candidates and research assistants to study and document braided ropes, baskets, headdresses, textiles, and clothing. She has seen what remains of costumery. "These guys didn't just cover themselves, they really decorated themselves," she said. In artifact storage, she lifted out objects made of colorful feathers, red and blue and black. She saw warrior outfits and tasseled regalia. "People wouldn't put these on to work in the field. You'd have an outfit for something special. Clothing had power and people got duded up for certain occasions."

On this pictograph panel, two anthropomorphs wore what appear to be sashes around their waists, woven with patterns, and Webster said she's seen these elsewhere. One came from a burial in southwest Colorado, a young man of maybe fifteen years laid to rest in a cave, dressed in a braided rabbit-fur sash with similar patterns, dark brown zigzags. In historic Hopi, Webster sees parallels with coming-of-age garments. "A kid doesn't just go get a kilt," she said. "They are acquired at a certain age and they come along with a ceremony." She sees gifting of textiles as a key

cultural feature to Pueblo culture back to its origins. The young man buried in the cave, she believes, acquired his sash at a certain age. "I don't think you'd find that sash on a two-year-old," she said. "My impression is that it's a coming-of-age garment for men."

Webster sees the same sash on the tall petroglyph of a man near the San Juan River in Utah, a site called the Wolfman Panel. A male is rendered in sharp detail down to the curve of calf and thigh muscles, his hands and feet enlarged and hanging down as if floating, which may depict someone who has died, or who has spiritual powers. He wears a head ornament, a hair comb with what is believed to be a feathered top. A remnant of dark zigzag paint shows at his waist, what Webster takes to be the same kind of woven sash she saw on the young man buried in the cave.

"I'm wondering if that's all men wore, if they wore braided sashes around their waist and let it all hang out," she said.

The daily clothing for women, she thinks, consisted of a braided skirt made of twined yucca decorated with hematite-colored yarn and waist-cords made of tightly braided human hair. "You're not just decorating yourself, but decorating yourself with symbolic objects," she said. The human hair in women's waist-cords may have come from relatives, someone close, if not the wearer herself.

This is everyday garb. Ceremonial attire would have been more elaborate. She agrees with Carol Patterson that profusions of headdresses don't show up in artifact collections, not like they appear in rock art. She sees hair ornaments and caps made of skins, most of their finery worn off, but not the mysterious stacks of head ornamentation that has been interpreted as clouds. The four faces of pictographs I saw in the alcove may have been people dressed as clouds that were dressed as people. What were actual articles and what were visions may never be known. This is what they saw with their eyes and with their minds.

◆

One night, camped on a shelf of bedrock, Renan Ozturk described to us climbing to a high alcove on the other side of the world, on an expedition into the Sky Caves of northern Nepal, which straddle the Himalayas. He roped himself into a cliff shelter not unlike our shallow desert caves, where he found mummified people protected along a back wall. The bodies were lying faceup, all in a perfect line, and to him it looked as if they had meditated themselves to death. They wore regalia and were in different ages of corporal decay, skin leathery and gaunt. These were early Buddhist corpses from about the same time as cliff dweller occupation on the Colorado Plateau, both animistic cultures in complex and elemental landscapes, both well decorated. The Sky Caves of Nepal are on sheer, barren mountainsides, while those of the Four Corners are tucked back into bedrock cliffs. One group comes from glacial valleys and mountains heading wildly skyward, the other from a four-cornered maze of walled-in desert canyons and bone-riddled mesas. You wouldn't thrive in either without prayers or blessings on your side. These burials, or mummifications, were part of the prayers and blessings. If anyone was going to help you, it would be ancestors, and here they lie.

Indigenous Buddhists are more about sky burials for their religious higher-ups, while Indigenous Southwesterners tend to put them in the ground in front of dwellings or bury them inside of caves. The archaeological record has revealed there are painted bodies across the Southwest, numerous precious arrowheads laid like chainmail across the bones of chests, hair tied into bobs, and torsos dressed in sashes of turquoise, shell, jet, and hematite. Some were buried with animal parts, eagle wings, raven wings, or a string of vertebrae laid out where a snake was placed in a grave.

Ozturk said his encounter in the Sky Caves was haunting. He shows nothing but a kind expression, hard to imagine him

perturbed. I've seen him on film contemplating death on a portaledge in a high Himalayan blizzard, nothing but gentle resolve in his countenance, even as a summit evades him and no one else has survived it. The cave, he said, elicited a different emotion, one of the most amazing sights he'd ever encountered. He'd seen bodies frozen on mountains, their skin like hard rubber, easily identifiable by colorful gear and brand names, rigged with ice axes and goggles, the apparel of high-altitude climbers. These were random deaths from falls or freezing. The mummies in the cave were planned, prepared, and imbued with spiritual power. Other burials in the surrounding caves came with masks and beads, intricate garments, and paintings on the walls around them.

Meanwhile, our people bury their dead in shirts and ties, in dresses with lace around the throat, put into the ground or a crematorium in our finest. If you want to know how we want to be seen, look at us in our funeral homes. I imagine I'd be laid out in a button-down with sleeves rolled up, maybe a pen in my shirt pocket, a small notebook in one hand laid over my chest. I am from a non-animist culture, nothing fancy, GDP worshippers and irrigation agrarians praying to foreign countries for trade deals. If I could, I'd at least take a cloud with rain painted across my face speaking to where I come from, a land where we pray for rain.

Hearing of Ozturk's discovery, I wondered if the four faces on our night-wall represent burials at the back of the rock shelter, long ago dug up, beads and bones passed around by Indians and ranchers, ending up in closets and boxes, some artifacts still on mantles, all of them gone from here. What they wore in their burials may be the garb of a cloud person, adornments of early katsinas.

Polly Schaafsma writes, "It is essential to acknowledge that these attributes are not 'decoration,' and that they possess agency that facilitates communication with the spirit world."

She refers to rock art in which costumery "overwhelms the human body, even to the point of nearly obscuring it." I think of Barrier Canyon imagery from the Archaic age, the most finely attired of all the anthropomorphs, human shapes up to eight feet tall with no arms or legs, covered top to bottom in colors and designs. I don't know if this is what they wore, or if, like Patterson suggests, they are clouds and they are covered with symbols that pass on information. I don't know if there is a difference between what is dream among the people who made these images, and what I consider to be the unalterable real.

◆

The gear we carried was our regalia, 150 feet of rope, harnesses rattling with carabiners and aluminum chocks. Our packs were like the burden baskets pictured in rock art, bodies moving in procession with loads on our backs. Our prints denominated sponsors, a different tread for each company, Vasque boots on one friend, Oboz on me. Ordinarily, we wouldn't dress this way. We were on pilgrimage. This was our ceremonial attire.

Anchored to the roots of a juniper tree, Ozturk went over a cliff edge with his backpack clipped and hanging below. Ropes shivered with wind and his weight as he stepped backwards, ballast of his backpack swinging below like a pendulum. I'd argued for finding another way, not fond of ropes myself, but the group agreed to pass through here, coming down from the wooded shoulders of Utah's Abajo Mountains into briars of sandstone canyons. We'd been following painted faces and handprints, crossing one canyon after the next. It seemed we couldn't turn around without finding a sign, painted cliff dwellings, circles and spirals under overhangs, a simple zigzag etched into rock. The four faces weren't the only faces. There were fives, threes, and ones. These canyons were ripe with *koshari*, Patterson's early katsinas.

After Ozturk went Matt Redd, a local rancher-cowboy who

grew up out here. His family used to graze the arable canyon bottoms in the area, a small slice of history atop a much longer story of human presence. With one hand gripped above him, the other directed the rope below, Redd said I was going to love this. I wasn't so sure. His head dropped from view. I was next and the sun was setting. We needed to get down quickly. Out of water with a storm blowing in, Redd and I would hit the ground running to find a source before nightfall, and the remaining three would stow climbing gear and find a camp. Redd and I knew the country, accustomed to scouting for seeps or melted-out pools. I kept our mission in mind, directing my focus as I clipped in and stepped backwards. I don't mind heights, but ropes I have trouble stomaching. All the knots and jangling pieces of protection suggested to me imminent failure. I needed a good reason to be doing this.

A canyon spread open, sinking my stomach, and I felt better when my boot tips left the rock and there was nothing more I could do but lower myself. Wind whipped the trailing rope and I saw Ozturk holding my belay. I lowered into an ear in the cliff, high in an alcove with a hundred feet of space below. Halfway down I forgot my concerns and paused the descent, spinning slowly. The sun was on the horizon, half of its circle below ground, the other half sending out sheets of honey breaking into long, purple shadows. Sun, cliff, and horizon formed a convergence, something you see often out here as land and sky come together. With all of these angles and paths, ridge lines and sun and moon, planets dodging one way and the next, everything intersects at one time or another. When you find yourself at such an intersection, you pause. Through a stinging February wind, I turned into the last sun and felt warmth on my face.

After me came James Q Martin, a tenacious climbing photographer, and behind him Collins, who cleaned up our anchors to leave no trace, and rappelled like a spider. After Collins touched ground, he slid the rope down behind him.

Redd and I moved into the canyon looking for water. We found camp an hour later by headlamp, plastic dromedaries loaded heavy. We'd broken through slabs of ice and filled up in the head of a steep drainage. Something we both knew about this desert, there's always water. Even when precipitation has been preoccupied or unwilling, years of drought coming on top of each other, you can still find hidden sources.

Wind that night gave way to cloud cover and we slept under tarps like mummies. The prickled sounds of sleet on our tarps turned to the hush of snow, the sound of cloud people talking.

◆

Hardly a cloud was seen in those coming days, a night's snow melted immediately, ground turned back to warm sand and rock. We descended a route where we thought we'd need rope, but it ended up being a dance of ledges, handing packs down, climbing out of the sky. Now we were the rain, we were the conduits between the sun and the earth. At the bottom of the route, put there as if greeting us, were a couple Barrier Canyon pictographs in red ochre and dabs of pure white kaolin clay. Beside them was what looked like a Fremont flying spaghetti monster painted in red. The spread between the paintings was a few thousand years, Archaic to Fremont. It's common to see people returning to garnish the same place at different points in history. The older figures looked like phantoms, floating without appendages, wearing headdresses of some sort, or baubles hanging down over their foreheads. Next to one of the red figures hovered a large white snake with a tail bifurcating like roots.

Snakes are one of the adornments you often see with anthropomorphs, often held in an outstretched hand. Was this a dance, snake holders calling for rain? The motif is seen across the Colorado Plateau, a human figure holding by one arm a zigzag, what looks to be a snake or a lightning bolt. This goes as far back as the Archaic period, predating Basketmaker, snakes in hand, held

at the neck, base of the head, the way you'd hold a snake. On some, you can see small, triangular heads and forked tongues.

In the Moab area, an Archaic humanlike image is painted in ochre on a high cliff, red robe of an anthropomorph. Inside of its open mouth is a snake painted green, what may have been the color of water, malachite-blue before it oxidized over the last few thousand years. The figure's arm is cocked outward, open palm holding a little person, a homunculus with wings. This little figure may be what is called, in Acoma, *Ko'Bitcitia*, a shy rain spirit known to hide in the east behind clouds. Loud noises are said to scare it into letting go of its rain. The name *Ko'Bitcitia* is also given to small stone fetishes of animals or people placed on medicine altars. In a 1932 report, anthropologist Leslie White, who studied the Rio Grande pueblos in New Mexico, wrote that airplanes were being called *Ko'Bitcitia* "because they fly over the clouds." This is a sky spirit, a direct connection to rain.

In the red pictograph, one wing of this small figure is down, feathers draped, and another is up, as if dancing, or pointing the way. The larger person's green pupils inside of its red face seem to address the smaller form, as if paying close attention, receiving directions.

The snake is the center of the image, the place you were meant to notice first, like a small, important key. Its green body is as slender as an asp, painted vertically so it is not held in the person's teeth, but emerges from its mouth.

Snakes are known among Pueblo cultures as guardians of springs, carrying prayers for rain. The Hopi Snake Dance, a rain ceremony, comes to mind when I see this figure with the snake in its mouth. This ceremony is recorded in black and white photos from the late 1800s, showing dancers hold twisting, live snakes in their mouths. The snakes are not little wrigglers, but fat bull snakes that wind up in knots. It looks like serpents are pouring from their mouths. The men are shirtless, wearing decorated kilts, chests and faces painted, necklaces around their shoulders,

hair blooming into feathered headdresses, bracelets of shell on their forearms. Hardly an inch of themselves remained unadorned, skin painted in streaks and zigzags. Their bodies are not so different from the many pictograph bodies and heads I've seen painted on rock, lacking arms or legs, as if to say these are not ordinary, daily humans.

The Snake Dance is performed in late August or early September, toward the end of the summer thunderstorm season, and the coming of the gentler, more nourishing precipitation of autumn. It is a call for rain.

With early fire seasons and wells drying up in drought, I think about old ceremonies, if not dressing for them, at least contemplating hunter-gatherer ways, getting up and moving to where the rain falls rather than bringing it to us. If we need it that badly for croplands, if we look at distant clouds with yearning, we might start dancing and singing, we might hold snakes in our mouths, painting ourselves, adorned in prayers to communicate with the clouds. The scales might tip in our favor.

I look at myself and my companions, and I wonder what prayers our adornment carries. We seem not to be a call for rain, but for industry, for copious exchange across oceans. Our clothes come from faraway countries, gear born from mines and well pumps. There is no ochre or clay on our bodies, no shells ringing our arms, and most of our belongings are made from materials refined in tanks and extruded, or fibers grown in fields that stretch beyond horizons. Regardless of what comes from my mouth or pen, the devotion of my garb is to the artificial, a civilization that no longer favors feathers or snakes or clouds.

Seen from the future, if the images of our time were to be studied by anthropologists, we might appear as the first to paint electronic walls with ourselves. We record selfies of our rituals, our ceremonial dress. Fixed up with ties and earrings, paisley and stripes, certain manners of haircuts, tuxedos, high heels, ball caps, T-shirts, cuffs, and collars, we are a unique appearance.

Our petitions to mysterious forces beg for more and more and more.

The five of us were also a prayer to motion, twisting through canyons, up and down routes, pausing for a short while to catch our breath below painted cloud people, me in the shade of a boulder, the others in the shade of junipers. The day was dazzling, sunlight falling on rockfaces, a bright hall of mirrors. These canyons felt like clockwork where the movement of people and clouds winds up the gears. *Go this way*, the rock art seemed to say. *Follow us.* We picked up our packs, clanking with straps and plastic things, knives on belts, cameras in pockets, and we went.

⋄7⋄

Birth

This is one of the better sunrises. You can see forever. The land is a grand staircase. Cliffs step down to buttes and into canyons. Light falls into shadow. With so much iron rusting in the rock, the entire horizon is red. Towers in the distance stand like water gods. From up here, the head of all the cliffs, it feels like you can see half of the Colorado Plateau.

First sun lands on her pecked face as if waking her. The light climbs down her body. She is a petroglyph and she looks over everything, the land open in front of her as if a sea has parted. Her hair is rendered in the twin whorls known historically among Hopi women. Her figure is as slender as a tuning fork, her age a thousand and a half years at least. Cleanly pecked legs are slightly apart to let through a golden-headed bundle where she is giving birth. As the sun moves down her legs, it illuminates the infant.

Another rendition of her is on a boulder outside of Moab. She is a petroglyph with arms outstretched, hands turned into claws, and a mask for eyes. The wide girth of her body holds a melon-shaped object between her legs. The panel reeks of birth and pain.

She is also in a meandering, pale canyon in northern Arizona coming off the tilted, wooded backside of the Mogollon Rim. There, she is a hair-bunned woman of stocky geometry and butterfly lips for labia. Between her petroglyph legs is a suspended form that looks like a star, like a milkweed seed, a small person with a head, two arms, two legs, and what I presume to be a little penis.

I have heard sacred birth stories in Navajo, thunderclouds gathered at a flat-topped butte, and when they part, a baby girl is found wrapped in buckskin. She is Changing Woman, the beginning of the people. Birth legends are soaked into the land. I have stood at the butte in northeast New Mexico where Changing Woman is said to have been born. I have seen its top wreathed in thunderclouds and rain. You go back to these places and find that the original narratives are still happening. It is as if the land is a story telling itself. People have marked it as a way of witnessing the story.

The soaring birthing scene in Utah, looking over a big spread of the plateau, is pecked into patina as dark as cherry-chocolate cake. To one side of the petroglyph birth mother is a depiction of what appears to be Basketmaker copulation. A petroglyph man and woman look like they're in a hieroglyphic Kama Sutra, two people seated upright, legs entwined like chopsticks. From the mother's other side, what looks like a comet sails over her head. A unique event is being expressed here, not just any birth, but a specific one.

An almost identical scene, though roughly worn and hard to make out, lies about seven miles from here in the lower benches and rockfaces of an incoming canyon. An anthropomorph with a small figure between its legs appears in a similar setup. A flying object drags a tail over the mother's head. The infant has scratched lines emanating like a halo or hair. The same tale is being told in two places.

The first time I encountered this high birthing panel, two couples, mid-sixties, were already at the site in hiking boots and jeans with trekking poles. In conversation, they revealed a history of sheriff and ranch work in the area. They were locals enjoying their day in the early light. Coming from a small Utah town that starts with an *M*, they said you didn't want to ask people from a neighboring town starting with *B* what they thought of this birthing panel. I'd come with a friend, Connie Massingale,

a Bureau of Land Management site steward from up by Moab, and she couldn't help asking, "What would they say?"

"They'd say that's Our Lord and Savior," said the taller gentleman in a denim shirt, gesturing toward the petroglyph of the woman giving birth, baby coming out headfirst like a two-legged package. Its downward-pointing head had been embellished with scratch marks, golden hair, or a halo.

A woman sitting beside the man asked if we knew that boulder at the bottom, gesturing several hundred feet down to the rubbled flanks below us. She said, "That's what they call the Father, Son, and the Holy Ghost." She was referring to three figures on a hard black crust of patina, two chunky anthropomorphs, one with a sculpted hairstyle, headdress, or halo, and a third in the middle with two vertical rows of dots for a body and what might be a bighorn headdress. Holy Trinity, I thought, is a stretch. Spirit-like anthropomorphs similar to these also show up in ones and twos and in some places tens or twenties, not just threes.

I couldn't tell if the couple was making fun or found it interesting that this birthing panel is interpreted as a Christian nativity scene. At that point, you're throwing rock art interpretation to the wind. But it's not out of the question. Not that we're seeing Jesus and the Mother Mary in this panel, but the nativity part. Holy birth is a worldwide theme. A mating, an auspicious birth, a sign in the sky, a snake coming from above with a circle in its mouth, are archetypal fodder.

Whatever these birth scenes mean, the outcome is clear. Sex leads to childbirth, and women do the squatting, a thing we've known forever. Without this, there are no holy people, there are no hands being held, there is no culture.

◆

Kelley Hays-Gilpin, bringing her research of Indigenous iconography from northern Arizona, told me that rarely is rock art a

recording of quotidian acts. It's usually something special. "It's not just somebody painting, *here's what I saw this morning, here's what somebody in my village was doing, they were planting a field or they were weaving or making a pot or giving birth*," she said. "It's not a checklist of daily activities."

She told me it's fine not to know what rock art means, okay to guess. She said not knowing is not just a white-people's problem. Rock art is not as monolithic as that. "People from other clans or groups might not understand," she said. "If I'm Havasupai, I might go to this ancestral Hopi clan site and have no idea which clans those are, or why they put clan symbols in that place, but I can still appreciate the place for its beauty and its obvious importance."

The point Hays-Gilpin wants to make is that you don't have to know what you're seeing. In fact you couldn't know. Some esoteric knowledge has been maintained in Indigenous communities, some has been lost, and most is not the business of any stranger who happens along.

Hays-Gilpin, nearing retirement age with prismatic gray hair, and wearing beaded baby-Yoda earrings, sat with me at an outdoor table in ponderosa pine shade. I came to her because she'd been balancing between Indigenous and academic for most of her career. She told me that ignorance is a fine place to begin. At that level, she said, rock art may seem exotic and strange, and the feeling doesn't go away with closer inspection. It becomes richer and more nuanced, but never fully understood. "By contemplating rock art and interacting with it, photographing it, drawing it, and getting to know it," she said, "you're getting to know that place as having been important to people."

That's a surface understanding, she said, telling me, "There are also people who interact with rock art from a position of, *that's my family*."

Some know why it was made and what they are supposed to do with it, while the rest of us can stare in wonder. She explained

that rock art becomes about relations, bloodlines, and familiar stories.

"Rock art" is one of the least sophisticated terms, a broad brush across languages and traditions. Art, for as much as I appreciate the word, is a naïve reduction, an admission of how little I understand. Beyond is a can of linguistic worms.

Hays-Gilpin said, "If you ask Hopis what you call these, they say *tutuvuni*, or footprint markings." When she talks about ancestral Hopi, where rock art is considered a sort of history book, recording the migrations of people, she uses the word *tutuvuni*. "But usually I'm talking about work by multiple groups of ancestors," she said. "If you go back to older Basketmaker or Archaic rock paintings and engravings, then they're not necessarily footprint marks, they didn't necessarily function in that way."

Looking for the appropriate word from Zuni, I got on the phone with Chris Lewis. He told me the Zuni word, not really a word, more of a phrase. He laughed when I asked to hear it again. I asked him to repeat it a few more time, counting nineteen syllables of what sounded like many small shells tumbling down a stream. He said it means "things that ancients put on rocks."

♦

Birth scenes are one motif that can be clearly gendered. Some rock art appendages that you'd call penises could also be labial. Gender is unclear, perhaps intentionally so, fluidity an accepted part of the culture. The birth panels, however, were women's. That much is clear. Men may have created the birthing panels, or men may have not. It could have been women dressed in feathers tied by a cord around the waist, bodies painted in a glittering blush of hematite, where they lifted bone to rock and commemorated the moment.

I went with Carol Patterson to what she called a fertility panel, a woman's panel. I didn't ask what the rest of the panels

were called, a chain of galleries in southeast Utah, like an art walk at the bottom of a cliff. From miles away, I wouldn't have pegged this as a rock art site, a corner of a butte in a parched red basin, hardly a tree to be seen. It turns out there's water, enough for a bearded spring that drips into columbine flowers and pillows of slender grass. Rock art and the presence of water, sometimes only drips, go hand in hand.

Dressed in desert denim, Patterson was no-frills, blue from her faded coat to her jeans. She wore her hair straight below the shoulder, tied back into a ponytail as gray as a coming rain. To reach the panel, she kept us moving. I stopped at the spring to take pictures, calling to her that I was coming. I couldn't leave a spring so quickly, caught by maidenhair ferns nodding in the breeze. Water dripped into crusty little pools and holes in damp sand. The gentle overhang, crowded and green, smelled like loamy duff and chlorophyll. This water seems to be the reason for a half-mile of rock imagery. Maybe it was the view, the open desert laced with sand-choked washes, and stacks of other buttes in the distance, but I believe it was the spring. Patterson said drought or not, it drips steadily. I tasted a bead off the tip of my finger and tipped back my head to catch a few drops in my mouth. It tasted like nothing, like air, what you want water to taste like.

When I found Patterson, she was gazing at a wall that was hard for me to catch up to, passing columns of petroglyphs along the way like flipping through a book to find a page. Patterson was businesslike with her instructions, taking advantage of the last sun. If it had been noon, she would have spent more time on the way here, but she wanted this panel to be seen at the right hour, honey-gold light reaching from the top of the cliff down to us.

I'd known Patterson for a decade and a half. I knew the way she fell into rock art as if forgetting she'd come with company. I'd run into her when she was returning from a project, mapping

sites with a crew of interns, or leading Indigenous representatives to rock art to document their take. Her job as an ethnohistorian is to remember for people other than herself, gathering data in a feverish effort, tripping over her words when she starts describing rock art and the mythology that accompanies it. Fifteen minutes with her and I couldn't keep straight the names and places, words in Ute or Zuni languages spilling out of her mouth as if by accident. If Patterson says this is a woman's panel, it is.

The wall was covered with many carved niches and polished dishes, more than I could count at first glance. Rub marks went as high as a person on an ancient wooden ladder could reach. No bighorn sheep, no anthropomorphs, no glaring starbursts, it was mostly polish and scratch. The wall must have given up fifty gallons of sand in the making.

My first question was, is this rock art? Of course it is, but the shapes were made by grinding, not eyeballing straight lines and curves, matching a sheep's head to a sheep's body. It's a different class of imagery, not figurative, but purely interactive. The rock was being acted upon, engaged with, made like a scatterbrained honeycomb or a game board. Maybe sixty holes had been etched into the rock, what Patterson calls niches, with flat bottoms, each large enough to hold a pomegranate or a mandarin orange. Along with these incised holes were maybe a hundred polished wall-slicks, like dishes and bowls smoothed into the rock. In between are older petroglyphs covered over and partly rubbed out, some still showing, placed strategically between rub marks: the petroglyph of a spiral and one of a crookneck staff. If the wall were a game, it would have been Snakes and Ladders.

Patterson said, "It has to do with birthing and..." she searched for the next words, wondering if it should be called a marriage panel, being not just for women. "Praying for fertility," she said. "Let's call it fertility. They are praying for healthy children, for safety in childbirth, and for a happy marriage, and a good marriage, and prosperity."

What Patterson showed me in Utah is similar to what at Zuni in New Mexico is known as the Mother Rock. Ethnologist Matilda Coxe Stevenson, hired by the Bureau of American Ethnology in 1879 to document Indigenous cultures in the Southwest, produced monographs and a book on Zuni society. One of the monographs includes the Mother Rock. There, Stevenson describes in 1902 a masked dance by women, and dressed-up personification of goddesses. The girls and women were dressed in regalia. Specifically, Stevenson refers to the names of the dancers, how old they were, with children or childless, married or not. They were members and initiates of a women's society called the *Ko'tikili*, a fertility cult within the Zuni culture. Black-and-white photographs of the Mother Rock show a sheltered overhang where the rock is riddled into hundreds if not a thousand holes made by the all-female *Ko'tikili*, and probably many other women. As bubbled as baby Swiss cheese, more empty space than rock, the entire wall appears shaped by hand.

Archaeologist Sally Cole, author of *Legacy on Stone*, one of the most thorough rock art books on the Four Corners Region, described this fertility rock at Zuni as "densely pockmarked with abstract imagery, including small pits, larger holes or niches, and grooves. Vulvalike symbols have been formed by using pits and incised lines." Cole explained that Zuni women and men would visit the site if they wished to have a female child, an important move in a matrilineal society.

Kelley Hays-Gilpin, researching iconography out of Flagstaff and specializing in gender representations, talked with me about this kind of palpated rockface. She said, "By interacting in this very tactile way with rock surfaces, which are the interface between us and the reproductive power of the earth, you're interacting with the earth itself." She said these sites are ostensibly about birth and fertility, but those can manifest in many ways. You may want prolific basketry or corn or rain. "Is it prayer, is it offering?" Hays-Gilpin said. "What's the right word? You're

connecting with the earth to bring whatever it is that you want into fruition, whether it's moisture or babies or game animals or the skills and inspiration to produce baskets. That's why you see all this touching and grooving and grinding and pitting."

The panel Patterson brought me to was similar to the Mother Rock at Zuni but smaller. The rock was smoother than any around it, so many hands having touched it that they'd abraded the sandstone down to a gentle wave.

"They're carving a little niche," Patterson said, her voice authoritative and lilting at the same time. "Putting a little fetish in that niche, or a sprinkle of white corn pollen, or blue corn meal. That's what they would do, offerings to the ancestors to intervene, to come and help with childbirth, help them be fertile and have a healthy baby."

As Patterson talked, her hands moved as if polishing the slicks in front of her. She wove the panel in the air and her voice softened as if she was seeing the people, affected by them. "You feel their hands, their little hands, rubbing," she said. "You feel the connection to their heart and their prayers and their love for their family, for this newborn."

Patterson was not being clairvoyant. Based on Stevenson's ethnographic work, and what she's learned in-person, especially from Zuni people she's invited to the site, she knows what this panel is about. There was nothing here but heart and mothering. She knows what is at stake, being a mother herself, and now a grandmother. She can see the people who came to make physical contact with the site, where they knelt and where sacred water was poured.

◆

The birthing scene high in the cliffs seemed less purely female and more narrative. Detailed peckings and images continued around the birth. Not busy or overwhelming, the other petroglyphs are given ample space, as if they conveyed the stories that

happened afterward, the Homeric journey of whoever was born on this rock.

This birth, like many, Patterson told me she sees as a narrative. Based on the glowing hair or halo on the infant, she thinks this could be the birth of mythic hero twins. "The story extends from Navajo and the Pueblos and Chemuevi all the way to the Maya area," she said. "It's a pan-regional story about the hero twins. Their mother's kind of an earth figure, and the spider-grandmother is their spiritual advisor. They transform into animals and they hunt; there are all these episodes in their lives."

The episodes may have been recorded around the birthing scene, petroglyphs of wolf tracks and a thin, tall flute player. Many little U-bracket petroglyphs on the upward face of a nearby boulder suggest fertility, known as symbols having to do with birth and fecundity, possibly representation of female genitalia.

Why the birth mother and the rest were placed here is not clear unless you know this is a route, a break in a cliff band that is otherwise impassible. The depths below look catastrophic, fallen cliffs and sheer rock leading down into gray, goosenecked gorges. Coming from the bottom, boulders lead to angled walls, taking you several hundred feet up to what you'd swear is a dead end, but it's not. The moment you are assured there's a way to the top, you find the birthing scene, petroglyphs of animal tracks, and other welcoming figures. You've come to the right place.

I know hardly a route in this country that isn't met with rock art or at least stumps of mortar where a granary or cliff dwelling once stood. These signs are advertisements. They were put where travelers were most likely to see them. You would have walked through a pinch of ancestors and remembrances, a holy nativity scene you may have known well, commemorating the birth of the heroes, Monster Slayer, Born of Water, brought into the world to make it safe for people. So many memories would have been stirred in this panel, that a thousand years ago the air around it must have seemed rarified. How many eyes went

by, thousands, and over the centuries tens of thousands, water haulers, cliff dwellers, hunters, shell traders, flute players, babies on backs, children with baskets, runners with baskets full of bird feathers and turquoise, soot-faced refugees shell-shocked from the horrors they'd seen. This panel watched all manners of history, pinches of corn pollen, women making prayers as they went through.

We were the next to be seen, with our cell phones for cameras and masks in our pockets. Connie Massingale and I stayed after the local couples left. A woman of short stature, Massingale had hair the color of dry juniper smoke braided down her back. One of the mothers and matriarchs of these canyon-mesas, she volunteered for the Bureau of Land Management to take care of rock art sites. A sturdy walking body, wooden stick in hand, she is the kind of person I imagine coming through here when these petroglyphs were first made. In her sixties, she would have been as old and wise as they get, a grandmother many times over.

"For just giving birth she's very slender," Massingale said, looking at the petroglyph of the birth mother. "Her arms should be more like this." She lifted her hands over her head, scratching the sky with her fingers, a more accurate portrayal of labor.

We left the site that morning, going back through fallen boulders to a gap in the caprock, a slip-through to the other side. Precarious hulks of erosion looked like dead ends, but they weren't. More petroglyphs assured this was the way. Through a vacuous bend beneath a leaning, hollowed cliff, boulders have broken off like the heads of giants. Moving in the shade behind them, you feel physically small in a landscape the size of legends, a feeling they must have experienced, the scale of being human inside thrones of the earth.

Cracks lead to the top. Take any of them. Sliding through and climbing, any burden that was carried is taken off. Ascending to this uppermost caprock, you find nothing above but sky, emerging at the edge of a great mesa. Headfirst, then hands, then

pulling up your burden behind you—a daypack or woven basket—you climb out of a crack and into the blue, stepping onto water-pocked sandstone, the world gleaming around you.

◆8◆

The Hunt

If you encounter rock art while walking randomly, know that it's not random. You've stepped into a pattern. Suddenly you find you are a pin in a map, an axis around which the land seems to turn. The earth says, Right this way. Or it says, This way is right.

Images appear where they do for a reason, not because the rock is pretty or easy to peck or paint, but because of where it lies in the lay of the surrounding country with its confluences, crossroads, and pathways. A swarm of spirals could speak to water nearby or a place to watch the sun or moon. A depicted herd of game animals shown all running the same direction may

indicate where drives and hunts took place and can take place again. What may have seemed like cold physical geography reveals relationships, gives and takes. What may have seemed like America, the United States, ranchland, Forest Service, becomes a much older web woven between buttes and mesas by busy spiders.

One canyon in Utah I find rock art every time I look. It feels like a curtain is pulled and suddenly, there's another one, and another after that. This redstone hall of petroglyphs goes on for several miles, not a continuous spread of images, but congregations and nodes separated by hundreds of yards and half miles of nothing. In between, you find untouched boulders and clean rock, then another spray of petroglyphs where it seems like confetti flying around you. Why did they mark one place and not the other? Was it a settlement pattern, a hidden map of soils? They had their reasons, and I am curious what those might have been.

In the middle of winter, this canyon is snowed in, north faces heavy. Cliff shadow and short days keep the place buttoned up for months. Three of us were making several miles, tracking cliff bottoms up and down, a rollercoaster of talus cones and toppled boulders. We'd spent Thanksgiving together more than a year earlier, a houseful of relatives and friends, laughter and stories, before the virus. This year, it was a risk being together, but we took it, comparing our contact budgets, them isolated in Utah, me isolated in Colorado. With snow up to our calves in the shade, and boot soles on bare ground in the sun, we followed the canyon together panel by panel. We three had the same question about rock art in this place: What drove their pattern? It was worth getting together to find out.

Rock art geeks is what I'd call us. We each had our interests, hungry for petroglyphs, eager to learn more about the lay of this causeway of cliffs and rock towers. To be honest, the other two were more curious about this place than I was. I live a hundred miles from here in Colorado, while their home is a working ranch

nestled below cliffs nearby. Matt Redd grew up running cattle on the family ranch and still lives there. We had trekked in the area together less than a year earlier with ropes and packs, finding pictographs of cloud people in warrens of sandstone. Now, we were out for a day hike. Kristen Redd, Matt's spouse, is Utah-born and takes easily to backcountry. The two move swiftly and fluidly, no trail but for paths laid by geology and erosion.

Their family's been around for a solid generation. I've walked with Matt's mother, Heidi Redd, looking up canyons and finding petroglyphs. Heidi, with pewter hair braided down her back, showed me a panel of bighorn sheep that looked to be flying. She told me this is where she used to come alone with a bottle of wine and watch the sunset.

It's important to go to the elders. They know the ways of these places.

Matt, fifty years old, carries an air of watchful humor, everything slowly considered. He cracks a smile or a laugh, but not outrageously. Maybe it's the cowboy in him, sturdy-shouldered, slow to ruffle. Kristen, the same age as her husband, is a laugher, throwing back her head, known to whoop and shout. They fill in for each other, a pleasure to travel with.

Stepping into a vestibule created by an inward cliff-corner, a room the size of a walk-in closet a few hundred feet tall, we found a scroll of petroglyphs. Long, horizontal lines traveled from wall to wall as if artists had wrapped the place in ribbon. At the end of the longest line was a flute player detailed enough you can see the position of its fingers on flute holes, as if you could hear what note is being played. This was one of the clusters, a gallery set off from the rest. All around the panel were pecked U-shaped brackets, enigmatic symbols you see throughout the San Juan Basin and up the Colorado. They look like horseshoes, thought by some to be associated with fertility. I told Kristen and Matt they may represent labias, but sometimes you hear things.

Kristen, half-and-half silvered and charcoal-dark hair,

looked at all the U-brackets like an alphabet game on the wall and said, "You can't swing a dead cat in here without hitting a vagina."

She stood in the vestibule, planting her hiking soles in the dust and rock rubble, and looked at the space around her, wondering if women had come here to give birth. The width of the foot placement was about right. The Redds have a daughter, so she has a picture of what happens. She speaks of birth with reverence, one of the most important events that could happen in any place. It was agreed, this spot must have been for reproductive magic, maybe where young women would come to be granted strong children, easy birth, or men would come to make peace with the feminine. Matt let out a small chuckle.

Years ago at the University of Utah in Salt Lake, Kristen took an archaeology class on rock art. Her instructor explained most of what he saw as fertility rock art, geared toward birth and abundance. "If he'd been a hunter," she said, "it would have all been about hunting mythology."

When I pressed her on the question, if the site we found was actually about fertility, she said one way or another, it all is. "You can hunt to your heart's desire, but this is all about fertility," she said. "You always come home to mama."

I took out my journal, made a note. Fertility site. What we had so far was magic monsters, maze-like squares, giant feet, and one hunting scene after the next. There'd be a thousand different figures by the end of the day, hundreds of individual scenes, several points in the canyon where rock art congregates with pretty much nothing in between. Our day felt like walking through a novel, each stop part of a narrative.

Matt was raised on the family cattle ranch nearby in an open circle of desert ringed with cliffs and gunsight buttes, arable land if irrigation water's added. In his youth, rock art was in all directions, more ubiquitous than mailboxes on county roads. At fifty, he remembers being ten, getting off horses with his dad,

and being led up to a tableau of lost-god petroglyphs and a cat-eared figure behind a shield. He remembers being hoisted up on a ledge, his small face turned upward to see thousand-year-old heads and shoulders, slots for eyes, as if they were wearing masks. He didn't think they were robots or aliens, or whatever kids think. He thought they were the people who used to live here.

When Matt talks about the human history of the area, it comes in volumes, rock art near the beginning. After that come violated treaties with the Ute people and desert claims and homesteads, cattle camps and buyouts, and roads getting paved. He sees the land changing hands again and again, and the past never leaves, like a heartbeat in the canyons.

Every summer morning when he was a kid in the mid-seventies, a Navajo ranch hand would drop him off in the fields where he'd spend the day moving irrigation pipe. Not long after sunrise, Matt would have the pipe set, irrigation wheels turning, and he'd climb a butte nearby to kick rocks and find shade. His usual spot was a shallow cave overlooking the field so he could see when the wheels reached the other side of the field and he had to go back down. The shelter had formed when a ceiling slab fell away, leaving a cool space with a back wall. It was tall enough for sitting, too short to stand up. Along the back wall is a long panel of white-painted figures and shapes, early Pueblo work, around nine hundred years old. These were company for the day as he sat at the entrance just inside the shade. He'd watch the turn of irrigation wheels across the field below, motion almost imperceptible but for the green press of alfalfa behind each wheel, and sprinkler water sparkling in the sun.

"I knew these came from a history disconnected from my own," Matt said. "It was a time before all of this."

I didn't spend any of my childhood on a ranch running cows or setting irrigation pipe. I was a suburban kid and rock art to me was like Dungeons and Dragons, some other amazing world

based more in imagination than daily life. Matt saw a connection between himself and them, something more specific than all of us having the same handprints. He thought about rain the way they thought about rain. Some canyons were good for hunting and some were hard. In the rock art, he saw them growing crops and killing a deer, and he saw himself acting out the same motions. He saw himself in them, and them in himself.

◆

We hugged cliff bottoms, hiking up and over, down and through. Kristen called from up higher and Matt and I climbed to meet her through snow freshly hoar-frosted, fallen a few days ago. She'd found a cluster of petroglyphs, which led to more, and more beyond that, a concentration of panels, human forms, and chained circles.

A boulder the size of three master bedrooms had cracked open, letting light through from one side to the other. One end of the crack had been pecked into articulated human footprints, with six toes on one foot. The track was leashed to a wandering line of a petroglyph that ended in a bottle-cap-sized circle, an arrangement I've seen many times across the plateau. You could count this motif like coins. I've heard from archaeologists and Hopi interpretation that this line from a footprint leading to a divot refers to a journey taken by foot, the line coming out of a toe and continuing across the rock to a circle, a place on a map they came from. Interpretations like that are worth repeating, but sometimes Hopi interpreters are funning you, and archaeologists have more on their plates than can be deciphered. What this image truly means is beyond me.

A crack opened in the cliff and we entered it, following the light through a passage decorated with clusters of petroglyphs on either side, figures coming and going, bighorn sheep, a stick person posed as if flexing muscles, and one small tableau of a bighorn sheep running at a human form whose left arm is

cocked back as if throwing a weapon. On the other side of the crack, at a sweep of petroglyphs, Matt pointed out the remains of an historic brush fence. It came right up to the wall where the crack opened, the middle of the rock art panel. The fence was a hundred years old at least, juniper wood cut with a hand ax. The petroglyphs were a thousand years old and older. Looking at the ruins of a wooden fence, put here by people with names he knew, passed down through the years, outfits and ranch hands who worked in this canyon, he said, "They weren't here for the rock art."

The fences we found that day gave away the rock art pattern. At every gathering of petroglyphs was another line of rotted fenceposts and twists of broken off, rusted fence wire going back a hundred years. Matt came up with the hypothesis that this was related to animal movement. He'd run cattle through this canyon and knew what these fences and barbed wire were for. Wherever the canyon squeezed in tight, they'd have fences to keep cattle penned near the bottom. Fences of chopped-down junipers, he said, were from earlier, larger cattle drives, used to keep cows from escaping out smaller tributaries or up in the talus where it's hell on a horse to get them back down. Pinch points in the canyon were used to hem them in as they headed for summer pasture and in the fall came back down.

Kristen jumped in, saying the petroglyph makers would have been doing the same thing. Instead of cattle, people a thousand years ago must have been running wild ungulates, keeping them pressed to the canyon floor.

The canyon was a game drive, maybe eight miles long. Once you're in, there's almost no way out. With deer and bighorn running up the canyon, any of these pinch points could have been kill zones for taking down game. In places they waited with atlatls, and rock art went up around them as if adding a cheering crowd of petroglyphs to the game drive.

◆

Where the snow is melted out, the ground is flecked with chipped stone, especially around rock art. It seems that they gathered at these points, working tips and blades, waiting for yips and howls and hoof-beaten dust to come their way from along the canyon as the game drive arrived. The day would have been like a whale hunt among northern peoples, or the mammoth hunts of old, preparing special blades and weapons, sharpening and refashioning, feeling winter ahead and pecking rock walls hoping for good kills, meat, and skins.

As a weapon, the atlatl is key to the hunt. It's a two-piece throwing spear, one hinged into the other, catapulting a projectile two or three times as far as a handheld spear, accurate across the length of a football field. For a game drive, you'd want an atlatl. The bow and arrow wasn't needed.

The pictogram for an atlatl is a line that pierces an oval, or two circles, at one end. The circles represent leather or twine finger grips attached to the shaft, where you'd hold it for throwing with two fingers and a palm.

My friend Rory Tyler, obsessively recording rock art around Moab, told me he believes 70 percent of the rock art he sees is hunting oriented. "What else is there?" he asked. "Fertility, astronomy, fighting. But mostly hunting."

Tyler is not a hunter himself. He doesn't need to be. He is more of a statistician, an accountant for rock art, adding up the numbers. He finds petroglyphs of mountain lion tracks associated with panels that include atlatls. Those two go together with game animals rendered all the same direction in a running pose, what he sees as hunting scenes.

His take is literal, down to matching the numbers of rams, ewes, and yearlings with numbers in average herds. People linked by hands and arms show up in some of the same panels, telling him that they used human enclosures, sealing off the escape with their bodies.

"You had more game drives in atlatl times because you couldn't sneak up on them," Tyler said. "With bows and arrows, five, six guys could get together and have a nice little hunt, but if you're trying to pick two or three hundred sheep off a big mountain, the bow and arrow is not your tool."

Game drives in North America date back to the Ice Age, documented in stone-lined runs herding caribou from Massachusetts to Lake Superior. Some of the largest game drive sites on the continent were positioned below glaciers on the Front Range of the Rocky Mountains in Colorado, driving ungulates along rock stacks toward ambushes. The shape of the land becomes the playing field. Box canyons and narrow walls around a creek or wash bottom form the runs.

Tyler finds hunting panels where whole herds are trapped and people are depicted wearing tall headdresses possibly to panic the animals, to keep them running. Tyler is in the vein of the late, Wyoming-born hunting archaeologist George Frison, reading and re-reading his classic book *Survival by Hunting*. Tyler can't help imagining what he sees in the rock art as real events on the ground. "I'm fifteen and I'm going to go out and get a lion," Tyler said, having noted that mountain lion tracks show up at hunting panels, as if they were being called upon as great predators, agile hunters. "The next time a big hunt comes through, I'll be thirty and I'll have my lion tail. I'll be one of the guys who gets to stand out there and chuck my atlatl at the sheep."

What I and most other rock art followers and archaeologists call a centipede—a straight line of any length with many smaller lines and dashes coming off of it, sometimes with two antenna-like segments at one end—Tyler believes represents brush fences for hunting and channeling game, as bristled, frightening, and impassable as giant centipedes. When he looks at the country around him, Tyler sees hunting landscapes. Rock art shows how it was done and what magic was needed to make it happen.

Years ago, I attended a meeting with Hopi elders who were receiving requests from outsiders. I got up and asked questions for research I was doing, an eager writer in my thirties. I was followed by an Indigenous man from a different tribe. He got up and said the deer were sparse on their lands and hunting was dangerously poor. He said that he came because the Hopi had been here the longest and that their prayers and ceremonial support were needed to bring back the deer. He didn't ask any questions like I had, no papers held up in his hands, but instead sat back down hoping his request had been heard and the deer might return.

Hunting is a barometer. It tells how the land is doing. Making it right requires physical and spiritual maintenance. When prehistoric animal populations were healthy, the land was good and people lived well. The land was made good not just by game animals, but by the presence of rain and all that follows. When rain vanished, when hunting declined, everybody paid.

◆

Kristen and Matt Redd live with a constant diet of changing climate. The ranch has been transferred into Nature Conservancy hands, and they've turned the property into a research center focusing on climate, restoration practices, and the carrying capacity of the land. The place doubles as an experimental station and a working ranch where Matt believes they are running a healthy outfit of irrigation, crops, and desert-adapted cattle breeds. Meanwhile, scientists come and go studying cottonwood and sagebrush, riparian restoration, lizard community responses to climate change, and how long crusty desert soils take to regrow in the wake of cattle tracks, tire prints, or waffle-stomping hiking boots. Experiments are laid out in plots on the ground, lichens and blue-green algae taking three years, maybe five to start to reappear after disturbance. It may be ten or twenty, sometimes fifty years before the living crust of the ground fully recovers.

Working with the US Geological Survey and the US Department of Agriculture, researchers are put up on cots and tents at the ranch. Over the years, they are learning the repeat lessons of prosperity and collapse, and how we can help create one and stave off the other. Study areas are being tested for cottonwood tree genotypes from Arizona to see what grows best in a drying climate. Patches of land are sheltered from rain to simulate a projected 30 percent reduction in precipitation, seeing how soils and plant communities react to what is likely coming.

"That's what keeps me up at night," Matt said. "Where is that line for what is sustainable, and are we trying to extend ourselves beyond what the landscape can really support?"

Matt believes that people who made rock art would have had a wealth of knowledge similar to the papers and studies coming out of the research center. They would have had similar questions, concerns, and observations. Troops of scientists, he thinks, can produce similarly useful information if you're not coming from centuries of living directly off the land.

"I'm of the bias that they had this kind of knowledge," he said.

Kristen said that the knowledge may be comparable, but what we do with it is not the same. "They didn't have technology to buffer themselves," she said. "They knew exactly the carrying capacity. We're so padded by technology that we can't see what's right in front of us."

Matt is the scientist-rancher, Kristen the eternal activist. The combination of the two, and the researchers they attract, is helping define what a healthy, dynamic ecosystem looks like in this desert, and how easily it can turn into a stagnant and dying one. Evidence from tree rings, soil records, and woodrat middens shows decades of prehistoric drought lined up with malnutrition in human bones, dwindling crops, a lack of game animals, and ultimately people migrating elsewhere. Kristen and Matt want to know how we can stay.

The rock art we hiked through came from times of thriving. The hunting it described was legendary, game animals portrayed in abundance. Images were made with accurate, thoughtful, and numerous strokes. People had time and meat, and probably plenty of corn, beans, gourds, squash, and grass seed. That meant they had rain and favorable seasons. On years of deep drought, seasons dry and empty, people passing through this canyon must have seen these petroglyphs and felt some kind of reassurance. If days were good in the past, they could be good again. They must have wondered how to call those days back.

For this reason, Kristen and Matt's inquiries into local rock art are not trivial. They and the researchers that come to the ranch are seeking a full history of climate and survivability here, a baseline for what this land can do. Seeing this rock art, one wonders if we are in a similar time of abundance, possibly the tail end of a great era. This is when people must have hooted and hollered, running game drives into canyons, feasting while they could. Some must have asked, How long does this last, and how can we remain?

◆

I saw remnants of Tyler's brushy centipedes below the cliffs the day I walked with Kristen and Matt. Splintering, spalling remnants of historic rock stacks and brush fences showed the way, defining the movement of animals driven through this canyon. Petroglyphs came with baling wire and a rusted lid from a Prince Albert can. Hunting magic may have been placed at each station along the canyon, each pinch given its own retrospection:

Fertility, monster-gods, and legends.

Barbed wire, tobacco tins, and rusted nails.

I see lines of people moving side by side, maybe to drumbeats or loud rattles and songs. Deer looked up from autumn browse as intimidating headdresses came into view. Those animals who didn't get away, four-legged and cloven-hoofed, ran

deeper into the canyon where drums grew louder and dust stirred. With cries and shouts and hearts beating fast, the canyon would have come to life, turned into a spectacle. Stone-tipped atlatl darts began sailing through the air.

For an earlier book, I researched distributions of Ice Age stone weapons in Utah and found a concentration in the area around this canyon, as if this drainage had been known for good hunting back to the Pleistocene. It makes sense that rock art would spring up in abundance here, that ranches would settle in and do well. Rock art does not appear out of some whim. It was made at junctures in a much larger web. You could say that's why a scientific research center grew up in the area. This is a place worth understanding.

With the sun below the horizon at the end of the day, the canyon turned into a cold, gray fuzz. Eyes in the rock art were dimming, narrowing, heading for sleep. I heard a shout from ahead, a giddy hoot. Coming around the corner, I found Kristen standing in front of a panel she'd heard about but in her decades of living here hadn't seen. The cold wall was trimmed with a maze of boxes like a crossword puzzle. A bighorn sheep petroglyph appeared to be entering from one side. Hidden within was a single anthropomorphic person with arms and legs spread as if ready to pounce. To me, it was the hunt, the labyrinth of a canyon leading game to their capture.

Dots trailed up the rock near two enormous footprints, one with five lightbulb-shaped toes, the other with four. A zigzag came out of the side of the five-toed print, same motif as one we'd seen earlier in the day, ending in the same kind of coin-sized circle. My eye told me this was a migration symbol, an effort to get here by foot. The maze, I thought, tells of what happens once you arrive, this canyon designed for the hunt. This is where people came together, joining hands, making one purpose of themselves.

•9•

Joined Hands

Time, some said, moved slower that year. Names for days of the week escaped us. It was always the umpteenth day of some month. For me, deadlines in 2020 were still on, work found wherever it existed, but I couldn't tell you about much more than sunrise or sunset and the arc of the day connecting the two.

Five-thirty at dawn at a rock art panel is a thing I could tell you about. Late October crisp with stars, too dark to write in a journal, I had a headlamp with me but I wouldn't use it. Flick it on and I would barely be able to see for the next few minutes. I stood in the dark and waited.

Waiting is important, forgetting what I was here to see. I kept time by stars blinking out behind cliffs, a thin blue line forming on the eastern horizon. A massive boulder had split in two. It must have been the size of half a duplex, cracked wide enough to walk between the two sides. The largest, flattest face was a gallery of pictographs and some scratchings, invisible before dawn. To see it, I had to wait for the blue line to grow and the stars to fade. Hoodie pulled over my head, hands in pockets, not quite freezing, I waited for something to happen.

With Johns Hopkins on refresh, red dots blossoming across the map of the world, this pandemic felt high-paced, changing the way time usually passes. Mortality in the US had reached the size of a moderate city, two hundred thousand confirmed deaths from the virus, the population of Des Moines or Baton Rouge. It was a time in history to notch on a stick. I knew some of those who'd died, a friend's mother I'd had dinner with just before the

start of the pandemic, a local man in town, an orchard grower. These people were becoming part of my timing, every day the numbers going up, a clock that wouldn't stop ticking.

Out here, you don't think so much about this. Time moves more like water, stilling, pooling, turning in circles. I could have come several thousand years ago and this morning would have looked the same, peaks of boulders beginning to take on the faintest hue. Where I knew a panel existed was a shell of blackness. I worked my eyes to see anything, but the rockface was a heavy blanket. Every morning for four days I came to the same place, not far off a dirt road in southern Utah, walking slowly up through boulders so I didn't stumble without a light. My destination was this shadowed well, a giant boulder broken in two. I watched until the indigo grew into a thin marigold band. That's when red figures began emerging.

The image to come first is a circle of seventeen people painted in red hematite, dark as blood when they first appeared, a stain within a stain. Hands were clasped, arms connected in V's from one person to the next. They looked like a ring of candles around a birthday cake, humans with legs, bodies, arms, and heads, the tallest as long as a pointed finger. Some were rendered short enough to have been children. It seems they represent individual people the artist may have known, people who had faces and names, members of a community.

People holding hands in a circle or in a line is a theme you'll pick out across the Colorado Plateau, one of the more common images. Some represent game drives where people made a net or a wall of themselves closing around game animals, and others, like this red circle, appear to be dances. Either way, these seventeen knew each other well enough to clasp hands, announcing the occasion of their gathering on the side of a boulder.

I paced out a circle large enough for seventeen people standing around a flat space in front of the brightening pictograph, making an orbit on the ground. That's how many would have fit

in a circle in this place, seventeen including children. From that measurement, I concluded that whatever this panel represents, a dance, a meeting, the founding of a clan, it probably happened in this space, here under my feet, seventeen being an expected number for a single household in the tenth century AD.

How could I not see people I knew in these figures? My son Jado when he was little, and his tall older sister, Aspen. I saw my new love with her crazy-happy smile, and my ex on the other side of the circle, all of us present, her man next to her taller than everyone. I'm sure it was complicated back then, too. You would have recognized the feel of each hand, knowing your kid when he was five, your wife of many years, a grandfather whose bones you could feel through the skin, a daughter with long, slender fingers. Arguments and reconciliation would have been shared between these people, countless meals together, and laughter at a joke or someone's prank. In the gloaming, this pictograph showed a gathering of loved ones, I was sure.

What this circle meant to the original people, I can't say, but it clearly involved unity and convergence, a group facing inward, backs to the outside. It felt like trust and knowing. This is what you would need to survive in a land occupied by people of different languages, dialects, and traditions. Some out there were warring and some were so steeped in ritual and worship that their polychrome wall paintings looked like macabre carnivals. You would have held each other's hands in this place and together found a way.

◆

Characters introduced themselves at the opening of dawn. I picked out larger, red-painted figures hovering around the circle. These didn't look like people, bigger and more complex than the ring of hand-holders. I saw these as god-spirits or floating legends. Fields of red thumb-dots like rain came out of the dark, placed at four corners around the circle of hand-holders.

The scene looked as if precipitation were being called in, as if on the day of this dance it rained hard and in all directions. A red, broad-shouldered anthropomorph, with scratch marks that made me think female, held up a staff and appeared to be jolting one of the thumbprint rainstorms with a bolt of lightning that shot out in a zigzag. It looked to me like a meteorological event where after a flash of lightning and a beat of thunder, the rain falls harder. It's a known phenomenon, the electrostatic charge of lightning triggering precipitation into what is called a "rain gush." Rain increased up to a hundred-fold instantly. This is something they would have noted. When a cloud is struck by lightning, rain grows in intensity.

Every layer of light enhanced the story. A flute player rose to the left side of the circle, where flutes are often associated with springs and precipitation. With a thunder-being on one side, flute player on the other, and everyone in the circle, including kids, I could feel drops falling on them, faces lifted up, eyes tearing from the sky and from joy. Remember the day it happened, a circle of chants and prayers as storms opened up and the ground was soaked. This may have been enough reason to memorialize the event on stone, letting people know, *When we dance, the clouds listen.*

You can make up any story you want, the panel doesn't seem to mind. People are dancing into a hole in the world or they just came out of one, teetering at its edge. They are skydivers, circus performers, or firefighters holding a net, telling you to jump. You'll see reproductions of this panel on T-shirts and posters, the site given all sorts of edifications and directions in guidebooks. It's been vandalized over the years, scratched up with names and dates from old ranch families, but the core images are still present.

When dawn was bright enough to read by, these newer additions appeared, modern chiseling beginning to show. The magic hour was around 6:30, a solid twenty minutes when the

pictographs were visible but graffiti and historic etchings were not. That's how long you have to see the elemental parts, the red images as they were originally painted. After that came Joseph H with his practiced cursive, and Ray M. Mooseman, May, 1914, in a knife-blade font. A kid who worked cattle out here in the 1920s, known for drawing faces on rock art panels, put one of his illustrations here. He couldn't read or write, I'm told, so he scratched into rock to tell his story. A hematite double-rainbow painted about a thousand years ago he turned into the top of a head, scratching in the profile of a pig-nosed person with teeth.

I can't fault people for leaving their mark, the next wave to say we are here. But we are here now, we see the names, we get the point. We already know the founding fathers and mothers, Zola D. Roundi using a blocky, three-dimensional script for the first letters in her name. After her historic layer, the next itera-tion is not so pretty. It becomes crude and throwaway. I've seen defacement of rock art panels with screwdrivers and spray paint. One panel was vandalized with charcoal and an arrow saying WE WENT THIS WAY. That was a kid in Boy Scouts, and the leader was punished for a violation of antiquities laws. Maybe as a kid I would have done the same, but I don't think so. It doesn't take much to realize that you or I are not one of the founding fathers or mothers, and nobody centuries from now needs to know which way we went with our daypacks and water bottles.

The circle of hand-holders painted on this rock is from ongo-ing traditions. At the Pueblo of Paaqavi on Hopi Third Mesa, roofs were thronged with onlookers, the plaza below packed with a crushing audience. A couple hundred people gathered around a circle in the middle of the plaza, the center kept clear by women and girls slowly dancing from side to side. The danc-ers held baskets they'd made. Nearly shoulder to shoulder, gray-haired grandmothers to skinny little granddaughters in regalia, they looked like the morning pictograph, holding a space, form-ing a circle as they swayed right foot to left.

Go back farther before this modern dance ceremony and the motif reappears. An 1879 photograph taken by Joseph K. Hellers shows a circle of about forty women in shawls holding up painted tablitas. It is the old village of Oraibi on Third Mesa at Hopi, and the photo is entitled "Hopi Women's Dance." The same moment appears in a northern New Mexico kiva mural from around 1400 AD. Painted images of women from a crumbled pueblo site called Pottery Mound show them holding baskets, facing in toward the middle of a circle. From brighter days, before the pueblo became a mound of ruins and broken pottery, its ceremonial kivas were colorfully painted and in one, these women are shown along the outside wall facing inward. Finely dressed and presenting their round baskets, they look the same as the dancers at Paaqavi, the same as the painted panel, a cultural pattern of people in a circle facing inward on repeat.

This sort of circle was represented in the ancient Pueblo world back to the beginning of agriculture. More than a thousand years before Pottery Mound, a circle of hand-holders was recorded on some of the earliest ceramics on the Colorado Plateau. A late Basketmaker bowl 1,500 years old shows fourteen people with joined hands painted black around the inside of a white-slipped bowl. The order is boy-girl-boy-girl, though the painted figures are taller than boys and girls, more likely young men and young women holding each other's hands. Women are shown in twin hair buns and the men have a feather, or some protrusion out of their cap.

Jump ahead in time to the late Hopi-Tewa potter Jacob Koopee, great-great-grandson of famed First Mesa potter Nampeyo. In 2008, Koopee painted an orange ware jar with seventeen women encircling the jar's exterior. Bearing a hairstyle known as the squash blossom whorl, similar to what appears inside the 1,500-year-old bowl, each woman is painted with her own personality, heads cocked one way and another, representing not generic people, I think, but individuals.

These are all instances of the same kind of dance or gathering. For more than a thousand years people in this high desert have stood in circles holding hands or showing baskets. The circles they formed had more or less the same number, the same size, not a crowd, but intimately tied together. These were the first round-dances, ceremonies for rain, calling up spirit beings with lightning bolts as a flute played into a downpour of red thumbprints. Each morning I picked out new images from the panel, adding to the picture, and the center remained the same. Dancers circled up hand in hand saying, *This is how we call the rain.*

◆

My fourteen-year-old son and I were camped in the nearest town of Escalante, Utah, a highway for a Main Street with most places shut down in the pandemic. In online school that year, Jado was game for anything, so I rented a tent space near Wi-Fi where we could sit under a ramada and both get work done. I'd come back from the panel around 9:30 every morning, mask up, grab a quiche and fresh grapes from a to-go window, and wake him in the tent. By that time, I would have experienced what felt like an entire day. Sunrise can take that long.

Jado wanted to come with me the last morning and I told him if he could get moving early enough, he was welcome. That morning, not long after five, he was out of his bag shoving me to wake me up in the bracing, star-filled darkness.

At the site, he stayed still, waiting, watching in the first percolating light. He sat on the boulder top, a silhouette against the stars with his knees drawn up, Venus above him a bright pinhole in the sky. As it had each morning, the ring of people began to appear at the first shade of light. The number of figures is not overwhelming, no newspaper rock or dizzying canyon wall. It is a sane and private number, something you could at least record with your eyes in one or two sweeps.

By the time we had enough light that Jado could see around

us, it was like letting a ferret loose. He dislodged from my company and soon called me to come see whatever he was encountering. He was all over the split boulder, ranging ten times as far as I'd gone the last few mornings. It turns out the boulder is broken into multiple pieces, a joinery of cracks and wide-open fissures. I followed him and we eyeballed each other from forty feet apart through the rock's guts, peering into lichen-fringed splits. They had done the same, I guarantee, especially the kids who might have had a hideout up here. Children could have been the ones who led the adults to the place, a favorite boulder, a playhouse. My two kids used to have their own split boulder when they were little, learning how to jump off of it, curling up in its spaces like burrowing animals. Their hands were always finding each other, Aspen taking Jado's, the two swinging hands together, or jumping off at once.

Boulders were known this way. Like clouds, they had faces and moods. When I see the split rock my children grew up on, it is not a piece of geology in my mind. It is a place on the land that holds memory, existing within me and beyond me, tilted and broken in two long after we're gone. It's a place where I would have left rock art.

When the kids were little, we went to Washington, DC, for an urban immersion for several weeks. Some of the only boulders we found had been rolled in front of a museum and we climbed on these gray hunks, remembering what it was like to feel the weight of your body, the grip of your hands. Within a minute someone with a lanyard walked by and told us to get off, that it wasn't allowed.

What will we replace boulders with? These are the boulders we built fires against, coming back to them in different seasons, watching days pass from under their shade. The children jumped off of them as a dare. Some offered shelter out of the wind. This desert was navigated by boulders, and some were embellished with images.

A dusting of blue on the horizon disbanded into a full color spectrum that preceded sunrise. To watch the sun come up, Jado and I stood on different points of rock, measuring distances between us and between horizons, feeling the range of our bodies.

Orange light fingered through a healthy piñon tree and landed on the panel of seventeen people holding hands in a circle, an icon across millennia. By full morning light, we were already gone, tracking through surrounding boulders and their dry juniper woodlands. Cliffs ran up high, and terraces of livable earth lay below. The thinnest sign of what may have been pit houses descended toward a creek with sherds of broken pottery, faint mounds and chipped stone, evidence of settlement. Our circle expanded from the red dancers, revealing spirals on bedrock and a horned figure pecked into the bottom of a cliff. A community began to appear, and at least two more boulders were faintly spattered with pigment, their pictographs long eroded.

We moved out farther from the panel into cottonwood trees that were ruptures of flame, late October written all over them. A creek chatted and sang over rocks, carrying yellow leaves downstream. Our circle widened to the truck, and the highway, and later that day to a dirt road in Colorado, taking us back home.

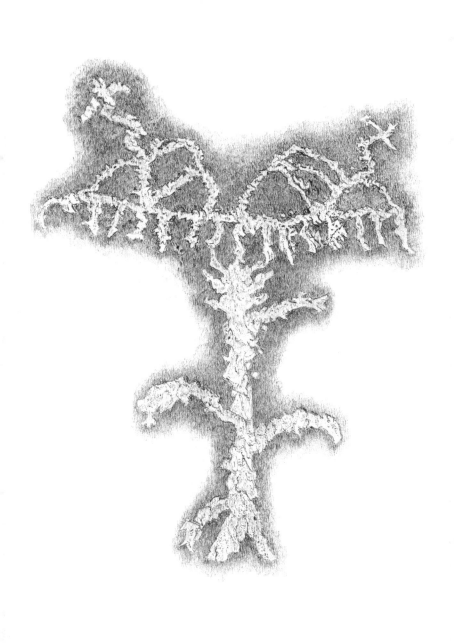

·10·

Rain

Everything pecked or painted in these dry and rocky corners is a rain symbol. Without precipitation, there are no adornments, no spirals, no births or hands on the wall. To say something in this desert is not rain is specious. The canyons are formed by it, dug out by floods and the sapping pressure of springs that only flow when precipitation is strong. Native corn grows in dry sand where all you might need is one or two storms in a season. All life hangs on rain as if by a single toehold. Carol Patterson is not wrong in calling a shield figure a rain god, or naming the painted *koshari* in alcoves, telling me they are cloud women, seeing lightning and rain inside of them.

Sitting under the iron-colored slabs of the San Francisco Peaks in northern Arizona, I talked to Kelley Hays-Gilpin with a picnic table and lunch spread between us. Drought was part of the conversation. It always is. It was May and hardly a scrape or bowl of snow remained on the mountains, worrying no matter what part of the Colorado Plateau I visited. After we talked about drought, we went on to politics and family, and what she's learned about rock art that she could share with me. It came back to drought, though. Someone said something about rain. It sounded like a prayer. I hope it comes, she said. She looked through pines and called the mountains above us "mother." That is how the peaks are known at Hopi, birthplace of the katsinas, benevolent rain spirits, carriers of prayers. For the Zuni, the katsina birthplace is farther east across Arizona, high mesas around the town of St. Johns. In the summer, thunderstorms build up

the slopes of these highlands, letting loose precipitation and scraps of fog on occasion. In the winter the mother mountains over Flagstaff stand bone-white, all that water conveying life to everyone below. This isn't where the gods dwell as much as where they emerge, high country causing clouds to build, the upward spirals of air that lead to rain.

◆

I was back on the phone with Chris Lewis at the Pueblo of Zuni in northwest New Mexico. He said a lot of the more fantastical figures we see are clouds in human-like form. He told me everything is about rain. Every. Single. Thing. "That's all we do every day of our daily lives, from when we get up to when we go to sleep," he said. "Hard thunder, soft thunder, hard rain, soft rain. It's in the turtle shells and shells from the ocean that we use, the musical sound of rain."

When we spoke, it was a summer afternoon, temperatures sweltering into the high nineties for both of us, no rain in sight. Lewis was on the phone outside, where he could get signal. His air, like mine in Colorado, smelled of distant wildfire smoke. Restrictions were starting to lift after a punishing winter at the pueblos. Communities of a thousand people lost up to fifty of their members. Whole families died, grandparents to in-laws. Lewis told me the pandemic was hard on the ceremonies, too. Dances and feasts were cancelled. He said he knew that the following year would be dry, which it was, his corn plants tiny, producing half a laundry basket when usually he fills three. "The villages didn't do anything for a whole year," he said. "We stopped making clouds."

Does he believe they are making clouds? It's a question you don't ask, one that won't have any resolvable answer. Maybe, maybe not. We were settled into our tenth, or was it twelfth, summer of drought in the Southwest. With Zuni still closed to outsiders a five-hour drive from me, and both of us under the

same arc of clear blue sky, I felt close to Lewis and utterly separate. We were on islands shouting across to each other.

On the phone, he pointed out a couple lone clouds in his sky two hundred miles and a couple mountain ranges from me. "It's so bright blue," he said. "I'm looking at two tiny white clouds. They are people who never participated. They're the loners, they come by themselves. That one reminds me of my uncle."

When you live in drought, you pay this kind of attention to anything resembling moisture, the mere possibility of it. You begin to *relate* to it. These two clouds, from his description, weren't carrying rain, no chance of building into anything. They were like two old friends out for a stroll, no concern if they evaporate into nothing, no reason to send us rain or even a stroke of virga. They weren't thinking about community, he said. They were the kind of people who don't go to ceremonies and dances, and he described his uncle who prefers to stay at sheep camp and rarely comes in to see anyone. These are the lives of clouds.

Sometimes I see animal shapes in clouds, seahorses and anteaters. That's a brush with animism, watching clouds pick shapes for themselves. When the air is parched and trees feel like they might burst into flame, I look more closely at the clouds. I size up their potential, wondering what mood they're in, wanting them to come into a circle, shoulder to shoulder, and begin to boom and spill down on us.

◆

Micah Loma'omvaya at Hopi told me his name means "beautiful, handsome clouds coming."

When we walked in a field of boulders covered head to toe with petroglyphs, and the San Francisco Peaks floated on the horizon in northern Arizona, he showed me a congregation of cloud images. It looked as if rain prayers had been chanted at hunks of fallen, blush-colored Wingate Sandstone. Clouds were portrayed as flat-bottomed bubbles with lines of descending

rain. One looked like a storm, cumulus domes with arrows of lightning flashing out the sides. Petroglyph rain fell toward the shape of a leafy cornstalk proud with tassels. The style of the illustration, a century old, maybe two, was familiar enough I could tell what it was.

Older cloud imagery, early Basketmaker and late Archaic, is animist, abstract, not figurative. Clouds are rendered anthropomorphically, more like people than clouds. I think of the tall red figure near Moab, green snake in its mouth. A conceptual version of a cloud, the pictograph suggests how clouds were experienced by people.

Up high in the bend of a walled-in canyon, this figure is a robed ghost, blood-red body, eyes green, mouth wide open holding a green snake. The figure's torso, nearly as tall as my own, had been painted in vertical thumb strokes, making the body seem to be filled with rain, red rain, cloud-blood. Step back from the figure and take in its surroundings, paintings of snakes and horizon lines with sheets pouring down. A little, humanlike figure held in the hand of the bigger figure is known in Acoma oral history as *Ko'Bitcitia*, the shy spirit said to hide in the east behind the clouds. Frightened by loud noises, like thunder, it lets go of the rain.

You find on the dry years that your eyes linger on clouds. It's not like lying in the grass, rolling a stem between your teeth finding animal shapes in the sky. Now you look at them with desire, wondering what it takes for them to swell with rain and let loose.

◆

Years ago, I backpacked with my stepdad up a deeply entrenched canyon on the Navajo Nation near the Arizona-Utah border. It was summer, abysmally dry, daytime temps over a hundred degrees. We'd been drinking out of blackened waterholes when my stepdad found a babbling spring on day four. Coming out of

Navajo Sandstone, it braided down a ladder of wild grapevines like a Maxfield Parrish dream.

That night I camped in a slick rag of a sleeping bag next to the stream. My face was close enough that droplets dotted my eyelashes. No harm for just one night, I thought. I kept a metal cup set under the trickle and splash, listening to silver sounds of it filling. When I thought to wake, I reached out and drank.

Maybe I didn't say thank you in the morning. Maybe that's why the clouds evaded me all that summer. I still call that my blue-hole summer, the one where rain was clearly avoiding me. Camped on a high bench of this canyon with my stepdad, looking across folded ridges and the breaks of faraway Monument Valley, we'd been watching thunderheads sail over the desert. They turned a charcoal-blue and the darkest turquoise, a color that looks like the sea. Veils of rain unleashed from under them, sweeping the hot earth, but not on us. If I were a forager of Archaic age, I'd get up and walk there. I'd find full waterpockets and potholes, and months later, maybe ricegrass. If I were growing corn, standing over my parched canyon and rows of sandy, shriveled stalks, I'd be watching people of the Kayenta region over yonder getting doused, wondering what they had done right, and what I had not.

The blue hole didn't leave me for months. I felt like bad luck wherever I went. Some years you learn your lessons.

After several days, we walked back upstream and forded the low summer San Juan River, packs on our heads, tepid water flowing around our waists. We set camp on the other side between a ridge painted in white spirals half a mile in one direction, and the circular mound of what had been a great kiva near the river, a masonry ceremonial chamber from the eleventh century.

That night, a thunderstorm barreled in from the east, the place where the benevolent, timid *Ko'Bitcitia* are said to hide among clouds. The storm charged from up the river as if eating

it. Steely echoes of thunder radiated into the canyons and the air smelled of ions spun on end.

Carol Patterson told me, "If you can make thunder, maybe you can create rain." She was referring to Basketmaker petroglyphs depicting large leather rattles, like drums, possibly worn or shaken overhead. They show up both as rock art and as artifacts, appearing sometimes like headdresses on tall anthropomorphs, whom she calls "thunder-beings."

She said, "The sound is what frightens the clouds, bangs against them, and makes them rain."

Patterson takes this from the nineteenth-century ethnology work at Zuni by Matilda Coxe Stevenson, who describes "lightning people" shooting arrows to make the rain come harder. The smaller flashes, she wrote, come from the bows and arrows of lightning children. Stevenson wrote, "The thunder-people have human forms, with wings of knives, and by flapping these wings they make a great noise, thus frightening the cloud and lightning peoples into working harder."

Chris Lewis reminded me that calling the rain is not just about making noise, but also about timing. He said if you start making noise before the rain begins, you might scare it off. Instead, you should be quiet at first. Lewis's eleven-year-old grandson has learned to come into the house at Zuni when clouds darken and he whispers to his grandfather, "It's coming." Lewis puts a finger to his lips and they both listen. If it starts to rain, he said you can raise the volume. He said, "At the dances, when it starts to rain the drums go harder and the dance gets louder."

If the rain slows, so do you, quieting until the last drops fall. In this way, you and the storm are doing the same thing. It is less calling the rain than welcoming it. He told me, "When the rain comes, I say, oh, hello, you're here, so nice to see you!"

This tradition seems to be as much about asking for rain as greeting it, being at peace with its whims. Mysticism and

animism may serve that purpose, aligning yourself with forces and elements around you, forming a personal relationship with them rather than an abstract one. The goal may be the same as science, having a deeper rapport with the world.

That night, it felt as if the world was about to be deluged. I could feel moisture on my skin through the air. My stepdad and I closed packs in their covers and he grabbed his raincoat. I didn't have one. The smell pouring from the clouds was like mushrooms and sky. It was everything living, everything possible. Lightning erupted inside dark folds, close enough I could see strokes of a downpour through the night.

I don't know where my stepdad went, off in the black of night to brace for what was about to hit. I went for the circle of the kiva and sat on a big black river stone in the middle. If sitting here was desecration, I didn't know it. I was so thirsty. We'd run out of spring water, rattling iodine pills into our hands from their stout little bottles, drinking what tasted like bleach and death-rot. Tonight we were drinking warm river water and iodine. Tomorrow we'd hitch a ride out of here on a highway and we'd be drinking iced tea, looking at online gauging station reports that would show peaks from flash floods striking all night.

The storm came from up the river where cliffs are draped with petroglyphs, what you might say are people in regalia, box-shouldered figures with lines stacked around their heads, easy to call headdresses. I've come to see these less as human characters and more as clouds. I see them as the front of a thunderstorm coming at you, cumulonimbus shoulder to shoulder, the great rain-bringers.

If it's going to happen, if you're going to be hit by a whirling vortex of rain, why not be in an ancient circle? Could sitting here be construed as some form of respect, or ancestor worship, drawing together strands of history with the here and now? I'd later reconsider my decision. Maybe sitting in this circle was the mistake I made in my blue-hole summer. I had no deep lineage

here. I was borrowing this ceremonial site like a hermit crab poking into an abandoned shell. Wind howled in the canyons, screamed on ridges. Lightning fused the red-walled landscape into my eyes. The perfume was now an olfactory flood. It almost smelled violent. My mouth stammered open as if to drink.

At that moment, the entire thunderhead pivoted in front of me. Turning on a dime, the boiling tower of blackness rotated and headed south into the night. Thunder boomed into the canyon we'd been hiking for the last week. Those dry corn rows I had imagined from a thousand years ago were getting soaked.

The copper-penny smell of rain dragged away. Thunder softened. White light flashed far off. I sat in the circle of the kiva, ground still warm from the day, my mouth open, asking…what?

◆ 11 ◆
Galleries

Most of what you might encounter are airy panels, figures given room, a spiral next to a few interlocking forks, or a tidy scene of hunters with a few bighorn sheep running away. These panels are easy on the eye, as if posed in a museum, lighting focused on one item at a time. Then you find a wall flooded with images, the definition of a palimpsest, figures overwritten, older ones showing through from below. Images seem to be swimming among one another, a swirling school, a murmuration.

I am mistaken thinking these were meant for me to see. A flock of birds doesn't spot me and think, Oh good, he's looking. They serve their own purpose. Mine is to look up and notice.

Standing inside a shelter covered with hundreds of red-painted figures is bewildering. I don't know where my eye should land. Perhaps on a flute player directing his music toward a pumpkin-shaped female squatting with open labia and Hopi-style hair whorls. Or I start with handprints, each with intricate and unique designs laid into the palm. Being in this overpainted space feels like reading name tags, saying hello, shaking hands, starting up conversations, moving on to the next, which is not, I believe, how this was meant to be seen.

If you walk up to a panel and have no idea where to start, even after staring for a minute or two, it's probably not a panel, but a gallery.

In dry washes blooming with fossilized lithodendrons of northeast Arizona, the desert painted in badlands and rock-rimmed plains, you'll find a place called Newspaper Rock. Right

off the highway, it's not one rock, but many old caprock boulders tilted this way and that, bearing more than six hundred petroglyphs. Rather than a newspaper neatly folded, it looks like pages blown across the desert. A petroglyph snake turns the corner from one side of a boulder to the other, accompanied by prong marks, walking feet, a sunrise symbol, a thunderbird, lizard men, stickmen, bighorn sheep, concentric circles. People with hanging hands and feet stand among tick-marked yardsticks, spirals, boxes, and wavy lines. A knobby-ankled ibis with a curved beak appears to be skewering a small, frog-like person. You become lightheaded trying to look at it all.

Southeast Utah also has a Newspaper Rock, off a paved road into the Needles District of Canyonlands, a two-and-a-half-hour drive from the Four Corners. You'll find a parking lot and a pit toilet, but don't let these distract you. The barricade that protects the site is easy to see past. Don't climb over. Bring binoculars if you need a closer view. About 650 images can be counted on two hundred square feet of wall, the size of a cinema screen. You are seeing a couple thousand years in one glance, Numic bloodlines covering each other. Polly Schaafsma sees at least two distinct time periods here: historic Ute ancestry post-dating 1700 AD, represented by a horse and rider shooting an arrow into the rump of a deer. Below these is a more expansive Pueblo ancestry of horned anthropomorphs Schaafsma identifies as Southern San Rafael style between 1100 and 1150 AD. This style consists of antler heads and warriors, shields of spirals and, more than anything, representations of animals, especially bighorn sheep. If you stare long enough, trying to read beneath layers of footprints and four-legged animals with antlers and horns, it feels like falling into a well. The patina is dark, nearing black, petroglyphs electrified, off-white pink, the under-the-skin color of Wingate Sandstone. I've learned to look past the vandals who put up a ladder and added names, past the Ute layers, and the Fremont before them, wondering if I'm not seeing the long lines

of Archaic imagery from several thousand years ago, faint as handprints on silk.

The largest of these sites, called "great galleries," will take half an hour of walking and pausing, lifting binoculars and putting them back down, before you realize you're not yet halfway through. Figures number in the thousands, and sometimes continue for the length of a canyon, a mile or more of one gallery after the next. I've imagined pictograph alcoves in these great galleries being put up by firelight to the pounding of dancers, metates grinding like drums. I see artists feverish with sweat finishing a series of images, turning toward the crowd, and diving across upraised hands, red spattered paint going everywhere as they crowd surf. That never happened, of course, but sometimes you let your mind wander. I might be thinking too much of stage shows and Saturday nights, which could find some form of kinship here, the energy of an event remembered for generations.

More likely, the work was slow and quiet, maybe done to a chant or just the arrhythmic tinking of bone on rock, the careful painting of a calligrapher.

◆

The air was so tranquil on a January night, it felt like I'd dropped to the bottom of the sea. I brought two lights with me, one to find the way, another to use once I got there. A half-hour walk at most, I picked the middle of the night to visit a gallery of red pictographs in a canyon that converges from forks in both Colorado and Utah. I'd thought about using a candle when I got there, the right size and illumination to draw near and away. I wanted my point of view changed, not distracted by the overwhelming number of scenes swirling around this alcove. A candle wouldn't work, though. Licking pictographs with waxy soot would be an act of vandalism. As would touching them with a hand or rubbing past them with a jacket sleeve. These places require the lightest visitation.

Maybe I came to shake the image out of my head of an event stage raked with smoke and lasers, and while I was at it, the picture of savage artists slapping up paint while hillbilly rabble-rousers fired off rockets in the background, more like my family than theirs. I looked for a quieter, older origin. I brought a handheld light the size of a matchbox for this endeavor, taking the gallery in smaller doses. I carried a notebook to quick-sketch vignettes, a way of parsing the site, adding up numbers of motifs and groupings. If nothing else, this was my way of being a scientist.

Patches of snow hugged the ground as my headlamp moved into a close-in hallway of cottonwood trees. If I'd come in daylight, my hands would have been in my coat pockets, and I might have whistled as I strolled along the cold, dry wash. Instead, I drifted like a carp downstream through the darkness. Light landed on ground hard from freezing, cottonwood leaves crisp and soundless.

If there are ghosts, this is when they sit, when they let you come close. A storm had moved out days before and no others were on the horizon. High pressure ruled a crystalline atmosphere full of stars. Veils between centuries felt thin.

Shadows opened and closed as I passed by. Faces appeared and disappeared, cottonwood trunks and boulders smiling and scowling. I watched for anything that might move. Let's say I was to see something, what if it ran on two legs, trailing feathers like a trickster?

Try not to let your mind play tricks on you. Try not to think of anything at all. Listen to your breath and make the walk a contemplation, moonless and suspended. There's no doubt in my mind the land is haunted. It's not a childhood fantasy. So many memories cannot be in one place without continuing to ring.

A bird burst from branches and my light jerked to follow the panicked flapping. Maybe a winter wren, or a startled towhee, too fast to see. Wings silenced in seconds.

I would have welcomed the flash of a rabbit or a fox, or any other bird, but there were none after that first one. The only loose moisture in the wash was my breath. It drifted around me like summer clouds.

I slowed when I rounded into the alcove, switching from headlamp to my small, soft light. Frosted illumination washed in, enough to make red pictographs visible, so many it looked like you could walk straight through them and they'd brush past you like beads. I didn't want to blast them out with the hard, white circle of a headlamp, better to let the edges fade, figures tapering into darkness. This may be more of what people saw in them when they were fresh, the eye settling on scenes, isolating images. Red matted brushes had gone up on every paintable surface, and they must have worn out, new ones brought in to replace them. Hands would have glowed red from ochre, faces blushed from scratching the nose between dipping, brushing, and dipping again.

My hazy circle cast onto handprints at eye level and moved down to an insect-like person, hair and hands raised like an exclamation mark. I see children gathered here as torchlight moved to show this red jumping man, the storyteller barking the next word, scaring everyone.

I've heard of boys coming out of ceremonies wide-eyed, and you will never hear what they saw down in the kiva. Some of the ancient initiations, before these gentler days, might have scared a person stiff.

Don't turn your back to the panel, I thought. This is too powerful a place, so many memories looking down. I hardly got out my notebook, pausing to take a few shots with my camera, but mostly I spent my time in quiet study. I didn't want to make a sound, didn't want to stir the air. Though I'd come to count pictograph figures, I hardly wanted to breathe, much less stand like a stenographer, scribbling and adding up, wagging my pen at one figure and another like I owned the place. All the paint looked

the same, a brick red dug from the same source. Each image the halo moved over I saw as part of an individual scene, a discrete painting session. I could detect a time difference between their making. Days? Weeks? Years? So far, dating techniques aren't accurate down to the scales I was thinking. A carbon-14 date off a panel like this, getting within a century or two if you're lucky, would require a sample pried off and ground up at the lab for analysis. Which piece of which story would you remove?

I touched my light into snow-crusted sage and fallen rim-rock beyond the alcove. I was not thinking of coyotes that walk on two legs, and certainly not thinking of flesh-witches and specters seeped into me from stories I'd heard around here. Don't turn your back on the black outside, I thought. Navajo people have words for this kind of feeling, not something to put in print, nothing you'd want to summon. It is the last breath of the dead. A friend and I once hitched a ride on the Navajo Nation in northern Arizona and the guy who picked us up, a young Diné man, asked where we'd been. When we told him we'd been seeing cliff dwellings and rock art, he pulled over his pickup and apologized, but said it would be best if we got a ride with someone else, and maybe not mention where we'd been.

Ways of responding to these galleries are countless. You come to them with dread, elation, curiosity. Imagine painters running brushes all over, one after the next, a time-lapse of generations. You see an artist in silence working alone, like Michelangelo lying on his back, pigment flecking off a ceiling into his eyes.

This is how easily some art can be destroyed. Paint hangs on by a crust and it feels like a single breath could make it come down. A simple act, a brush of the hand, could cause time to end.

◆

Everything is moving and breathing, you realize. As still as the desert seems, it is up in arms chanting and dancing. Stepping

into a busily painted room at night is opening a door onto a party. Everyone is here, come on in.

Ethnographer Ruth Bunzel, born in 1898, wrote: "To the Zuñi the whole world appears animate. Not only are night and day, wind, clouds, and trees possessed of personality, but even articles of human manufacture, such as houses, pots, and clothing, are alive and sentient. All matter has its inseparable spiritual essence."

If a rock is living and thinking, certainly the art painted on it is a nonstop chatter.

Kelley Hays-Gilpin told me the same, saying, "The whole earth is alive and animate, and can be interacted with at any place." She calls rock art sites an "accumulation of animacy," shying away from calling it power, saying the word is overused and misunderstood. "Not power *over* something, but power *with* something," she said "Life force maybe. A concentration of life force, or where life force is more accessible, where you can interact with it and approach it."

My circle of light moved from one red figure to the next, as if waking them, opening their eyes. When I looked to the ground, I saw dishes polished in the bedrock. These had been used to hold pigment, brushes dipped and brought to the wall. The chamber hummed with life force, memory, power, whatever you want to call it. It was the only place lit up out here, no streets or towns, no glow on any horizon. From a distance, it must have looked like a soft eye in the black earth, silhouette of a person standing with a lamp overhead causing the ceiling to glow. Without anything else happening on this winter night, air breathless, nothing to see but a crush of pictographs, I backed away. I hadn't drawn a thing in my journal. It felt like too much of a distraction. The light softened and spread, and figures faded. The cave returned to darkness.

Nothing scared up as I walked back to my camp. Images swam in my mind, humans, not humans, spiraled hands, forked

meanders painted up and down the wall. Whatever I imagined of these figures, they came down to the simple fact of people leaving many memories in one place. It is what Carol Patterson calls, "the presence of meaning." You don't have to know what it is, only that it exists.

Getting back to the road and my truck, I dropped a sleeping bag on the ground. Stars took up most of the sky, asterisms and names of constellations I memorized from camping as a kid. Even looking up felt bustling, so many stories overhead. I fell asleep zipped into my bag and if I dreamed, I don't remember.

·12·

Symbols

When the wind blows hard, it feels like a beast. It is hungry and wild and nothing escapes it. Anything you want safe you have to hold down.

In April, the sky is the mouth of a whale pulling you in, and anything you grab flies in with you. Utah catapults into Colorado. Arizona lands in New Mexico. The sky is cloudless and the ground up to a hundred feet is a gauze of blowing red sand. The dark spindle of an eroded volcanic neck appears and disappears. This kind of weather can go on for days and then it stops, clouds move in, and snow falls hard.

I walked with Micah Loma'omvaya through such a wind, precursor to some other weather pushing in off the Pacific. I hear of cleansing ceremonies, poisons drawn out of you as a singer paints with sand or burns piñon and sage. This felt like such a ceremony, purely the action of wind, everything cleaned from us as we walked toward a nest of boulders pecked up and down with petroglyphs.

Loma'omvaya wore a ball cap to shield his eyes. If he turned into the wind, he had to take it off, and sand peppered his face. He said you can tell his people were born for this landscape, pointing out that my forehead was dry and chafing and his had a sheen of skin grease. I touched my forehead. He was right; it felt like a rough moon. My bloodlines come from northern seas and mountains, little in my genes to help with the desert or a wind like this. He put his ballcap back on and we walked into the gale.

We were unmasked, which felt unusual, but in this wind and

nothing but sky around us, there was little danger of passing a virus. The reservation was still on curfew and we met in daylight hours. I'd have to be gone by dark.

The first boulder we came to was awash in faces, arrows, bird tracks, corn stalks, spiders, animal tracks, animal bodies, and stair-step clouds. Loma'omvaya immediately began talking about clans, gesturing with his head at images and naming who was who. He had things to say to me, but when he addressed the rock, it seemed he was speaking to the petroglyphs.

"*Tapamveni* means pounded symbol, to me the word for petroglyph," he said.

Loma'omvaya explained that these boulders, at least forty of them marked into galleries and isolated panels of snakes, spider people, and a cadre of other clans signs, were a record of clans coming through, each symbol a sign of a matrilineal bloodline and a distinct ceremonial history. We were along an ancestral pilgrimage route used by both Hopi and Zuni people. Springs flowed out from under the caprock of a nearby mesa, enough to warrant a stopover. Initiates would pull in here on their way to gather salt in a river gorge to the west, a ceremonial journey, and also a salt gathering for the people. He said when a clan member came through, a symbol would be added into the rock, and this is how many came through.

"For myself, I was brought up with symbols as a Hopi child," Loma'omvaya said. "They're actual things in life, corn or coyotes or the sun. I'm seeing the reality of objects, and for you, they are symbols."

As a Hopi society initiate at forty-seven, Loma'omvaya carries with him pieces of the old religion, pre-Christianity, animistic source material. If I wanted to understand the meaning of rock art, picking up nuances my eye could never detect, I would study under someone like Loma'omvaya, but this is clan knowledge, not mine. The esoterica of Hopi ceremonialism is not public. He wasn't here to blow my mind with secret information. We

were here to look at clan symbols together, taking an account of who has been coming through.

The size of a cottage, the first boulder was covered on all sides, a collage of orderly chaos. So many petroglyphs had been rendered in the bright inner layer of rock that the faces seemed to glow. "They definitely tried to use as much of it as they could," Loma'omvaya said as we walked along the boulder's side, the size of a living room wall. "This is where the clans are totally together," he said. "They started here, showing they are part of this brotherhood. Wouldn't you like to have your symbol here among the first initiates?"

He told me the eruption of the Sunset Crater volcano between here and Flagstaff, which occurred about a thousand years ago, drove his people out. "Then we lived along the Little Colorado River," he said. "We were all over. A thousand years ago we know where we were, and a thousand years before that. All the places we were before, that was ancestral Hopi, and now we are here."

Loma'omvaya pointed out the markings of Coyote Clan, Spider, Reed, Sun, Snake, Bluebird, Mockingbird, Eagle, Bow. He said, "Squash Blossom Clan," gesturing at what I might have mistaken as a petroglyph of a snowflake the size of my hand. As soon as he said it, the snowflake flipped to become the webbed petals of a squash blossom. Once I saw one of them, they began snapping open like flowers on the boulders around us.

He showed me a petroglyph of a cottontail rabbit as seen from behind, rump and little fuzzball of a tail. Next to it grows a tall plant. The artistry is modern, I'd say 1950s. "Cottontail and tobacco," Loma'omvaya said. "They go together. It's in their clan histories." He led me to a group of thirteenth or fourteenth-century rabbit petroglyphs, a design I might not have recognized as rabbits, easily thinking them deer or dogs. They converge on the stalk of a nondescript, leafed plant that on any other day I would have called, with some certainty, corn.

"Do you recognize that plant?" he asked.

"Tobacco?" I said.

"Tobacco," he said. "Rabbit Clan, Tobacco Clan. It's all about relationships."

It may have been that Loma'omvaya, or one of his society ancestors, made some of these very marks when they traveled during their initiations.

Our tracks were blown away by the time we took thirty steps, moving from boulder to boulder, more petroglyphs than I could think about counting. We were well into the thousands. I asked about this and that, but my questions felt useless, pushed into the wind. A gust hit us, and Loma'omvaya stopped talking. I closed my journal around my thumb. We put our faces down, bills of our ball caps shielding us, eyes closed. After sand sheeted past us, we looked up.

I asked about small round faces pecked into the rock. They had dots for eyes and a mouth, two antenna-like protrusions sticking up. Hardly larger than a coin, they appeared playful, and I told him I see these images all over, having heard interpretations from cat people to a representation of a chest pendant. Carol Patterson had been pointing out similar petroglyphs as Ko'Bitcitia, rain spirits known to Acoma people.

"That's Muyingwu, the little germinator deity," Loma'omvaya said, smiling, glad I'd picked it from all the hundreds. It signifies the Pocket Gopher Clan, close relatives of his own clan.

He said the symbol is related to the Men's Singers Priesthood, the ritual society to which he belongs. Muyingwu is the katsina responsible for sprouting seeds, bringing life. The role of this priesthood society is to focus on the perpetuation of life forces and on creation for a prosperous Hopi future and for the world. This is what he sees when he comes upon this petroglyph, to an uninformed eye nothing more than a small face with antenna. While other societies might be about war, weaving, childbirth, or rain, his is germination. Society initiates are responsible for

employing ritual knowledge in the ceremonies, sworn to live in humble and pure ways that make the ceremonies more effective, bringing rain, ensuring fruitfulness and fertility.

"This isn't theory for me," Loma'omvaya said. "It's practice."

He was educated off-mesa, earning a master's degree in anthropology from University of Arizona. When he was nineteen, he was initiated into his society at Hopi, which took him away from school for two years. Like N. Scott Momaday or Jim Enote, he is of both Native and Western mind, a Socratic education within a traditional upbringing. After initiation, he finished his degree and returned to the village of Soongopovi, a mesa-top citadel established in the twelfth century. He explained that there are no more initiates lined up after him, considering that initiation starts at the age of five. Elders are waning, few left to teach decades of symbols and stories, gestures with corn meal, or chants for rain. The commitment is a lifetime of training, learning ritual details and generations of stories, and an obligation to perform duties at social and religious festivities and annual rites. I asked why it was ending and he said, "It's not the direction Hopi is going right now."

"And if no one else is initiated?" I asked

He said, "Then this legacy, this thread, ends."

He didn't seem outwardly saddened, a smile I'd seen on Buddhist monks, accepting the turns of history with apparent ease. He told me Hopi is much older than whatever we are experiencing now. He wanted me to know that part of the Hopi way is migration, the spiral, constantly turning, a culture that keeps its core but does not stay the same. It is always moving toward that middle place.

"When I bring my children here, I tell them what these mean, and they know they are part of it," he said.

As we walked behind one of the larger, central boulders, Loma'omvaya picked up from the ground a long, stiff reed, big around as a thumb. It had been tipping back and forth in the

gusts, and I'd wondered where it came from. Using it as a pointer, he drew a circle in the sand, the rough circumference of the Colorado Plateau. He showed Navajo people moving into the area, establishing the Dinétah homeland, some of their clans dating back a thousand years or more. The older, original Hopi homeland he slashed in the sand with what he calls various invasions and incursions, territories and reservation boundaries. "This is where we're at," he said, and erased the map with his boot.

In ten seconds, he'd given me a thousand-year history lesson: once the Hopi and their ancestral kin were everywhere, the people were many, and now they perch in a handful of pueblos stacked on three desert mesas in what is called Arizona. Now they live among Navajos and Anglos and whomever else has poured in around them. Again, he began drawing with the reed. He made a tidy circle the size of a shield and bisected it twice, turning it into quarters. He added a dot to each quarter, saying this is the sacred earth symbol, this is the homeland we all were given.

Loma'omvaya was showing me history and symbology, and also how it was done. A reed like this must have been here a thousand years ago. Watching its tip slice through sand, an initiate would have learned how to make a symbol and how to recognize it. Stories would have flowed, names of clans passed along, songs sang to germinator gods or snakes pecked into a golden, patinated plane of rock. Bone awls had been used on the rock with hammerstones. Like a signature, each initiate who passed on a pilgrimage left a symbol of a society, a clan. With one kind of eye, you see mystery in rock art, inexplicable signs from a lost civilization. With another eye, you see people still doing their work.

◆13◆

Processions

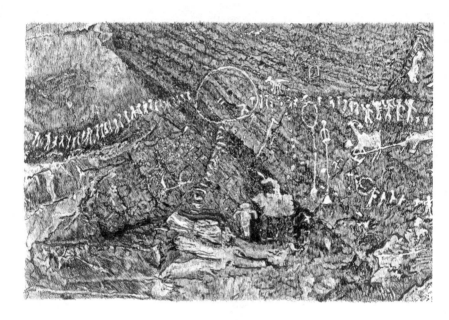

Binoculars are handy, but they can become a crutch. They can make you miss what you're looking for.

I work with a couple pair, one a little brick of Leicas for scanning cliffs and faraway boulders, the other a pair of blocky Nikons, a 1960s edition, bought cheap because they made so many. The Leicas are small enough to fit in a shirt pocket, a prize that I won in a nature-writing competition some years ago, one of the few items I still own from my twenties. These Nikons are for longer study, not used for detecting imagery, but pulled out once it's been found. I want something with weight, a pair I can grip and lean into for slow study. At sensitive sites, you don't have to come in close and step all over the dry grass and broken

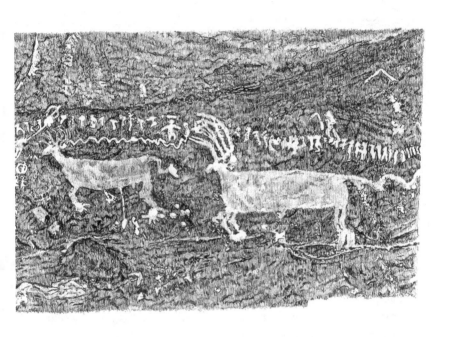

bits of rock or pottery. The ground in front of a decorated rock-face can be as consequential and sensitive as the rockface itself.

I walked cliff lines and panned their bottom ten or twenty feet, heading toward a panel I knew from a previous visit, a six-toed figure. Six toes is one of those vexing motifs you see across the Colorado Plateau, mostly on cat images and human-like anthropomorphs. In this case, I'd found one near the Colorado-Utah border under the white-capped La Sal Mountains, and I was taking the long way there. I trained my smaller pair on a theater of cliffs and boulder slopes a good three hundred feet up. Focus rolled tighter onto what looked like tall, tapered figures. My heart quickened. Dark pigment, yes, I could

see hematite used for two or three bodies tapering downward. Just as I believed I'd found a lost Barrier Canyon panel, I zeroed in and found them to be water streaks.

Cryptoglyphs, I call them, nature's rock art.

Nothing there, I kept moving.

Slow down, I had to remind myself, miles to go connecting one rim to another across cattle country and rocky slopes, and be home by dinner. It was the year of working at home, conjuring odd jobs, and whenever possible stretching my legs in the desert. I stayed in my county and the edges of surrounding ones, careful when I sneaked across the border from Colorado into neighboring Utah or Arizona on dirt roads, avoiding COVID checkpoints along the highways.

My phone hiccupped in my pack. I'd forgotten to turn it off and had wandered into signal. Pulled out, shut off, it went quiet. Too many tools, I thought. Even the binoculars seemed to be rushing me along: look up, look down, look up, look down. After a while, you stop walking closer to what you want to see, using the binoculars instead, dismissing faraway rockfaces as empty when they might not be. I slipped the Leicas into my coat pocket, unloosening my fingers from mask elastic, and got up on a boulder to see where I was.

Slow turn, take in the valley. Meditate on distance and nearness. Boulders lay all around, a garden of them the size of cars, some of busses. Beyond them looked like the site of a great quake or war, boulders splintered sharply and standing a story or two tall.

Of the hundreds within view, a squat boulder presented itself like a resting cat, its side bearing a line of marching petroglyphs. There was no squinting, no pulling out binoculars, no mistaking what I saw. It was a motif known around the Four Corners as a procession panel, people in a line going somewhere. It was like seeing handwriting resolve on a page you thought was blank, a needle showing up in a haystack.

I hopped down and found the panel through a field of similar-sized boulders. Drawing close, I slowed as if dusting off my shirt for a proper hello. I barely say anything out loud, maybe a whisper, a mumble, a *good morning.*

There is no one way to approach a panel. Everyone comes up with a different salutation, even if it's remaining silent, as I often do. Carol Patterson, who imagined young girls giggling in an alcove at their grinding holes, raises her voice an octave when she sees something new. "Oh, hi, little bug," she says, encountering a small petroglyph at the corner of a complex panel, one she'd studied many times without noticing. "Look at you there," she says to a lizard on a rock, speaking to it, forgetting anyone else was listening. She does the same for flowers and little trees growing out of the rock, not an affectation, but a natural place for her voice to go. The life in rock art is not imaginary. It listens.

I took an angle to the panel, not wanting to leave tracks that add up when you're not the only one visiting. There were no other tracks, no hardened earth. I came close enough to count seventeen figures in a row, all facing the same direction down the line. They were small, each no taller than a pencil, or the stub of one, a different height to each. Bundles that would have been the size of basketballs hung on their backs, suggesting they were traveling west to east, though I wasn't sure, and pictures I later showed to keen observers came back with different answers. West to east, east to west, at least it was clear they were moving. The circles they carried, each the size of a penny, could have been objects hoisted in front of them, women walking with baskets, or with pregnant bellies.

One of these burden-carriers, near the middle, was the height of a full pencil, taller than the rest, and stepped aside, facing the same direction but not in line. This gave the panel dimensionality, a sense that somebody was walking out of line, the presence of depth and vanishing horizon. It was someone tall or important, possibly a leader, a herder, a person ushering the

group along. Not an elaborate set of petroglyphs, it wouldn't necessarily hang on a gallery wall. Its figures were simple, each with a vertical line for legs and body, roundnesses for their heads. They each carried a burden and some had split or bent legs in a stepping motion, though it was hard to tell which way they might be stepping. Were they arriving or leaving? A roughly made bighorn sheep was also in the line, as if joining the parade, an inclusion about which I wouldn't hazard a guess.

The boulder wasn't immediately remarkable, a piece of long-fallen cliff nested here for a good many thousand years. In elevation, it stood only slightly above those around it, enough to give it a view across a broad and distant valley. I happened to see it not because my eye is particularly attuned. Rather, it was meant to be seen, not like a banner or billboard, but like a glimmer. They wanted this to catch the eye. If you knew what to look for, the site stood out.

The purpose of my day was not to remain here for the hours I wanted. I was out to get the blood pumping, moving through cliffs with crags and ledges, boulders to scramble over. Hours ahead of here was a six-toed petroglyph I wanted to see. To treat a procession like this right, I'd need the sun's arc from start to finish, not sitting in hours of meditation, but moving from boulder to boulder, understanding why they'd put their petroglyphs here. I took some pictures, scratched a note or two, and left the scene. You can't stay at every one. There are too many.

◆

I think of the land in terms of movement. What gaps would you take and where would you shelter in winter? I couldn't stay still in one place if I tried. For thirty years I've been slowly moving around the northwest horn of the San Juan Mountains in Colorado and pinching up against Utah, four different towns and a couple wild tipi plots in the woods where I memorized stars through open smoke flaps. I can't say what drives gradual

peripateticism, curious to move to the other side of a pass, keeping the same mountains on my horizon and staying in motion. This is how I live in a place.

I pay attention to this sense of scale and belonging as I walk ridge to ridge, keeping the same snowy landmarks in view. People may have moved and traveled for different reasons, but their eyes fell on the same beacons. My pace and range of migration is different and not so different from theirs. I move as one, or as a small family. It appears that they moved in extended households, processions. My moves have been personal and theirs were communal, ritual. All the while, we kept the same skylines.

Processions are signature Basketmaker and early Pueblo motifs, people in a line carrying burdens and going somewhere. Finding one is rare. I've seen a dozen in my lifetime. Joe Pachak is one of the few I'd trust with a more precise number. A rock art documentarian and sculptor from Bluff, Utah, the one who builds wooden animal sculptures that have burned the last few winter solstices, Pachak has spent most of a lifetime recording, drawing, photographing, and cataloguing rock art around the Four Corners. His knobby, hard-worked hands gesture this way and that when I ask him how many he's seen. He points toward processional rock art in Arizona, Colorado, and Utah. He says, "Just a guess, I've seen between forty and fifty." He says he's heard of procession artwork in New Mexico, but hasn't seen them.

The panel I found in Colorado is pint-sized compared to the largest procession, which is a panel in Utah with petroglyphs of almost two hundred people walking toward and entering a large, thin-lined circle pecked into toasted red sandstone. Gravity emanates from that panel. You can't help walking toward it, feeling the momentum of humans going somewhere. They don't randomly fall into the circle in the middle, but deliberately go there, moving in ranks, many carrying burdens, some with staffs or heads with birds perched on top. The land around it looks like a hundred *Titanics* going down at once, the earth tipped into

a tectonic disaster. If you climb to the top of the angled ridge above this great procession, passing other, smaller procession petroglyphs along the way, the desert opens like a map. The view encompasses fifty or sixty miles of mesas and ridges in all four states. You are seeing a clear fifty miles from the ridge top in all directions. The Four Corners region looks like a pepperoni pizza laid flat and dried out, red, orange, and bleak. Monument Valley stands in Arizona like a game in play. The dark head and tail of Sleeping Ute Mountain rises in Colorado, and next to it, the rooftop of Mesa Verde, the Fort Knox of the Anasazi world, cliff dwellings jammed into canyons. In Utah, twin buttes of the Bears Ears rise above juniper ridges and naked red gorges, as if a bear the size of a mountain put its paws on the horizon to take a peek over the top.

Few places on the Colorado Plateau furnish such a view. This is where the people came, I think, the center of the circle, a cultural heart of the ancestral Pueblo world. This is the place lines of people must have led. Sites of late Basketmaker and early Pueblo cultures are thick in the area, ground loaded with pottery and rock flakes, villages mounded into hills of rubble and arti-facts. Above the procession panel, at the high point of the view, are the ruined remains of a masonry structure turned orange by fire. It looks like a fire signal, a light that would have been seen from Colorado, New Mexico, and Arizona. If I were to haz-ard a guess, I'd say people came together in a concerted effort to make this place happen. Their arrival was memorialized in petroglyphs.

◆

When we rode in vans unmasked, and before our hands peeled from over-washing and sanitizer, I taught a field program at this large procession panel. We spent days exploring surrounding canyons and upwarped mesas. I wanted us to see the circle the way they saw it, not just a kiva or a dance plaza, but a circle of

land, sacred mountains pinning down each horizon. One day was spent at the main panel, the next looking for routes leading to it. Deep toeholds pecked into a cliff showed where a person could climb directly to the panel rather than take a circuitous route of ridges and side-canyons getting there. Along with toeholds are petroglyphs of sandal prints and lines of pecked animal tracks moving up the rock as if saying this is the way we all go.

We took the group higher, climbing one of the Bears Ears, its right, westernmost ear to be precise. Lyle Balenquah, a Hopi archaeologist from the Greasewood Clan, village of Paaqavi, was also working the trip. We helped participants up and over piñon roots and boulders to an elevation of almost nine thousand feet. The earth took on a slight curve from this elevation, horizons laid across each other like pages in an open book.

Looking at rock art, if you want to see more than what is on the face, you'll have to step back. Take in the panel and the untouched rock around it. See the canyon or cliff face from a distance, a mile or two or ten. Lose sight of it, but know where it is. See it through layers of mountains or ridges. Get up high enough where the lay of the land makes sense.

Balenquah said he could almost see home from our high, pine-swept slope. He was looking south past the dark bar of Black Mesa in Arizona, and just beyond it the pale skim of a horizon. That skim, just out of direct view, is Third Mesa where he lives, about 130 miles south of our position.

I looked the other way, northeast, toward a lone, white tip of a mountain in Colorado, and beyond it the brazen horde of the San Juans rising to fourteen thousand feet. I could almost see my home, too, ninety miles the opposite direction. Our homes, more than two hundred miles apart, we could see in one sweep.

This, I believe, was the circle that these petroglyph-makers were walking into, the outer coil of a spiral. Many other spirals swarm within this one, other center-places at other times, Chaco, in New Mexico, Hopi in Arizona, Zuni and the other pueblos of

New Mexico. I found from the red, steep slope of the Bears Ears that the entire land looks like it's spinning, homelands circling around each other as if in orbit. What the movement looked like on the ground, a formalized version, was the procession.

◆

Chris Lewis from Zuni has stared at this gallery of processions in Utah almost more than the eye can take. Invited with other Indigenous liaisons to look at one panel or another, going on record with a cultural analysis, and returning to Zuni with what he learned, Lewis has deeper cultural insights than most archaeologists. Like Jim Enote, he grew up with great-grandparents coming out of the 1800s. He described living with them on dirt floors with a woodstove, a life of sheep and corn. When he was six years old, he started spending his summers at sheep camp with his mother's father. From 1976 to 1984, he spent every summer there, and sitting in juniper shade watching the sheep move, his grandfather would tell him stories. This is how he became a repository of knowledge. He is cognizant of the legends and remembrances of his people, drummed into him every summer for nine years of his youth.

"People call it the procession panel, but I call it the migration panel," Lewis told me, seeing these figures not as a memorial of a public dance, or necessarily as a single event, but a movement of the people, a time in history when they came together from far away. Many of the stories he'd heard as a kid were about migration.

"There is sort of a caste system," Lewis said, describing four lines of petroglyph people on parade toward a center-circle. Two lines come in from the sides and two come from below. The lines are then broken into distinct groups, some people pecked with legs and arms, or carrying burdens. A row of people with hands held up comes with atlatls and projectiles, perhaps a warrior clan, or proficient hunters. Some of the figures are depicted

carrying staffs or wearing headdresses or feathers, dressed up like clouds. The panel seems like an official count, a record of who exactly arrived for this crux moment in the early centuries AD. I've sat in front of it for hours, and walked along its lines, counting the numbers of people. To me, it is an historical record.

"Clans outrank other clans," Lewis said. "The highest-ranking clans are Parrot and Dogwood, where the sun priest comes from, and other clans fall in behind them. The highest are in front. Crookneck staffs are the clan leaders."

These were more than lines of nonspecific people. This is a moment told in detail. In Lewis's description, I see shuffled dust of people coming together, ground hardened by their numbers. Knowing the strong relationship to colors and adornments in the Pueblo world, this would not have been a drab march. I hear singing and shells rattling, chants and calls. What they carried in the baskets on their backs is unknown, but the baskets themselves are known, broad-mouthed cones of woven willow or dogbane, wooden handles and carrying arms. Some baskets were coated with clay, used for hauling water. Others may have been loaded with corn.

Lewis came to this panel with an Indigenous group and the Anglo researchers who had invited them. He said the white party, armed with cameras and recorders, went for the middle of the site, the circle each procession led to. It's easy to be drawn there, with its large petroglyphs of animals and atlatl scenes. They had many questions. Was the large, central circle a great kiva, a ceremonial chamber set into the earth? Was the panel showing a dance circle in a nearby valley floor, a place now littered with spear flakes and the scatter of tool-making and broken pottery? Was it a gathering of clans, did it happen all at once, does the panel represent days, weeks, months, years of pecking?

The crew of Indigenous representatives who, along with the researchers, had made the trek here through titled rock slabs and canyon-bottom boulders, found themselves drawn not to

the center, but to the far right of the panel, what to them was the natural start. They were not so much fixated on where people went as where they came from. Following the longest chain of petroglyph people to its start, they found a small pecked circle where people emerged as if from out of the rock. Figures became so distant as they receded toward the hole that they were formless, losing arms, legs, no more burdens on their backs. They were reduced to scratches and cursory pecks.

"Tiny little figures come up and if you look at where they begin, there is a circle disappearing," Lewis said. "Wherever they originated, the area where they came from, something made it fall apart and they are all moving."

A theory often floated is that this panel shows a cosmological emergence, coming to a center-place, axis mundi, navel of the world. Rather than being an actual migration reading like the book of Exodus, this may be an origin story of the people. In Pueblo tradition, people climbed from a hole in the earth, their former world collapsing or drowning or burning behind them. The circles they came from may be where they materialized from this last world, moving on to the circle of the next, migration written into their histories like a mantra.

Kellam Throgmorton, a Binghamton University doctoral graduate now working at the Crow Canyon Archaeological Center in southwest Colorado, studies ancient household sizes, kin groups, and villages on the prehistoric Colorado Plateau. Based on room excavations and population estimates, he comes to similar conclusions as Lewis. This procession gallery shows a migration in a period of dramatic social change across the region between 760 and 800 AD. Villages and households were aggregating into larger groups during a time of rapid population growth that followed the widespread adoption of agriculture. The nutritional boost from corn and other cultigens allowed for more babies and longer lives, requiring a change in community structure. Families needed workers. Many tasks needed

accomplishing. Single households became room blocks, small communities, and the first stacks of multistory architecture.

Throgmorton believes these procession petroglyphs show the transition happening, either as a mythic narrative or a portrayal of an actual event. He sees individual households coming together to form a new, more generous unit, distinguishing at least twenty households from the lines of people pecked into the panel, each grouped by their unique likenesses. Whoever made the art, Throgmorton contends, was familiar with the individuals and groups they were representing, giving them each their own style and personality. Each of the larger companies was led by someone with a crookneck staff, making the gathering seem layered, hierarchical. He counted 194 individuals in total within identifiable households, people with names.

Or, this was a dance, a ritual remembrance, a declaration of unity. This may have been one of the greatest round dances of their time, remembered for centuries. People came a long way to be here, dressed in their best, bearers of crookneck staffs high-stepping toward the middle of the circle.

Joe Pachak, who has studied this large Utah procession more than almost anyone, says he believes it is not a single event, but a telling. He says, "You're paying taxes to be connected to all these other people, it's their regional system." By a regional system, he means an engineered landscape of what he calls "prehistoric steps and roads." He said, "It's like being dedicated to the cathedral you're trying to build even if takes longer than your own life."

The appearance of processional panels covers centuries and different styles. It was a period of forming a new future across a large geography involving trade and conflict. To see a new social order come to fruition, Pachak noted, takes more than one lifetime. You add your handprint to the wall, putting on another layer.

◆

Two days after I found it, I took Daiva to the small procession panel, as if I'd discovered a badge, a pearl, something small and important. She looked at the line of figures with their rounded burdens, then traipsed off in every other direction. I couldn't keep track of her through the junipers and boulders big enough for her to disappear behind. Staying seated across from the procession of seventeen, I counted and recounted, wondering if they were heading left or right. Was it a ceremony or a migration, and what difference might there be? Were they carrying salt or trade goods, tying the landscape together? According to Throgmorton, this would have been a household. At seventeen, it could have been everyone from this group, the old and the young. It was the same number of people from the red circle panel from near Escalante, Utah, the same number on Hopi-Tewa potter Jacob Koopee's painted jar, and three digits off from the figures painted holding hands around a Basketmaker bowl 1,500 years old. This seems to be just the right number.

Almost a hundred miles southwest of here is the great procession panel that Lewis calls the migration panel, and I wondered if this Colorado household was a part of it, one of the clans to arrive from far away. If it was a migration, pulling up stakes, as Lewis suggests, they may have started as seventeen and whittled down to a smaller group, one of the sevens or eights that made it to the panel. I have been told by many who know stories of ancient migration that the journeys were never easy. A hundred miles or more through hard terrain and other people's territories, long stretches without water, would have tested their survival and cohesion.

Daiva called, "There!"

I looked up as if out of Throgmorton's dream about household numbers. She stood on a boulder and pointed at a cliff another couple hundred feet above us. Sharp and broken talus led up to it. I pulled out the Leicas and trained them where she

was pointing. We'd heard of another procession panel nearby, told this by an archaeologist a few towns away from here. Sure enough, she'd found it. I could see the rhythmic nicks of petroglyphs high above us.

She found four snake skins on the way up, holding them in her hands like friable parchment, lenses of eye skin clear as glass. Snakes had left their skins in the rocks, peeled off against the grit. She has a thing for these kinds of animals, three of them tattooed on her forearm in a traditional pattern from her homeland in Lithuania. That explained her howl of delight when she arrived at the high panel. A few lines of people marched toward a center, where she found a petroglyph of a snake next to six distinct dots in a line, each the size and shape of shirt buttons. She shouted down to me, "Snake!" By the tone of her voice, I knew it wasn't a live snake on the ground, but the idea of snake, skins in her hand, petroglyph on the wall.

A little rougher than the petroglyphs below, these were nowhere near as detailed as those at the great procession in Utah. No more than a few inches tall, they looked like drummers in a marching band, walking along with their round burdens. I kept fruitlessly asking in my head, what's in the bundle? None of your business, they said.

Processional petroglyphs outside of Moab look like they're carrying the same kinds of round loads, and they come with birds on their heads. Painted in red near the Arizona-Utah border is another similar panel of circles or shields or drums being carried by people filing into a line. Others processional rock art shows conical burden baskets, some with bands over their shoulders or tumplines across the forehead. These all strike me as specific groups, a map of who was here at the time, who was in motion.

These procession walkers weren't all the people who lived in the area. Many probably stayed away or did not engage. The age of pit houses did not end as the age of room blocks and pueblos

blossomed. Several languages at least were spoken between the people of the Colorado Plateau. They had different histories, different destinies. Some traded with the south, some with the north. Those who died violently, bodies left in horrific states, burned and piled in their own chambers, did not always have the same kinds of artifacts as those who seemed to live in peace. There were classes, cults, and societies. I saw in this panel not all the people of this time, but a specific group, the ones who walked in lines.

Below us, the valley spread like a sea with cliffs parted around it, washes dry and cold. In the greening of spring you can sometimes make out lines of ditches they dug more than a thousand years ago, watering the first solid crops of corn. Corn brought abundance and children and generations grew. Alliances formed and clans were named. New kinds of communities were needed, ones that could shoulder the weight of increasing bounty. These petroglyphs of people walking with their burdens may show that change.

I believe these petroglyphs along the wall, gathered around a snake and its six dots, describe the people who went on to make these new communities. They carried loads of survival rations, ceremonial gear, weapons, blankets, shells, or water. A wooden staff with a crook in its neck was lifted and showed the way.

◆14◆

Crookneck Staffs

Chuck LaRue sat at a campfire turning a wooden rod above the flames. As he joined in with stories and jokes, he worked the wood, heating it and pressing it on his thigh. Middle-aged and nicely battered from years of tromping around the desert, he is a glowing character, quick with a good story. We poured tequila for each other, reaching across the fire. We used to pass a bottle, but not this year. First time with others in many months through lockdowns and quarantines, I felt shy, thinking I was maybe laughing too loudly or talking backwards. It had been several weeks since I was with anyone other than Daiva and I wasn't used to my mouth being watched.

LaRue heated sap inside the grain of the wood and brought it back to his knee. He didn't seem to be bothered by the company of others, going about his work with focused pleasure. The rod gave slightly under his hard, flattened thumbs. He said this is how it's done, how they bent their wood. He was making arrows, to hunt with, but he came with crookneck staffs in his truck, what he preferred fabricating.

Anything you might need, he has in his truck. The wooden flute I carry in my gear broke while I was out, and he rummaged out strips of elk sinew to fix it. He calls sinew "Paleolithic duct tape," because you wet it, apply it, and the sinew swells, tightens, and sticks to itself. He has lengths of straight oak branches he's harvested for making staffs.

These staffs show up in imagery all around the Four Corners. You see them in procession panels being carried by clan leaders. Staff imagery can show up as a simple crookneck pecked

into a cliff above a village site, as if lifted into the air saying this is the place. Nearly a hundred documented renditions of staffs, mostly petroglyphs, are found in the northern arms of the San Juan River in Utah, and more from the rest of Basketmaker range in Colorado, New Mexico, and Arizona. They're shown lying across each other, positioned at angles, sixteen staff petroglyphs laid out like semaphores around a circle. In an excavated Chaco great house in northern New Mexico, 375 staffs with curled, almost spiraled heads were found collected in one room.

Evidence of this unique kind of staff extends off the Colorado Plateau, found on painted Hohokam vessels from southern Arizona where people with baskets on their backs are depicted walking in lines one behind the next, crookneck staffs held before them. A petroglyph boulder near the Nevada-California line, known as the Cane Man Hill Site, bears a pecked person who seems to be springing forward, a bold walking stride, with a crookneck staff held forth. They seem to represent movement, people in lines, or going forward: follow the one with the staff.

LaRue has been able to accurately replicate the technique of making crooknecks by finding a long straight oak branch that forks at one end. Half the fork he cuts off, leaving a knot that would be polished like a thumb grip. The same knots are seen on crooknecks in collections, proof his method is accurate. The remaining half of the fork he bends at a fire until it begins to curl back on itself.

LaRue specializes in remaking artifacts, determining how they were fabricated, matching rock art to objects in museums and private collections, and teaching himself how to create them. His favorite to reproduce is the crookneck staff, about four feet long, good length for a walking stride. The head circles back on itself like a question mark. Some in museum collections are much taller, gripped at the shaft rather than the crook, suggesting the object is beyond physical function, but is instead a social marker.

I asked Leigh Kuwanwisiwma, former longtime director

of the Hopi Cultural Preservation Office, what this crookneck meant, sending him pictures from panels I'd seen. I showed him a petroglyph of a person walking alongside a line of other people, taller than the rest, wearing a bird atop his or her head, and carrying a crookneck staff. Kuwanwisiwma wrote back that it comes from the priesthood of an ancestral rain-bringing society. He described the people in the line as "one-horn priests performing a ritual dance." He called the staff *Kwaani*, which is the name for dried figs collected from agave stalks. Their abundance is a sign of good water, coming up tall with bright white flowers on favorable years. When they are heavy with fruits, sometimes the stalk bends over, forming a crook.

Ethnographic reports from the Southwest and journals of early Spanish expeditions tell of this kind of staff used to hook gophers or lizards out of their holes. Among the Southern Paiute people in 1848, Kit Carson wrote, "To obtain this description of food more readily, many of them carried with their arms a sort of hooked stick, not unlike a long cane, which they use in capturing them."

The crookneck staff could have been many things over its history of at least a thousand years. Now it's carried by Zuni ogres who dress up for ceremonial night dances and march through village streets rattling their shells and terrifying children. The staff may have once gone out of favor among the powerful, or it was scary to begin with, interpreted far in the future as part of an ogre's costumery.

This kind of staff is not alone in the world. Four thousand years ago, Egyptian ceremonial staffs looked much the same, made of wood, curved around the top, signs of divine power carried by gods and rulers. The Catholic crosier has a similarly curved neck, acting as an insignia of episcopal office, and it began as a wooden, bent-headed stick. It is thought to have come from the days when early church work involved travel, when a religious figure carried a walking staff going about the land.

LaRue won't venture to say what this staff might have meant in the ancient Southwest, lizard-catcher or the mark of a religious position. He uses them as walking sticks. He doesn't know if they were truly used this way, but for desert travel, reaching down to hoist gear over ledges, a crook lowered for a person to grab onto, he says there's nothing better.

When he was six, LaRue's parents moved to Hopi from Albuquerque. His father took a job in the community of Keams Canyon at a school where half the students were Hopi and half were Navajo. LaRue went to school where his father worked. He relished the landscape, saying when he first arrived in Keams Canyon with its naked pink sandstones, he thought it was the Grand Canyon. In black-and-white pictures from the 1970s, LaRue's blond shock of hair shows up in a crowd of Hopi and Navajo kids on an outing his father was leading. LaRue picked up mannerisms and histories here, and by being a researcher has become part of the cultural-academic apparatus that helps keep traditional knowledge intact.

An ornithologist by training, LaRue was tapped by perishables archaeologist Laurie Webster as a research assistant, traveling to museums around the country to unpack collections and decipher unstudied objects from the Colorado Plateau. Being an ornithologist got him the position when Webster brought him to the Field Museum in Chicago for a feather blanket, about a meter square. LaRue determined that it was made from several hundred birds, no wing and tail feathers, just body feathers. More than a dozen species were represented in this one small blanket, most of them ground-feeders. This led LaRue to track down remnants of small, human-hair snares, piecing together how this blanket was created from the catching of the birds to the weaving. "Imagine taking that many sparrows and warblers and stuffing them in a blender, then leaving them around for two thousand years," he said. "That's what I had to figure out." He found the blanket was made not just of feathers, but some full

bird skins. "Little birds skinned out to the beak, their skins and feathers wrapped around yucca twine," he said.

This is what LaRue does, he figures out artifacts beginning to end. He has a maker's mind. Mustached and middle-aged, a robust soul, strong storyteller, he looks at ancient objects and lays out the whole story. When I went to him about body ornamentation he's studied, in particular hair adornments people would have worn, he laughed and said, "You're opening up a whole universe." He described wrapped-twine wooden hair pins he'd gone through, decorated with feathers and paint, more adornments and styles than he could recall. Everything had a purpose, symbolism or utilitarian, often both.

When I see LaRue walking with a crookneck staff, I think he may be using it the way it was originally intended. It could have been the sign of a traveler, a route-finder, a leader helping people up over ledges, hooking bundles and baskets as they moved across the desert. This is how he likes to understand ancient items, making his own, putting them to use, seeing how they work.

The next day, a few of us walked as a group, and LaRue came along with his curved staff. We explored boulders at the bottom of an arena of cliffs on a sunny February morning. Half an hour by raven's flight from the Four Corners, petroglyphs had been applied to most of the boulders around us, panel after panel of atlatls and their throwers, corn stalks, yucca blossoms, bighorns, headdresses, waistbands, hair bobs. We split off from each other, him staying below, me climbing a couple hundred feet of talus to the foot of a towering cliff where I found a second, higher gallery. As I walked the rubble-struck cliff, ticking off paintings and etchings along the way, I stopped at a lone petroglyph of a crookneck staff. A foot and a half tall, a miniature, it was a likeness of what LaRue carried, down to the knot where the original branch once forked. I thought about shouting about what I'd found, but LaRue was a football field away, half disappeared in boulders as he moved from panel to panel far below.

This petroglyph was alone, no other images immediately around it. I looked to my feet, seeing broken rock, uneven ground. Was this a burial, one of the people you see in rock art, staff in hand, interred right here? I turned and looked across the canyon floor, green with vegetation where bedrock nudges water to the surface, a village site used for centuries if not thousands of years. Rushes and a few cottonwoods grew along a trickling creek. This staff petroglyph may have been an invocation, a sign of rain, an appreciation of this watered and livable place.

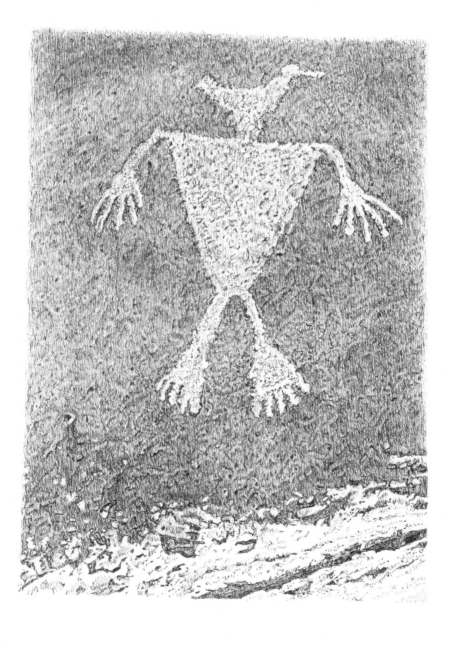

⋄15⋄

Ducks on Heads

Years ago, I called them duckheads. Then, because of what happened next, I decided to stop calling them that.

A friend and I packed into the same canyon on the Navajo Nation where I'd gone with my stepdad years earlier. I knew by now the bends of the wash and places where rock art gathers. This is the back end of the Navajo Nation in Utah, a perimeter with tacit allowance for foreign travelers to poke a little ways in, but not too far. The possibility of trespass increases until you're out where nobody gives a damn about your permit from Window Rock. I tried not to go that far. I didn't take my friend to the spring my stepdad had found, leaving that to posterity. We had enough to see as it was. At a boulder facing into a dry wash, we found a nest of duck-headed petroglyphs and I called them duckheads. I wanted to sound like I knew what I was talking about. It came rolling off the tongue easily enough that I used it for the next couple of days. It felt good to be familiar with something so old and meaningful.

Images of people either wearing ducks on the top of their heads, or with their heads made into ducks, are common around the Four Corners, most abundant in southeast Utah. Some sneak north near Moab, and I've seen plenty around the Colorado-Utah line, one possible contender near where I live in southwest Colorado, though that petroglyph could be a raven on a person's head. Others appear near Mesa Verde in Colorado, though they might be turkeys. The duck-head motif drops south into Arizona, and I've seen nothing of it in New Mexico.

What these images could have represented I had no idea and I probably had no right to talk flippantly about them, giving them my own nickname. To be honest, they looked a little odd. Who wears ducks on their heads?

A question they may have asked a thousand years ago is, who doesn't?

When we crossed the river and returned to our truck, the ignition key turned, engine sputtered, and smoke poured from under the hood. We threw the hood open and found our engine on fire. This was half a mile from where a thunderstorm had pivoted and carried its rain away from me on a thirsty summer night. I wasn't having good luck here. I'm sure my friend and I had been discourteous in more ways than one, and though I can't stake much on causation, I have my suspicions. For a second time, I had to hitchhike out of here.

With heaps of fine, red sand scooped in our hands and thrown into the engine compartment, we put out the flames. Hoses sizzled and metal clicked as smoke billowed under the raised hood. It was maybe a loose wire or a line chewed by a woodrat. The truck was old, needed work. Maybe it was something I said. After that, I decided not to pretend I knew these duck-headed figures like old friends.

◆

I came to know them better over time, shedding the oddness. Along with ducks on their heads, these people are often shown with weapons, mostly stone-tipped atlatls. One petroglyph shows such an embellished person lodging an atlatl into the throat of a mountain lion, a kill that may have been remembered for generations. Rory Tyler picked out a small number of duck-headed figures around Moab, north for their range. He found them portrayed in combat with the more numerous local action-figure anthropomorphs, people with knobs or feathers on top of their heads, what Tyler believes are the tips of depictions of mountain

lion tails. He imagines the figures with bobs or tails were fighting with duck-headed people from the south.

I kept wondering what a duck might look like in this context. If I had to attach one to my head, would it be alive, a pet duck, or dead? A dead one would flop around while I dodged flying projectiles, and a live one certainly wouldn't put up with such nonsense. The picture looked ridiculous in my head. This, I believe, is where I had it wrong. Perishables archaeologist Laurie Webster mentioned that she's seen plenty of mallard duck feathers used in ornamentation in the artifact record, but never a whole duck. "It's not like we're finding duck decoys," she said. "It's a metaphor. I don't think they were putting taxidermied ducks on their heads."

The image of a person with a duck upon the head is likely related to a Zuni cultural legend that tells of a hero who pays a visit to an underground lake. The journey is dangerous and cannot be completed without a duck, the one who dives underwater and comes back to the surface. This guide, the duck, takes the hero into the underworld and brings him back, the quest completed. If Joseph Campbell got ahold on this piece of history, which could be unfolded into days and nights of storytelling, he'd have found it absolutely archetypal. It is similar to a story he recites in many of his texts about a frog who dives into a pond or well to bring a golden ball back to a girl who dropped it. The frog, or the duck, is the diver who lives between the upper and lower worlds, helping people make contact between the two. To honor the duck, or disguise himself as one as he visits the underworld, Kiaklo, the hero in the Zuni story, wears the duck on his shoulder, or places it on his head.

I went to a couple who owns a ranch in southwest Colorado, a dynamic duo of rock art hunter and photographer, Ming and Garry Adams. They'd published a photo book, *Spirits in Stone*, which I keep at my desk for when I'm stuck indoors. I asked if they'd show me their favorite duck-headed figures. All

I had to say was ducks and we were out the door, a few days by truck and foot to see what they'd found. They didn't know what the motif meant either, but neither Ming nor Garry were ones to be bogged down in the shifting shadows of meaning. The Four Corners was a grand art museum for them, secret rooms everywhere. Between running cows and sheep, butchering, and selling meat, they took their spare moments to march through this high desert looking for symbols and depictions. Ming is nearly half the size of Garry, who is a tall man to begin with. She is the one who crawls through holes, finding a crack with a thousand-year-old wood-and-mortar bridge over a harrowing plunge, the wall beyond it festooned with petroglyphs. In the quiet of winter, they scoured the Four Corners for rock art and I tagged along asking about ducks. It was like seeing the Met with friends who know the museum well, whisking you past statues and paintings to witness a prize they'd found down a quiet hall.

Garry, the photographer, wanted me to see a duck at a particular moment. Under a bluebird winter sky in southeast Utah, sun close to setting, a jigsaw puzzle of hundreds of petroglyphs was about to go volcanic. Four in the afternoon in December, no other hour of the year has such a burgeoning shine.

Boulders lay against each other from falling, a clutter of sharp angles where Ming made herself comfortable, seated on rock, to watch the imagery above. Her eyes moved across galleries of petroglyphs above her on a rust-red cliff, towers of petroglyphs, ghosts, and levitating immortals. Humans were becoming animals, or the other way around. Petroglyphs of life-sized, circle-headed men were shown as ornately dressed, bearing ritual items and head gear. Some say they are not head-dresses at all, but waves of thoughts coming out of the mind, prayers emanating like tractor beams. Their head gear may be halos, representations of sacred positions. Carol Patterson tells me that some of the images around these anthropomorphic

heads are the sounds of thunder entering their ears, and some are lenticular clouds building over the mountains of their heads, said to be the birthplace of the sacred rain katsinas.

"The movie hasn't started yet," Garry said, waiting for the perfect light. Bald-headed and sun bronzed, he paused to take shots with his long-lensed camera, saying to wait for the coming light.

My neck grew tired looking up at petroglyphs. Some outlines were so high on the wall I wondered, did they fly? Thirty or forty feet up on a rockface, I imagined wooden scaffolding or ladders notched for climbing, single poles of trees carried from the mountains and leaned against the cliff. An ancient rock chipper would have wrapped two feet or worn-out sandals around the tip of the tree, arms stretched up, hands tapping a river cobble against the butt of sharpened bone. Grains of red patina gave way to bright bedrock. After a few thousand precise strikes, work that may have taken days, the artist would have leaned in close to blow dust from the creation. It was a petroglyph of a stylized person wearing a duck on its head, placed higher than any of the others.

The image high on the wall above me was armed with a glowing gold atlatl. Maybe this was Kiaklo himself, underworld traveler. Or it was a person carrying the spirit of Kiaklo. The duck is in the person, perhaps like a compass, showing the way. Hunters with atlatls and wearing ducks upon their heads will surely find their mark. The figure high above may be Kiaklo, and it may be every hunter or warrior who lived with this story. I, too, am glad to have a duck or a guide, whatever invisible force or being that helps us navigate. Perhaps this is what they felt when they looked up and saw this petroglyph.

Garry told me it was time, the show was beginning. Rockfaces brightened minute by minute into a brassy glow. Garry was glued to his camera, recording petroglyphs that opened as if coming awake. The sun, the wall, and the images on it were

animated and interacting. They seemed as alive as anything, flowers touched by the sun and unfolding their petals.

"Every purely natural object is a conductor of divinity," wrote John Muir, mixing animism with his scriptural upbringing. Animism is thought to be the earliest stage of human religion, pre-totemic, back to when boundaries between humans and everything else were thin. We remember it because it is real. Life can hang by the whims of animals and weather. When you pay that close attention, you come to see that you are not the only living, breathing thing around. The boulders, the sky, the raven, and the river are all characters on the stage. You feel the boulder beneath you, how it settled from its fall, seeing how it yearns to turn to sand. The sky is alive with its field guide of clouds and nights full of stars. Ravens work for the sky. Actually, ravens work for themselves. The river comes through in winter laughing over cobbles.

The light was going fast, panels facing north or east already in shadow, while western faces smiled. Images in front of us reached their vibrant peak. Garry wanted me to see this high figure with a duck on its head, brightness rounding into every pecked divot. It looked like it was carrying the sun.

◆

In a canyon as cold as a cellar, we moved through brush and into boulders cluttered around the mouth of a shallow cave. Garry said this is their marker canyon, and Ming said the ducks were in the next one over. We were twenty miles north of the sunset panel along the river. We stopped long enough to look in the back of a shallow, drop-down alcove, its floor plated in pieces of bedrock fallen from the ceiling. One of the slabs held a frame of petroglyphs on its flat surface. A neatly organized set of squiggles moved around a linear humanlike form, Archaic to my eye, at least a couple thousand years old. We'd barely gotten a look when Ming and Garry hoisted each other up through a crack

and exited the other side of the canyon. I stayed back, counting out a minute in my head, long enough to see the petroglyphs had been chiseled on a prepared surface, bedrock sanded till smooth as a ceramic canvas. One figure, alone, a burial I wondered, or a ritual held in this seeping hollow with a few tufts of moss growing in the back. That's all the time I had, hurrying up a crack and looking for their tracks through sand washes and juniper trees. I caught up behind Ming in jeans and hiking boots and short, quick steps, as Garry moved out front with his worn-out canvas work coat and his long stride.

The next canyon echoed as we slipped down into it, holding onto hackberry trunks and ledges of pale redrock. The metallic smell of winter settled into the bottom as if it had weight. Twice as deep as the last canyon, maybe three times, it rounded into a hollow back end, the rounded-out concavity of a cliff.

The last walls of a crumbled cliff dwelling stood on the sunny side of the canyon. What we could see of it through brambles and winter-bare poison ivy, the dwelling was positioned to soak up the warmth. The other half of this shell of a canyon remained in shade all winter. A long thin spring draped in ice ran along its backside. This is where they painted ducks. A burnt-cherry pigment had been used to form a confident humanlike figure, Kiaklo, I presumed. Over the figure's head swam a duck in the same dark pigment, its legs trailing behind, giving the clear indication the duck was paddling across a surface. The two were almost touching, as if the hero were standing just below the surface as the duck swam directly above.

Not every part of an ancestral story is known by each clan or society. Rather, knowledge can be a puzzle where pieces are added person by person. I came to Chris Lewis at Zuni asking about Kiaklo, and he said, "That's known as the blind one. I know he's the son of one of the gods. He was sent north to find the middle place. He went so far north he went blind from all the ice and snow."

Lewis told me that Kiaklo found his way back with the help of a duck. The hero tied shells around the duck's neck so he could follow the sound. "Like a seeing eye dog," Lewis said. "Kiaklo had a seeing eye duck."

Set off at the far side of the alcove, away from the nearby dwelling with its grinding stones and once-standing doorways, these painted figures seemed isolated. The cold, shaded bend was crowded with moss and twiggy monkey flower stems, the underworld side of the canyon. It is where water emerges from inside the earth, where a hero would have to go.

Ming was gone. She'd seen these pictographs before. Garry may be swifter on open ground, but once they reach a site and he pulls out his camera, she's already finding what's next. I could hear the nylon of her coat and daypack sliding through brush, while Garry probed the duck-and-man pictograph with his lens, commenting on the site's acoustics, his voice bouncing back on us.

In winter-dry oak brush, Ming looked up through branches and saw petroglyphs on a sunny cliff above her, two long lines of dots, each the size of a marble pecked into the rock. A human image stood at eye-level, its hands and feet spread wide, clearly among the living. Higher overhead she saw what looked like a shield bearing a sun.

Ming, mid-fifties and Taiwanese by birth, was once in advertising, a life of high rises and international flights. She's the business end of the ranch, the one you have to talk to about renting a cabin or grazing on their land. Garry, mid-sixties, comes from a Civil War history, family steeped in New York City. His father, a mineralogist, lived with his mother in the 1940s in mining camps from Colorado to New Mexico. The ranch house Garry and Ming built together atop a desert hill in southwest Colorado looks like an eccentric, twelfth-century citadel. Talk radio plays all night down at the barn to ward off mountain lions.

Their home is a cabinet of curiosities with the mounted

skull of a longhorn that once grazed their land, a miniature working steam train built by Garry's father, rugs, baskets, pots behind glass, books stacked up, and painted wooden katsinas on shelves. Wooly pelts of sheep they'd raised and sold for meat lie across the furniture, or are hung on wooden vigas outside. Dogs curl up on the floor and couch. Cats come and go. Garry's favorite ceramic bowl sits atop a display case in the main room. Zuni in origin, the scroll of paper inside says it comes from the late 1700s, having belonged to his great-great-grandfather. Paintings of deer wrap around the outside of the bowl, and the inside displays painted, stylized duck heads. Garry told me he doubts anyone could really know what the ducks ultimately mean. "All the different tribes seem to have different stories to tell," he said.

He told me that a friend from the Santo Domingo Pueblo in New Mexico brought over his Zuni girlfriend a few years back. She was impressed by the pot, he said, and mentioned to him how the duck represented their migration story, and how it led her people to where they are today.

◆

Zuni is known for its ducks. If Garry's bowl had been from the Acoma Pueblo farther east into New Mexico, the birds painted inside would likely be parrots. If the bowl had been from the Zia Pueblo, still further east, it might have been beaked, crested, and round-eyed roadrunners. Each pueblo has its origin story, and its own bird.

When I visited Carol Patterson at her home in Bluff, Utah, I noticed on a high shelf a modern effigy jar, its neck a circus-like duck head. It had a beak and big, black-painted, almond-shaped eyes. Deer were painted high-stepping around the outside, not unlike Garry's great-great-grandfather's bowl from almost three hundred years earlier, deer on the outside and ducks in the center. Patterson brought the jar down for me. I turned it over, seeing the signature on its base, "A A Peynetsa," Anderson

Peynetsa, a young potter from the Zuni Pueblo in New Mexico, known for his playfully fantastic effigies. The duck looks as if it is ecstatic, head knocked back, opening out the top of the head into a spout.

I said to Patterson, "Something about ducks."

She looked up from her work in the kitchen and said, "Yes, something about ducks."

She brought down a replica of an early Pueblo effigy pitcher, a duck's body with a handle, the pitcher opening at the top of the head to receive and pour. She said that sacred water was carried into kivas with duck pitchers. Excavations around the Four Corners have come up with many effigy pitchers like this, all the same heart-shaped body of a duck, their necks and heads opening into spouts.

I asked Patterson, who's been poring over Zuni ethnography since she started grad school in 1973, what she sees in duck-headed panels. To answer my question, she covered her kitchen table with nineteenth-century books with cracked bindings and velum over plates and illustrations. Modern scientific journals and field reports stacked up around us. When the space ran out, we moved to her kitchen countertop, turning pages through ducks and dances and origin stories.

In "Papers Presented at the Third Annual Symposium of the Utah Rock Art Research Association, September 1983" she'd marked a report from a pictograph site in Canyon de Chelly in Arizona. It told of a Zuni myth involving hero twins on a quest to find Corn Maidens in the underworld. The author wrote, "Notwithstanding the powers of the War Twins, they needed additional help to find the Maidens. Their major assistance came from the great White Duck. White Duck knew all the trails and never would get lost—no matter how bad the weather or dark the way." An illustration showed the pictograph in question, two rainbow-headed twins taking instruction from a duck ten times their size.

How many of these stories were told by Native Americans in confidence or were stolen or picked apart by post-colonial ambition, I don't know. These pages and papers, however they came into Patterson's possession, all point to the duck as a significant character at the beginning of the world.

◆

Micah Loma'omvaya told me that rock art sites are place-specific. When he sees them, he thinks of them as an indicator, a message about what tends to occur in that spot. "It is what you'll probably experience here," he said.

What you experience on the dark side of a canyon is a seep the sun doesn't dry out. Even in the freeze of winter, water winds down roots and rhizomes and falls off in droplets. A gentle rhythm taps on the ground, an accompaniment to a hero venturing into the abyss to find gods and corn maidens.

On another day, about fifteen miles from this underworld duck pictograph, we reached a scene of petroglyphs where many people have ducks for heads and stand in a line facing the audience, as if dancing toward us. It's a little intimidating at first, looking like you might be overrun. In these petroglyphs, pecked cleanly one after the next, the ducks' heads are turned toward each other, beaks touching as if kissing, and the people's arms are linked in rows. This was not one hero like the last panel. It felt like a troop, a can-can kicking across a stage.

An hour from sunset, these lines of petroglyphs had already fallen into shade, too bland for good pictures. Ming unfolded a golden, circular reflector to bounce the sunlight, imitating Garry's favorite late-day light. Having to do this at sunset meant, in reality, this would be a morning panel, these dancing duck-headed figures positioned to face first light. They are on a cliff-bench that juts over the land like the side of a ship or a bus. They look like they are going somewhere. Garry framed them with his lens, clicking one photo after the next.

Patterson told me that ducks that appear to be kissing could be exchanging breath, carrying sacred air from the underworld to the surface, or from the surface back down. They were making a straw of themselves, something to breathe through. Around them for hundreds of yards, for football fields, were starbursts and many flute players standing, seated, and lying on their backs as if playing to the sky. Atlatl petroglyphs laced almost every panel, with just as many duck-headed people, a connection to hunting or combat. It seemed the ducks were everywhere. I couldn't look at a concentration of petroglyphs along this sunset side of a mesa without finding one or two or ten of these figures.

We moved so swiftly in late-day light that I'd been behind for the last hour, stopping to catch my breath along the way. Bits of story showed themselves, hard to pass each one by. A petroglyph pictures a person holding a giant atlatl like a staff, and two duck-headed warriors approach from the right, weapons raised in their hands. A similar panel exists 180 miles to the south near the Little Colorado River in Arizona, a petroglyph segment showing a large person holding a giant, vertical atlatl, as smaller people approach from the right, posed as if dancing. I've heard this called a returning-home ceremony for warriors, part of something I glimpsed as I hastened through mandarin light on the side of a blocky, staircase mesa, catching up to Garry and Ming. These duck-headed people appeared to have been warriors, hunters, heroes, far from my initial impression born from duck cartoons and goofy quacking sounds.

When I reached them, Ming was holding the big golden disk over her head, shining warm light onto the rockface, causing petroglyphs of duck-headed people to glow. She looked like part of a story. In her red winter jacket and weathered cowboy hat, it appeared as if she were holding the sun in her upraised hands, something she'd pulled from the underworld of her daypack.

⋄16⋄

Desecration

In wind like this, people don't come out. Doors are shut. Hardly anyone was hitchhiking these days anyway. Signs along highways across the Navajo Nation left over from months earlier are spray-painted TURN AROUND and GO HOME. Coronavirus hit this part of the Four Corners like a bomb. A Christian rally on the reservation in Arizona at the start of the pandemic was a ready dispersal unit, a stroke of terrible luck as vanloads of people were shipped in from around the reservation and then returned to their families. The virus moved swiftly from there through small, intergenerational homes of the Navajo and Hopi nations of northeast Arizona, many without running water, exacerbating the impact. A horizon of elders was taken out. Micah Loma'omvaya told me that of the twenty-six priests in his society at Hopi, four died from the virus, all elders.

I was there April 2021. A year earlier, you wouldn't have stopped on the reservation even for gas. No one wanted outsiders to show their faces. By the time I arrived, vaccinations were moving rapidly and I was still watching my step.

You'll see someone now and then out in the wind, a Navajo man walking a fence hunched against blowing sand, or a great-grandmother in velvet out in the sage after her sheep, scarf pulled over her head. On a day like this, we all look like ghosts. The horizon is a blur.

When I walked with Loma'omvaya in the wind that day, visiting clan panels, what I didn't mention was the graffiti. While old images shined through, two thousand petroglyphs still bright and carefully pecked, the new ones were difficult to

avoid. Boulders were marred with scrawls and scratches, names and dates pecked as if in a yearbook. He called it vandalism. He knew some of the names. He said about one, "He is not a good man." Many were less than thirty seconds in the making, a sharp implement employed, maybe a screwdriver, the *go-homes*, *fuck-you-bastards*, and *assholes*. You hear the argument ad infinitum that modern graffiti is merely us expressing ourselves, same as ancient people were doing. Walk through a garden of clan petro-glyphs and see that these are not the same. Who looks at these scratches, I wonder, and thinks *fine work*?

A birthing panel near Moab was recently tagged, which must have taken all of a minute. A clumsy pictogram was left of a penis and balls paired with the words *eat ass*, and *white power*, with *white* misspelled, scratched out, and scribbled a second time. Dashed off across Basketmaker figures in hundred-point font, not next to them but directly on top of them, the words are barely legible. I asked archaeologist Kelley Hays-Gilpin for her take on this kind of desecration, how it could be interpreted from a rock art perspective. Having seen cultures across human evolution lay their rock art prints on top of others, she told me it's a sign of ownership, a cheap one at that. What she sees expressed in graffiti on top of rock art is that Indigenous people lost the battle and these vandals have every right to oppress them and erase them and put their history here. "It's such crap," she said. Hays-Gilpin lives in Flagstaff where freight trains pull through day and night and she spoke about the long, graffitied boxcars spray-painted in worm signs and ghost faces. Are these modern rock art, are these graffiti? She said, "Urban kids in LA paint box cars that then roll through here with some of the most amazing paintings I've ever seen." This, she considers art.

When Jim Enote observed rougher petroglyphs, half-fin-ished, done with shaky hands, he thought of low periods, when the people were not well and did not have time for artistry. He thought of hard times in history. It seems Enote was also

speaking about the work of modern vandals. They are often imprecise, rarely made with beauty in mind. They suggest hardship.

One kind of graffiti is erasure, another kind art. My brother-in-law, a Bronx-born street artist turned medical doctor, joined me hiking for several days in a Utah canyon teeming with pictographs. I thought he'd enjoy the nature of this ancient art, outdoors for all to see, older than the United States by twenty-five times. We walked into nighttime alcoves with headlamps, red-painted centipedes glowing in front of us and rising over our heads. He grew up heart racing, running through yards and subway tunnels, tagging, filling in letters and crosshatches, adding stars and faces, then getting out. I took him through galleries draped with paint, faces and phantom-heads, wraiths and thunder gods, and he was astonished. A well-tattooed man, he wanted to take on a tattoo of one of the pictographs we saw while we were out. When he took a photo to a tattoo artist, he was told it wouldn't translate, it would look like a sloppy birthmark.

One day, Tony and I sat at a blank panel of rock, bright and red in the sun. Not a scratch on it, the surface was untouched by human hand. We both swore that it wanted rock art, as if they'd been fools not to work a site like this, if not just a splash of spirals. Most of the great panels, when you go looking, are like this: nothing. So many rockfaces are empty, never worked. Imagery collects only in certain places, ordained locations. Tony, who moved to California after his medical residency and was still tagging and spray-painting the sides of trucks, said the rock wasn't so different from train cars or buildings, places you tag and places you definitely don't. Some parts of the city are relevant to your kind of art, and in others you'd be shot dead. Looking at a desert face that seemed to yearn for rock art, he mused about seeing a big fat tag out here, one with sparkles and thunderbolts. He looked at me with his wide-brimmed trickster's grin, what you'd expect from a graffiti artist. I said this is one of the places

where you'd get shot dead. You don't leave a mark out here. It's other people's land, clear as day.

Tagging is a form of ownership, covering over those who came before and saying, *Mine*. Tags may be art, but they are also claims. When the city comes in and whitewashes its walls, covering over years of graffiti, it is the city claiming ownership.

I have seen rock art treated in ways that take ownership beyond the gangly scrawl of drunken lunatics or the tagging work of a spray-painter. I have seen pure desecration. When I walked with Loma'omvaya, I noticed certain clan symbols had been intentionally obliterated. They were not just scratched out, but taken down to bare rock. You couldn't tell what clan had been there, all traces removed. The destruction wasn't quick and angry. It was thought out, done with purpose, ritualized. Loma'omvaya pointed out a fresh one as we passed, a blank spot rubbed into the rock, a row of clan petroglyphs missing. "They just hit that," he said.

◆

One panel I have hesitated to visit over the years is on redrock that is scalloped like a shell. I'd pass by on the river, knowing it was somewhere up through cottonwood canopies in the conchoidal arcs of a cliff. Those I traveled with would go up to it, and I'd stay down with the boats, bare feet in water along a tepid, half-clear river. In the summer, when rain has been scarce, the flow is down and you can see rounded rocks beneath the surface.

Sunbaked walls along this river glow with headdresses, halos, tablitas, and chest ornaments. Scene after scene of petroglyphs carries you along, oars dipping, beers popped open. We stopped at many of the sites that day, scrambling up dusty cutbanks where trails had been made over the years, rafts and duckies tied to cottonwood roots big around as your thigh along the river. We stood on boulders and along cactus-patched slopes craning our

necks to see profusions of atlatls and bighorn images. Binoculars panned across people wearing ducks on their heads. Somebody asked about a desecrated panel and I said I knew one nearby.

Why I went this time, I'm not sure. The world seemed upside down. An early September trip, still summer in my book, this was my first time on the river since the start of the pandemic. The last group I'd been around had been a guided weeklong last spring. On that trip, we'd spent our final day on this same stretch of river under rainy skies, all of us coming off dripping and caked in wet sand, but glad for the galleries of rock art we'd seen. Now it was blazing hot and there'd hardly been rain in the last two seasons. A pandemic and a drought, horrible fire year, kids in cages, president tweeting from the last lit window in the White House in the middle of the night, the whole year felt screwed on backwards. The CDC said twelve outdoors was fine, so we counted out pods, one group from Flagstaff, a couple from Colorado, separate kitchens, two handwashing stations, and masks in pockets for loading and unloading gear.

We tied off to cottonwood roots, rafts dragged up smooth cobbles. Paddleboards were carried and planted on red sand. Up toward the panel, we rose through cottonwood canopies glittering green. Boulder gullies led upward along a trail that had been formed by river people. Conversation stopped when we got there. In front of us, the largest figure in a troop of Basketmaker anthropomorphs had been destroyed. In a lightly sprinkled gallery of petroglyphs, this one stood out white and charged, as if being electrocuted.

Figures around it had been nicked and chopped, not destroyed, but taken down, hash-marked at their knees, feet, hands, and heads. These were ritualistic blows, and though I'm told this is Navajo work, I've seen it going back thousands of years, an old treatment. I once traveled with Navajo archaeologist Will Tsosie in New Mexico, looking at petroglyphs in curry-colored sandstones, and it was hard not to ask about the

desecrations we saw. Were they to ward off sickness, as I'd heard, or to break a curse, to make a powerful figure impotent? He pointed out places where sand had been gathered from the rock-face, grooved out of the cliff, holes pecked inside of older petro-glyphs. The sand, he explained, was collected, and considered sacred or potent. It was carried in a pouch, used for blessings and prayers.

This was different. I'd seen nicking and chopping before, but the big figure, what I would have called a box-man, had been grotesquely removed by hard and mesmerizing strokes, the implement made of metal, a hatchet or a blade. If this had been graffiti, I would have stared at it with simmering exasperation. Instead, it was a thing I didn't want to make eye contact with, if it had eyes.

Polly Schaafsma told me that powers are seen as inherent in rock art figures, and power can be subverted, directed to harm living people. On its own, she doesn't know rock art to have a negative or positive influence until someone gets ahold of it. She said, "Somebody was using the power that they saw in that panel in a bad way, making people sick, so the way to stop that was to chop out the figures so they weren't powerful anymore."

A river traveler told me he'd camped at this bend below the desecrated panel and had nightmarish dreams. In the morning he went up to the cliff, never having seen it before, frightened to find the chopped-up figure was the same as the one in his dream. It looks like a terrible beast. I don't know anyone who comes back from this panel full of smiles and laughter.

Whatever was here had been permanently transformed, its body undone, made into a new creature. You can see where the original arms, legs, body, and head were, but they'd been covered with stroke marks. Any adornments or identifying features on the original petroglyph are gone.

There was an illness on the Navajo Nation, 1930s being one date batted around. That puts it out of range for downwind ill-

nesses from nuclear weapons testing, so it may have been a virus, or may have been one person, a woman I have heard, who was ill. A Navajo healer instructed that this panel be desecrated and closed, and the disease would stop. Something about this figure and those around it drew the healer's attention. Who knows what is hearsay at this point, and I have little interest in clarifying the story, but clearly this wasn't graffiti or some violent tirade by a slovenly fool. It was intentional and ritualized, the figure herringboned with slash marks. It feels like a troubled wound. You carry a small dose of unease with you for days, hoping there's enough river to wash it away.

◆

Northern Arizona author and ethnohistorian Scott Thybony recorded an account from a Navajo man, Danny Blackgoat, about a desecrated panel in northern Arizona. Blackgoat, who Thybony describes as wearing a single turquoise earring and a Four Corners Power Plant cap, showed him where several large rock art figures had been obliterated. "Hopis on a survey crew carved symbols on the wall next to the Anasazi petroglyphs," Blackgoat told him. "They wanted to reinforce their claim to the land. Within a couple of years, the Navajo people in the area began getting sick. The families called in a hand trembler, a diviner, to diagnose the problem. He told them those carvings had caused their sickness; they shouldn't be on the rock next to those made by 'the original people.' After holding a ceremony at the cliff, the locals chiseled away the Hopi symbols."

By "original people," Blackgoat wasn't referring to anyone alive today, but to people who made the rock art. Messing with it required erasure. That kind of power couldn't be awake and roaming around, it could make people sick, possibly kill them. It was shut down.

Not all forms of traditional desecration are dangerous or hex-like.

Some actions, like Tsosie mentioned, are to borrow or take a bit of sacredness by removing sand from rock art. You'll see aftermarket striking on imagery all over the Colorado Plateau. Along the Gunnison River in western Colorado, just above a bend of railroad tracks, is a series of Fremont panels, mostly animal petroglyphs, bighorn sheep, deer, a mountain lion, and one person in a throwing position, with a projectile sinking into the side of a bighorn posed in a running stance. Nearly every character on this panel has a pockmark taken out of it, the holes mildly patinated, enough to show the strikes were slightly newer than the original artwork. Some strikes appear as if done with a twenty-penny nail (though it was more likely a rock or bone awl). They were delivered to the bodies, and some to the horns and antlers. A mountain lion with balled-up feet, a long, straight tail, and prongs for ears, is missing most of its trunk, forelimbs, and face from people who chipped it out.

Not a single figure at this site along the Gunnison escaped defacement, yet I didn't feel desecration in the act, at least nothing near what the river panel elicited. This is what Tsosie and many others have described to me as the ritual taking of sand, a specific class of defilement. Sand would have been placed in a medicine bag for ceremonies or prayers. On a hard year when deer were scarce, bighorn hardly coming down from their perches, you'd have wanted a pinch from an abundant hunting panel, a memory from when times were good.

I've noticed more panels with than without this kind of treatment, rarely done to the same petroglyph more than once, as if the ticket had been punched. When I sat with the ghost-men petroglyphs that Daiva showed me, I noticed most had after-markings in their privates, heads, chests, hands, and feet, same locations on each figure. In the sandstone bends of southern Utah, a multicolored pictograph of an almost life-size ghost floats in the back of an alcove and a plug has been taken out of its chest at the heart, chipped around the edges and later repainted,

filled in with red ochre. This was not necessarily an act of desecration, but a way of accessing ancestral power.

Long after the people who created these images were gone, they are still deemed powerful and influential, still affecting the world. When I stood in front of the desecrated Basketmaker figure, its destruction made the rest of the site seem more alive and active, like an ant hill poked with a stick. Even the petroglyphs that hadn't been touched seemed to buzz. We caught the rock art naked, exposed, not covered over by time. Figures appeared to move, gyrate, the prayers that made them still coursing through their lines and curves. If they are locators for prayers, as Florence Hawley Ellis suggested, these petroglyphs are more than pointillism on rock. They are avenues of spirit. Desecration is proof. Why would anyone go to such trouble?

◆

Rafts and paddleboards danced down the river, rounding bends and slowing as we watched petroglyphs pass high overhead, bright marks in dark, sunbaked walls. We set camp wearing sarongs, dresses, and light shirts. Early September felt as hot as any summer day, those bright months relentless, mountains bereft of snow. Anything to cool off, we took our camp chairs into the river and set them in the shallows on rounded cobbles, water halfway to our knees. Mostly Flagstaff, some from Colorado, we sat and stood in the water at COVID distances, whiskey and tequila tipped into cups. We were enjoying togetherness for the first time in a long time.

Before sunset, a dear friend with a solo canoe paddled into our camp, an emergency room doctor from Arizona working the hospital out of Winslow, lifeblood to the Navajo Nation. He was paddling in late after a forty-eight-hour shift, his arrival timed with the perfect light of evening. We hauled up his boat under molten cliffs and he stepped out with yet another bottle of whiskey, walking toward us all, arms spread in the air. He'd

showered at home and drove straight to the river and didn't want to talk about work and the ravages of the pandemic.

Directly above us, on the canyon wall across from our camp, stood a cluster of petroglyphs, more floating people. High in the red cracks and faces, they were hard to see and tucked away. You could camp here and never pick them out, but once you spot them, they don't leave your eye. Chopping vegetables you look up and they are watching the desert and river below. Laughter and shouts went up to them, our party railleried and ribald.

Every time I've camped here, I've felt an affinity for these images up in the cliffs, like a family, close to each other. Restricted to a tall but thin meeting of rockfaces, they were pecked in tightly, bodies overlapping. They were clean, no destructive marks. Whatever the desecrated panel lost, this panel still had. I never went up to see it eye to eye, never wanted to leave tracks and break a trail. My tracks adding up over time, beaten into the ground, would have been their own desecration. You don't have to go up and see everything with your own eyes. Instead, I used binoculars and studied from below.

What the doctor didn't want to talk about was his ward clerk having died of COVID. To the end, he held her hand faceless behind his pandemic shields. He said her heart was bigger than any of ours, but it couldn't save her. Now, his second ward clerk had the virus and was going down. He wouldn't say it, didn't want to have a thing to do with it right now, but he felt like an alien, armored and hidden in his protective garb. He said that when he saw his patients, there was hardly anything human about him. He must have looked horrifying to them, the very beast or wraith they grew up hearing stories about. His appearance was not unlike the misshapen image of the desecrated figure I'd seen, covered over, destroyed. I thought that if they could only see his face and hear his unobstructed voice, they would be made healthy, or at least be lifted up enough to take another breath.

On the river, the doctor was flesh and bones. That first night

he got drunk and wandered into the desert, past a cliff dwelling crowded with masonry walls, ceiling painted in snakes and spirals, and kept going. We didn't find him and bring him back till the early hours of morning.

The hardness of this year we were trying to cover over with joy and hollers. At least for these few days, everything was holy, everything powerful. The doctor could have kissed me and everyone else.

◆

On the river I carried a thrashed and dry-wrinkled paperback from US Poet Laureate Joy Harjo. It went most places with me, fitting neatly in the bottom of a watertight, military surplus ammo box. On another trip, I broke a whiskey flask in my ammo box at this same camp. Harjo's book soaked up the entire thing, not a drop to be wrung out. This, I believe, is how we help make things right again. We bring to the world poems and prayers. We break offerings of whiskey. We howl at the moon and get lost in the dark.

I've stood at this beach before and read the same poem out of the same book browned with whiskey. The name of the poem is "Once the World Was Perfect," one of my favorites of Harjo's. I stood barefoot on cool morning sand, sunup, rafts ready to load, and I read out loud. I wouldn't call it a ritual, just something worth doing more than once, slowing down for the last handful of lines:

Then one of the stumbling ones took pity on another
And shared a blanket.
A spark of kindness made a light.
The light made an opening in the darkness.
Everyone worked together to make a ladder.
A Wind Clan person climbed out first into the next
world,

And the other clans, the children of those clans, their
 children,
And their children, all the way through time—
To now, into this morning light to you.

I read it loud enough petroglyphs could hear me up in the
cliffs. The figures looked out from their shaded crack, and this
poem drifted across them, words they'd heard before. I'd con-
sider it consecration, the opposite of desecration. It means to
make something sacred.

Consecration was why we'd come. Daiva and I were getting
married, which during lockdowns and group restrictions meant
we held one wedding after another, one on the river, the next
with friends outdoors at home, and after that a formal one with
a dress and a vest with a boutonniere at the ranch of our friends
Ming and Garry. With small groups and tight-knit love, we made
something sacred.

Night three on the river was the first of our weddings. We
built a fire and the air smelled of river water and burning drift-
wood. Rapids rumbled behind us in the boxy bend of a gray
gorge. Daiva wore a silver mermaid skirt and I wore a sarong
and a nice shirt, the heat of the day finally lifted. She twirled
and we kissed, promising forever. The doctor, in a top hat with
feathers stuck in the band, expounded on the nature of love, and
then laid down a broom for us to jump over. Our shadows, as we
jumped, towered on the cliffs, painting our figures with darkness
and light. I won't say that I forgot about the desecrated panel,
but I was no longer thinking about it. I was thinking instead
about the give and take, sacredness removed from one place and
planted in another. I was thinking about the kiss on my lips and
our shadows on the wall. I was thinking on this hot, dry sum-
mer, that this was a rain so badly needed.

•17•

Children

The first hummingbird of the spring flew in on us, echoing in a curved bay of sandstone. The bird was like a ruby laser, a small handful of mint and raspberries in a fortress of rock and ivory-colored sand. It buzzed my head for a moment, then the head of the man I was with. Finding nothing more of interest, it departed the alcove like a ricochet.

I looked at my companion, gray, tight beard, a tall dancer's figure, and asked if that was his first of the year. He said yes and asked if it was mine. I said it was.

The first hummingbird means the same phases that have happened forever are still happening. April brings nectar seekers up from the south as we come around the sun again.

The alcove we sat in was decorated along the back with petroglyphs of spirals and concentric circles. These aren't unusual around here, reservation land between Tuba City and Kayenta in northern Arizona. Most big rock shade like this will turn up something. Chip Thomas, sitting in the alcove with me, is a musician, photographer, and noted muralist. We came up exploring a bone-white mesa, inching along edges, reaching hands to each other. A few hundred feet below us, red dunes were peppered with juniper trees and hoodoo rock formations. Bedrock looked like fins and backs of giant whales breaching the sand.

We found this slight alcove with petroglyphs in the back, a place to sit out of the sun. He was fully vaccinated and my first shot was coming up. We felt that we could be together. He works as a doctor at a local clinic, a job he's held for over thirty-four

years. This isn't something we could have done a year earlier, nor could I have stayed at his house on the reservation as I had the night before. Being together was new territory for us.

When we first spotted the images in the back of the alcove, I crouched and looked out of the shade, calculating the summer sun a couple months ahead of now, figuring this might be a solstice panel. It's a habit, especially with spirals and circles, where I turn around to get a fix on the horizon, running through seasons and sunsets in my imagination as if flipping through cards. If we returned in the blinding thirst of June, I think we'd find the first light cutting across these spirals in an intentional manner.

April was more pleasant than June. We kept on with our conversation after the hummingbird whirred away, looking over pale and waterless desert where it had flown. A windmill glinted miles off where we'd been earlier that day looking at one of Thomas's decayed murals. He's a street artist, defender of public art, putting up wheat-paste-and-paper murals and letting them erode over the coming years. Not much was left of that one nine years later. He'd layered the water tank with larger-than-life black and whites he'd taken of a Navajo elder in military uniform. At the time of the taking, the man was being honored for his service, wearing a code talker cap. Now he was a ghost of himself, image rain-washed and wind-blasted into a white fuzz of old glue and paper.

Wheat-pasting is meant to be temporary. Thomas doesn't want his work to last. Rock art is different, its pigments mixed with fixatives or petroglyphs knocked into hard surfaces where they were meant to remain. He thinks by putting up art that decays, he might be matching the speed of our current age, or going up against it, showing us how fast art can disappear.

We talked about the mesa we were on, routes he knew from its down-sloping back side, rock art that he'd seen in the area. You might want to talk about other things. He's a political activist, percussionist, a Black man from North Carolina who moved

out here in his twenties to be a doctor, finding it easier to be a young African American wearing dreadlocks and walking down the street on the Navajo Nation than in most of the rest of the country. Now his dreadlocks are gone and he is still here.

There was so much to talk about between us, but landscape got the tongue. We covered dry washes, dirt roads, petroglyphs, and how the San Francisco Peaks off to the south look like a sailing vessel on the horizon.

Thomas's work you'll know if you drive across this part of Arizona. He has a mural up on the side of a boat wreck of a gas station abandoned decades ago along the highway. The ruins of a motel on the reservation he uses to put up murals, people honking or waving or flipping him off as they drive past. Reactions to his work seem mostly positive. He heard from a Navajo man that when he's driving his grandmother down the highway, they pass a mural of a girl holding a lamb in her arms, the little wooly legs hanging down and the girl reared back to heft the animal up. Every time the grandmother passed by, Thomas was told, she'd quietly smile to herself. He took that to mean success as an artist, eliciting a repeated smile from a Navajo grandmother.

Many of Thomas's murals are made out of images he's taken of children. The first piece he put up in 2009 on a roadside stand was of a little Navajo boy looking up at a balloon, the face and the balloon the same size. He told me he intentionally uses imagery that has strong, beautiful people within the community, all ages, wrinkled faces of great-grandmothers, chubby toddlers. He says, "These images are examples of the beauty the culture has shared with me over the past thirty-four years."

As a doctor working with the same community for decades, he thinks about the health of that community, bringing up strong and thriving kids. Some of these kids have grown up through his murals. He photographed a Navajo girl when she was a baby and in mural after mural in different parts of the reservation, she appears a year or two older. The most recent expression of

her is on the side of an abandoned gas station and convenience store where she is portrayed at eleven, wearing a COVID mask sewn out of a cotton Blue Bird Flour sack, the image of a bluebird positioned over her mouth. Her eyes are smiling and she's holding one baby rabbit in her hands while another is perched on her shoulder. The image feels like abundance and resiliency.

In the mortar of cliff dwellings or masonry granaries you'll see a small foot or hand impression in mud, fingers spread as if to say I am this many years old. The mud is protected by a rock overhang where the granary and the child's print may endure a hundred generations. They knew it could have such longevity. Ancestry sprawls across this desert, marks left from so deep in the past names are forgotten. New marks would not have been added lightly. Their little digits were pressed into mud, saying these will last, these will be remembered.

Child hand and foot petroglyphs show where a rock writer with hammerstone and sharpened bone rounded out each fingertip and toe. They are also painted, or pigment is blown around them, like a burst of life on the rock, the blossom of a community. These are prayers for rain and corn. They will be strong bones, feet that hop from rock to rock, and hands that drive the manos that make the meal. The community say, look, world, what we've brought to you. This is ancestry flowing on like a river.

◆

On the outside wall of another derelict motel on the reservation, the Anasazi Inn at the mouth of Tsegi Canyon, Thomas put up one of his murals and left his spray-painted tag inside one of the rooms. Several rooms over, door missing, window glass and clouds of pink insulation on the floor, a wall has been spray-painted by someone else. I'd call it an anthropomorph, body like a ladder, circle for a head, stick for a neck. The style would fit in with the late Archaic sequence, similar to many rock images I've

seen. Its round head is divided into four quadrants, suggestive of Hopi, the general pattern that Loma'omvaya circled in the dust with a reed, telling me it was the sacred earth symbol, the homeland his people were given. But it is not the circle Loma'omvaya drew. It was given dots for eyes, making a face. One arm on the figure is raised, pointing out the door, next to the words GO HOME.

I showed a picture I took of it to Thomas and he said he hadn't seen this simple, straight-lined figure, calling it fresh work. "Go home," he repeated. "What does that mean?"

"Maybe it's pandemic," I said. "Go home, stay home."

He nodded, could be. "Or it's decolonization," he said. He wondered if it was directed at him and his art. Go home to where? To his home at Inscription House, the small community where he lives on the reservation? Home to North Carolina where he was born? To Africa? To where?

In the last year, improvised, spray-painted road signs had gone up across the Navajo Nation, reading TURN AROUND and STAY AWAY. Billboards conveyed urgent reminders to remain at home if you could. If you drove across the reservation even when lockdowns lifted, you were like a missile, no pulling over for pictures no matter how the towers of Monument Valley drew your eye. Curfews, nine at night to five in the morning, stemmed a death count that per 100,000 people had reached the highest level in the country, exceeding New York City. Months after government agencies eased major restrictions, radio stations on the reservation were still loaded with PSAs of voice-acted radio scenes, Navajo parents giving their kids a hard time for not wearing masks or going into town instead of staying home.

Thomas was optimistic. No deaths on the Navajo Nation for the last two straight days, first time in several months. The local vaccination program was now one of the most successful in the world. People were beginning to lift their heads.

"Go home," Thomas kept saying, making it into a question. "Go home, be home, find your place? Go home, as in get out of here?"

This is why he's an artist. He knows there are many definitions. One expression can mean more than one thing, not just the interpretation you think it is, or want it to be.

I'm convinced that if you went back in time and asked the people who lived here a thousand years ago about rock art, you would have heard different answers. Some may have called it an eyesore, some may have bowed and prayed to it, and many may have said it was something that was always done. We put up signs for others to see, warnings, invitations, communication. It is our way.

◆

Thomas and I spanned across cracks and walked the boulder-tumbled midriffs of a cliff. The fall beneath us, if a boot sole were to slip, was a hundred feet or more, two hundred by the time all your parts came to a rest. We hugged the rock, staying as high as we could on the slopes of slickrock domes. Overhead were small, crumbled cliff dwellings with wooden vigas pointing out of roofs. You never get over the surprise at finding remnants like these, pausing to look up feeling crumbling perpetuity overhead, masonry stacked and mudded on a ledge, abandoned like a message: *Stepped out for some centuries, moved to another mesa, may be back.*

Thomas had a place he wanted to show me. Something about the site he'd found struck him, a vibe he would say, a feeling that knocks on your door and you say please come in.

We ducked down into an eye in the cliff, a natural shelter of standing height. It looked across at the window of a massive sandstone arch, a jug handle a hundred feet tall, as if for picking up the lid of the mesa. I saw what drew him right away. The site is visually epic, bigger than anything human, while inside the

shelter were handprints along the back wall. I gravitated toward two charcoal-pale prints side by side, thumbs to the inside showing left and right. The maker had been four or five years old. I'd held hands like this, a son, a daughter. I could see the person in my mind, little boy, little girl. Walking down the sidewalk or off in the woods, I'd feel fingers absentmindedly weave into mine. The last time it happened, it was my youngest, Jado, when he was thirteen and not really thinking about it, looking the other way, he reached out to hold my hand. I walked as if suspended, saving my breath, thinking this could be the last time.

As I passed one to the next, I began to see that every handprint painted in this alcove belonged to a child. No adults were present. What was this, a tree house, a kid's shelter connected to nearby cliff dwellings, a rite of passage to climb the route and spend a night here, lighting up the eye in the cliff with a small fire?

The handprints were at the right height for children. At eye level, the kids were not held up to make them, but they painted the impressions on their own. At some panels you see where kids were lifted, adding their little handprints to a pantheon of spirit beings and rain people. This was more kid-size. They could do it without help.

Still thinking about the picture I'd shown him the day before, Thomas, sitting at the mouth of the alcove with a circle of sky gilded by rock, said, "Maybe that tag at the Anasazi Inn was for me, saying, go home."

He might not be wrong, having put up at the same ruined motel a mural of a Native man with the letters B-E-L-I-E-V-E tattooed onto his knuckles. The GO HOME spray painting, with its four-cornered circle for a head and arm pointing out the door, went up after his.

"This *is* home," Thomas said.

Home was our theme for the year, the place where we spent more time than anywhere else. The motel room wall said to go there.

This rock shelter of children's handprints was home, too. Small hands put to the wall made it feel like the kids' table at Thanksgiving. Now that I was looking around, I saw a boulder on the ground topped with several precisely arranged slicks and grinding holes. It looked like a cribbage board, a place for crushing pigments and sweeping one hue into another to form the right color. These were paint pots, the same as I'd seen a year earlier in a yawning Utah cave, its back end crowded with more than two hundred handprints. Here were a dozen or maybe more, depending on what has faded away.

Children are the seed bank of any community. The rest of us, our time has been given. Anything we do from here out is a test of what we've learned and an attempt to do it well. The children, however, are the only chance of survival and continuity we have. They are the verb and we are the nouns. Thomas and I were both fathers, and he has seen more than one local generation grow into adulthood, patting their chests with a stethoscope, shining lights into their little ears, catching them in his hands slick from birth. I held up my hand to the pair of charcoal-colored prints, imagining this kid's small hands when they were reaching, grasping, learning to tie knots from pieces of cordage. How adored this one must have been, and all these down the wall, red prints fading by the century. They'd been beloved, pinched, and tickled, fed and taught how to grip a spear, thread a loom, plant the small jewel of a corn seed half a foot down in spring sand.

◆

One of Thomas's murals takes up the backside of a house, the black-and-white face of a child, maybe three years old, smiling and looking up, delighted by the sky. The face is almost as big as the house, filling the air around it with joy. Several years ago, he went off-reservation and installed a house-sized black and white in a town near where I used to live in western Colorado. It was the image of a Hopi girl with long, braided hair, white dress, and

high-top Converse All Stars. Standing almost two stories tall, she was pictured clearing the ground from around a corn stalk with a two-pronged rake.

From Arizona, one of my favorites is a circular metal water tank with the image of a baby's face looking up as if watching for rain. Thomas does others, adults, elders, teenagers, but the children feel like they are planted and growing.

One ancient pictograph in the alcove seemed adult, a set of interlocking lines made of a pinkish pigment. A five-year-old hadn't made this. Maybe an early teen. It looked formal, like a puzzle of *T*s, *I*s, and *H*s. It had meaning, like the teeth of a key have meaning. It must have turned some lock. It said, *This is what this space is for.* I would never know, perhaps no one does.

Another figure stood out, the simple geometric form of a painted dragonfly. It was missing one wing and its tail had degraded, but the blush-and-brick pigment was still strong. It was the same red icon I'd seen in the cave of hundreds of hand-prints back in Utah at the start of the pandemic. You see drag-onflies across the Colorado Plateau, one of the many motifs, and you are seeing a remnant of a story.

When I spoke with Kelley Hays-Gilpin at the Museum of Northern Arizona, we talked about families and what size they would have been in the archaeological record. I told her about my growing up with a single mother, and it had felt like the two of us against the world. Hays-Gilpin said that to ancient fami-lies, we would have looked like refugees, our chances of survival worn down to a nub. "Where is the other parent?" she asked. "Aunts, uncles, grandparents? They would look at our nuclear families and wonder what happened."

She said that this is why we hear the dragonfly story at Zuni. I told her I hadn't heard the story and Hays-Gilpin smiled, her beaded, baby-Yoda earrings flashing. "Two little kids who lose their parents and nobody's taking care of them in the commu-nity, Dragonfly starts taking care of them," she said. "There's a

legend about the worst thing that could possibly happen, you lose your family members and it's just you and your sister, or you and your brother. It's pretty clear that that's not meant to be a regular occurrence or not supposed to ever happen."

The dragonfly story, attributed to Zuni, has been told, translated, and interpreted in many ways since it was picked up in 1883 by Frank Hamilton Cushing, an early American ethnographer of the Zuni people. The gist is that a village fell on hard times, resulting in the people leaving in search of help and a better home. A brother and his little sister were left behind. To lift his sister's spirits, the brother used papery corn husks to make a doll, which was meant to be a butterfly, but it came out differently, slenderer and long, with two wings to either side. The little girl loved playing with this doll and when her brother prayed to it to help them, the doll came to life and flew off with its buzzing, papery wings. It came back with blessings from the Corn Maidens, and brought them food. The siblings planted seeds and grew copious crops, and when their people returned home, finding the ground prosperous again, they were made into leaders. The corn husk doll that had come to life was now the dragonfly.

Finding a dragonfly pictograph in this cave of small hands, I wondered if this was a similar story being told. Children may have climbed to this high shelter to hear the telling, or this may have been like an elementary school play, kids up on stage acting out the tale of Dragonfly's children. The stage is hundreds of feet up talus at the foot of a cliff looking through the eye of a gaping arch. This was an important place. Paint pots were ground into the rock to make pigment. Each hand went up, pressing pigment to rock as a remembrance, a reason to appreciate family, to keep ties strong, loved ones close. Dragonfly will be here for you if worse comes to worse. No one is left out. In a dangerous world, this is something that as a kid you'd want to know.

◆

With handprints, paint pots in rock, and a dragonfly pictograph, I thought the site Thomas showed me may have been a version of what I saw a little more than a year earlier in the cave, though most of those handprints had been adult. I had noticed with the group I was leading that the enclosure had remarkable acoustic properties. Our voices had rained down on us, as if the space were meant for telling a story. The only thing missing in this cave with Thomas seemed to be the echo. I asked if he minded if I played flute to test out the sound physics of the site. I had a wooden one in my pack, a Japanese shakuhachi that I carry for such occasions, broken and split at the end and repaired with sinew that Chuck LaRue had given to me.

Thomas, a musician, artist, and practitioner of health, laughed. "Please, please!"

I pulled the flute from my pack and turned to play outward. I don't claim to be *the* flute player. I see them in rock art all the time, and I'll write this off as coincidence. Of any lightweight instrument you can slide into a pack, I've found this to be the best. In a country of geologic concert halls, the sound goes far, and comes back from farther.

Bamboo notes sailed into an amphitheater of cliffs and the wide aperture of the arch. The music bounced back on us as if we were at the center of a parabola. Notes stacked on notes, echoes lasting softly for a second or two. One flute became two and then three. I was right, the handprints and polished paint pots went together with reverberation. I felt as if across the length of a year I had found at least one undeniable fact. These places of handprints are for listening. They are caves of community.

When I stopped playing, after the last strain drifted back to us, Thomas took a breath and I could hear it. A key had turned and we'd entered.

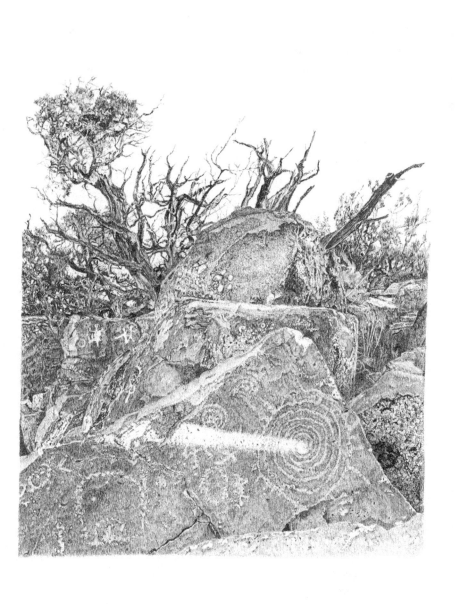

·18·

Sundial

The hills are crowned in ruins, stone walls fallen across each other half buried in dust. Broken pottery seeds the ground, redwares and blacks on whites. Rooms that once stood around plazas housed up to two thousand people, one of the great pueblo sites of the Southwest between the thirteenth and fifteenth centuries. It shrugs back into the earth a hundred miles or so from the Four Corners. The prow of a mesa rises above the puzzle of buried ruins and if you climb up to it, you will pass through waves of rock art, starting with people displayed in petroglyph form on a boulder, hands held in a line as if saying, *This is where we come together.* You'll see spirals and animals, turkey-track petroglyphs, ladder-like images of corn stalks. Plump baby footprints have been pecked side by side beneath a lip of rock crusted with neon-green lichens.

This mesa edge holds odd, small petroglyphs, turtle-like, frog-like, with human arms and legs. These little petroglyphs are signs of an ancestral phratry of clans found at Hopi, known as *Patki*, sometimes called Water Clan. These people are known to have migrated up from the south, coming with sun and serpent ceremonies, leaving their amphibious petroglyphs on boulders and in winding canyons.

At a caprock edge overlooking the ruins, a spiral petroglyph appears as if grown from the rock. It is an insignia, an emblem, centerpiece of the site.

The first time I came to this high spiral, I was with my family and we had a toddler unpracticed at walking. Holding little

hands in ours, we came to this rim of caprock and boulders look-ing across dry washes flowing to the horizon. We'd been explor-ing the ruins when we came up to the mesa edge. Little shoes shuffled and poked, leading us straight to this spiral, which we hadn't known was here. Thirteen turns to its arms, tick marks pecked around it, it looked like a sun. Finding it felt like gravity making a point, as if you couldn't help ending up here.

I'd soon meet Jerry Snow, from the Museum of Northern Arizona, who had been focusing years on this one spiral, find-ing the petroglyph to be a calendar, a sundial facing into sun-rise light. Snow and I watched together as equinox light split the image perfectly in two. It was a calendar, Snow concluded. At the tip of the mesa, looking down on sprawling pueblos, they could look up and tell time.

Seventeen years after I first saw this spiral with my toddler, and then with Snow, I returned at the tail end of the pandemic, vaccinations going into action, people coming back together like water filling a hole. We were a group of eight including my four-teen-year-old son and his fifteen-year-old buddy from school, gathered for what's called a sun-dagger event, a phenomenon that is known among spirals. This particular alignment had been discovered not many years back, two-thirds of the way between equinox to summer solstice, where a dagger of light crosses the spiral and pierces its middle. At dawn, we gathered around a crack in a boulder that would let the sun through to make the pattern. The spiral looks over what would have been commu-nities with barking dogs, human voices, and sounds of stones hammered against each other to make tools. Woodsmoke would have risen from hatchways and kitchens.

Our view felt like forever, an easy hundred-mile vista. A cadmium-bright moon lowered in the west over a forested rim. Eight of us found our places on surrounding boulders. Any more than that and you'd be jostling for position. We offered the prime spot, the top of a boulder looking directly into this bold

spiral, to an older gentleman with a French accent. He carried a long-lensed camera, so we deemed him important. How he'd heard about this morning's alignment, we didn't ask. The event happens twice a year, two mornings in a row at most. After that, the light drifts off and the celestial alignment comes apart. We'd all slept on the ground many miles up a dusty, rock-bottom road on a barren plain. We all knew each other. Even the Frenchman shook my hand and we remembered where we'd met, a paleo conference in Santa Fe years back. We had all woken early for the same purpose. Out of our sleeping bags at a quarter till four, gathered at the rimrock top of a mesa, we were here to see a point of sun reach out and touch the center of the spiral, a marker in the midst of seasons.

The morning before, Jado and I had left home in Colorado, driving out under the tail of a total lunar eclipse, what is known as the Flower Moon, Corn Planting Moon, or the Milk Moon. The closest full moon to earth of the year, it was also called a "super moon." For the eclipse, it was also being called a "blood moon." The phrase going around was "super flower blood moon," as if we couldn't lay enough names on its arrival. This morning, the moon had turned to a waning gibbous, a slim shaving taken off its right side, no longer so famous.

The only clouds were a few brass streaks above sunrise, not enough to cast a shadow. We watched as they brightened like melted iron.

I remember a similar moment at the eleventh-century Chimney Rock site in southern Colorado. A loosely formed group of researchers gathered for an eighteen-and-a-half-year moon cycle that would put the full moonrise between two natural, sandstone towers standing a few hundred feet tall. The moonrise, at the northernmost standstill of this long lunar cycle, was also watched by ruins collected on this high Colorado ridge, circles of Chacoan kivas set like perfect masonry nests into the top of the ridge. Tree-ring dates extracted from the site show

large construction episodes every eighteen and a half years, meaning they came up here and built to witness this cycle. This was the work of patient and assiduous sky-watchers. Among the scholars present for this Chimney Rock event, the one comment that struck me came from a woman from a Front Range university, bundled in down and gloves, buried in a parka hood to ward off the December cold at eight thousand feet. As we watched the moon rise like a newborn between two spindles of rock, she said it was too bad people weren't still celebrating this moment. How cold do you have to be, I wondered, how huddled with cameras on tripods pointing at a single, pearlescent globe rising between rock towers? If this wasn't a commemoration, what was?

Commemoration is being there. Find the place in your hallway where light falls on summer solstice, slanting through the hall, framing a picture hanging on the wall. You begin to recognize the turning of the years, how the sky is a spiral that always comes back to itself. You have context, framework. You can locate yourself. I was once camped in a motel room in northern Arizona where sunrise came through the door's eye-hole. An amber circle landed on a blank wall above the bed. In bare feet, I got up on the bed and with a pen drew a spiral inside this circle. In tiny numbers below it, I added the date. I thought that years hence, if not wallpapered over, the alignment may appear to someone on this same day and blow their minds.

This morning, I'd been up at two thirty in our wooded camp. I couldn't sleep. We'd all worried about weather. A single cloud would cancel the event, and we'd gone to sleep with cluttered skies. This morning, all was clear, not a skim of an obstruction. I'd waited years for this morning. On the mesa-side below the spiral was one of the larger settlements of the time, more than two thousand people believed to have lived in a series of stacked thirteenth-century pueblos, the ground around them carpeted with broken redware pottery and sharp black-on-whites. The site had fallen to ruins, hills made of architectural rubble. This

spiral, I believe, had been their highlight, the beacon shining above town.

I'd been awake for hours tracking stars as they winked through a canopy of ponderosa pines, moon shadows lengthening. One rock art alignment-chaser I talked with said he had a forty percent success rate visiting sites like these. The rest of the time he had weather, and sunrise did nothing. If I sat up in my bag, I could see the eastern sky clear as a bell. Knowing the light was going to come through a crack unimpeded and the alignment would happen, who could sleep?

The kids got up with the rest of us, mostly older gentlemen who picked through the dark to reach this mesa top. The Frenchman with the camera wasn't giving up his rock. The two boys hopped like popcorn from boulder to boulder, and sat for a moment, leaning against each other's shoulders as the northeast horizon brightened as if about to burst.

Living inside, we forget these things. Coffee starts with a ding, cream pulled from the refrigerator, cat let in through the back door. I can't begin to count the mornings I put my bare feet on the floor thinking about work or thumbing through my phone as if looking for a secret, not relishing the moment. Sometimes I stand at the kitchen window and watch first light strike the western horizon, the sun behind me building like a symphony. Most of the time I'm standing at the sink wondering where my glasses are.

This morning, the horizon was cut with a laser. You couldn't look away. The Frenchman lay across his boulder like a mermaid washed up on shore, and the two kids faced the light as if holding the best seats in the house. The man who knew this rock art panel, told me the date of the sunrise dagger, was my friend Scott Thybony, eyes squinting, accustomed to the sun. A tall man with handsomely unkempt, charcoal-gray hair, Thybony stood with his hands in his pockets. In his early seventies, he struck a strong pose against the sky. He told me he could see from here the

locations of three Hopi shrines on the edge of a mesa fifteen miles in the distance. "From here, that's where the sun rises on winter solstice," he said, pulling a hand from his pocket to point at the faraway mesa, lining up this spiral with the horizon. This landscape, and a few more hundred miles past every horizon, has been the focus for much of his life, living with Hopi and Zuni communities, traveling almost every backroad, mesa, and canyon around here. Earlier in his life, he was based among Inuit people in the Canadian Arctic, an archaeo-ethnologist, mapper of culture and landscape.

The sun poured through the edge of a mesa and rolled into the sky like a bright birth. A sheet of light broke across one mesa after the next, throwing long shadows. Thybony said we had fifteen minutes before it would come through the crack and start the light show.

"I keep trying to think of another word than *sun dagger*," he said, finding the word to be loaded. "It's more like a blade, wedge, arrow."

I told him I'd go with *sundial*. It seemed less dangerous and forceful than a dagger, and on the control panel of this ancient time machine, this must certainly be one of the dials.

In fifteen minutes, a lot of conversation happened, as if we were giddy for the sundial to come. We chatted about everything from the rock art sites we'd seen to pandemic woes, the first time many in the group had been with friends, vaccinated enough to come in close. Artifact researcher Chuck LaRue was in this crew and when we'd met three months earlier, him shaping wood over a fire in the Utah desert, we didn't shake hands, and tequila was shared only in cups. This time, I double-fisted when we shook hands, enjoying the feel of another person's strong touch. It's something I'd given up for the past year.

Hands in his pockets, waiting for the light to enter the crack, Thybony said, "Archaic people might have seen this effect, but they just didn't mess with it." Meaning alignments like this were

known, and people frequented this site long before the spiral was pecked, but not till later was it actually marked. Not until the beginning of agriculture did people begin timing themselves, another stage of human development worldwide. Boulders were moved to greet the sky. Large-scale connectivity became crucial and the first surviving calendars were etched into rock. It seems they needed to know not just the season but the month, the week, and the exact day.

The purpose of what we were about to see is unknown, or at least a mystery, but it would become clear there was, indeed, a distinct purpose. When orange light nicked the nearest boulder, words between us slowed. Lichen on the rock began to glow as our last comments were stowed away. A sundial of light formed on the left side of the spiral. It moved toward the outer line with a sharp and extending tip, an arm of light with a pointed finger.

At 5:32, the light was not so much a dagger as a narrow wedge, a dart, a blade barely touching a smaller spiral petroglyph above, and a swastika-like image below, both icons associated with migration. The light seemed to be passing through a petroglyph gateway, threading a needle. It could be a map, I thought. When winter sunrise first reaches this mesa, it comes through gaps and mesas fifteen miles away. This long point of light on the spiral could represent how the sun arrives across the land, the path it sets on the ground between landmarks and gaps to get here.

The tip of light nosed over the rock, not like a wandering snake but like a creeping machine, one track forward. Breezes murmured in juniper boughs and clothing rasped as we moved, resettling ourselves to watch. This was our form of respect or worship, the quiet witness.

Steve Lekson, one of the leading and more imaginative Southwest archaeologists, a professor at the University of Colorado at Boulder, told me he is circumspect when the subject turns to astronomical rock art. Though he sees evidence of

people lining up imagery with annual celestial events, he thinks the motif is not as ubiquitous as some would have it. "A lot of it is unfiltered enthusiasm," he told me.

On Lekson's list, this spiral alignment would have been a begrudging checkmark. The evidence seems incontrovertible. People found a naturally occurring sun pattern and pecked a spiral to fit it. They gave the petroglyph thirteen rotating arms, counting from one side to the next, a number seen often in Southwestern spirals. I've taken this to represent the number of full moons in a year, while Chris Lewis feels they are the number of years a place is occupied, and both could be true.

5:35 a.m.: the point of light touched directly onto one of the tick marks of the outer spiral. I've seen this kind of contact at equinox, a triangle of light in the Moab area landing on similar tick marks, the light's tip then rotating around the outside of a petroglyph spiral. Sunrises are ratchets, every turn striking the land in a different way.

My friend Rory Tyler, up around Moab, has identified and named more alignment sites than I can speak to, the very reason Steve Lekson curbs his enthusiasm. But humor Tyler, look at his laptop when he has you at the bar. The bartender knows him, it's okay. He takes you through sequences of sunrises, rock art panels lined up for them as if on parade. He found a petroglyph panel where a bird figure, what he calls a goose, lays a golden egg of equinox light, starting off a chain of light shafts and arrows that arrange themselves across a wall full of petroglyphs like an unfolding story. It seems like invisible ink, sunlight causing a hidden message to emerge. He told me, "The sun rules my life. It tells me where to go and when to go there."

Tyler sees the Moab Valley like a giant Rube Goldberg machine, dominoes knocking over cairns, pendulums swinging through each other, balls rolling down chutes. "The reason they did astronomy is because it lets you know the universe is in order," Tyler said. "I went to so many of these sites, and I'm just

waiting, waiting, is it going to happen? Even though I've seen it a dozen times, I'm waiting for it. Then it happens, and I'm so happy. That's my experience as a human being. I think that's how they felt about it."

Solar dates were used, and still are used, for planting and starting off dances or society rites. One part of the year Coyote stories can be told and another part they cannot. All that's needed is to check a panel from time to time and see where light is landing, which side of a solstice or equinox you're on. To some, this must have been like seeing the hand of creation at work and to others it may have been turning a page on a calendar and pinning it to the wall.

The Americas are awash with alignments, astronomically situated stone medicine wheels and stair-step shadows climbing the sides of pyramids. Lekson is right to warn that not every petroglyph is a calendar. Science can't take that kind of mania. Some are under boulders where you have to crawl in to see the imagery, protected mostly from outside light. Those, I'd say, are not celestially aligned. In some cases, though, I'd be wrong. An overhang in the lower reaches of Chaco Canyon in New Mexico, where sunlight does not land, is a pictograph believed to represent a supernova recorded around the world in 1054 AD. The pictograph is on the slab of a rock ceiling beneath an overhang, as if suspended in the sky. You look straight up to see it. Chinese records put the supernova on July 4 of that year, a red starburst first seen near to the horns of a crescent moon. The explosion in the sky was red and bright as a full moon, visible during the day for weeks, and at night for at least a year. This ceiling painting in red hematite shows three figures: a handprint, a crescent, and a starburst. The handprint is the clincher. For me, it says, *This event happened and we witnessed it.*

On the mesa's edge, while light came up to the first turn of the spiral, I thought of a snake petroglyph I'd seen in Utah where what looks like an arrowhead of light unfolds on the snake's

diamond-shaped head the morning of summer solstice and a few mornings to either side. In Fremont strongholds of northeast Colorado, an old-school field archaeologist, Glade Hadden, told me that the entire region was a calendar of rock art. You'd trip over yourself discovering new alignments. Fajada Butte in Chaco Canyon, New Mexico, is strictly off-limits to people like me, trespass enforceable by fines and jail time. I've never gone up to see its solar acrobatics, sundials and moondials cast onto and around a pair of spirals. Thybony had been to Fajada twice, sent in to document alignments where rock slabs stand like a deck of cards, allowing pieces and lines of sun and moonlight onto pecked spirals. He spent a night on the butte on the winter solstice and in the morning watched the sun fall through slots in the rock, casting two identical wedges of light like bookends on either side of the main spiral.

The land is a marker. Buttes stand like faraway thumbs. Mesa edges cut sharply against the sky. A crack in a boulder lets sunrise through and a dagger of light lands on a spiral. If there was any question about order in the universe, the answer is out in the open for all to see. Every year comes back to the same place. Put a quarter in the slot and the ride starts again.

The shadow of our mesa drew across a broad upslope to the south. The moon lost its brightness as it lowered in the west. Mesa shadows stretched like exclamation marks. Watching the sundial move was not like sitting with a grandfather clock in a living room where time seems binary, ticking back and forth. Here, time felt fluid, pouring over a sparse canopy of piñon and juniper, washing between mesas as if a flood had let loose. This crack in the boulders channeled some of that flood, tightening it into a long point of light. The boulder's face and the rising sun formed an oblique angle that hurried the sun's movement, as if the spin of the earth had quickened.

5:36 a.m.: the light passed across two turns of the spiral, steadily moving toward a third and a fourth.

5:37 a.m.: the light reached the fifth circle and a minute later the sixth.

5:39 a.m.: bull's-eye.

The tip of the sundial, the size of a fifty-cent piece, fit perfectly into a circle, a shallow cupule pecked into the center of the spiral. For a handful of seconds, the alignment seemed fastened, as if two planes intersected and held onto each other as long as possible, cherishing their contact.

5:40 a.m.: the sundial moved beyond the center, touching the next spiral arm.

By 5:44, it passed through the entire spiral and was coming out the other side of the thirteenth arm. After that, it continued across the boulder and off its edge, the sundial becoming a lance, the lance widening to become full daylight. The Frenchman was done with his photographs, the kids were off somewhere in the rocks exploring other petroglyphs, LaRue leaned on his crookneck staff, and Thybony still had his hands in his pockets.

Thybony watched us with an ethnographic eye, as if this morning was as much about the spiral and light as it was about the eight of us. He noted the license plates on all of our vehicles—Colorado, Utah, Nevada, California, and Arizona—as evidence of lines of travel converging on this site, something he said obviously happened here centuries ago. He told me that the search for the center-place is recorded deeply in Pueblo cosmology and migratory legends. "They'd be looking for a certain light or following a certain star," he said. "They were looking for a flower that grew from an unusual rock. They looked for signs, which certainly could be a calendrical event like this."

Thybony believes this morning's alignment is a cultural sign relating to ruins of massive pueblos nearby, a codification of their place over centuries of migrations, an arrival. As we stood around talking in the ordinary light of day, the spiral fully illuminated, Thybony said, "The spiral most Hopis interpret as a migration symbol. The Hopi, when they emerged into this

fourth world and set off on their migrations, some of the clans were meant to find the center-place."

Thybony, anthropologist by education and a writer by profession, former Grand Canyon river guide and archaeologist, has become a repository of stories. When he first moved out here in 1972, he herded sheep for a Navajo medicine man and had his own hogan to sleep in, and, he says, all the frybread he could eat.

He writes it all down, which adds up after decades of field interviews in this dry and rugged country. Even our morning conversations would end up in his ledgers.

What he's picked up over the years allows him to speak with some authority at a site like this. He said that when the spiral is a migration symbol, especially among Hopi, its center represents a place the people are preordained to reach.

Standing taller than any of us, a healthy-looking figure, Thybony said, "It could be that when the people lived here, they thought they had found the center-place. This spiral and the light-wedge represent finding it. This may commemorate or consecrate the place."

"The center moves constantly," said a friend of his, a white-bearded man who used to live and teach on the Navajo Nation, abutting and surrounding the Hopi Reservation.

"The center of the universe moves with you," Thybony agreed.

"I think that's pretty consistent for Native Americans in general," said his friend.

This kind of conversation is one you should hear around rock art sites, not simply our own reactions, but reference to the larger cultural lay of the land. In his many recordings of conversations in the field, Thybony has one from Gary Tso, a Hopi tribal member who took him to an astronomical rock art panel in the Hopi Mesas. Tso told Thybony that when anyone comes to Hopi, they should be told, "Welcome home!"

"We believe that every last man, woman, and child was destined to come to this place at one time or another in their lives because this is home," Tso said. "Everybody was meant to come here. Now you can lead a more complete life, a more fulfilled life because you have found your way, as we say, to the center of the spiral, the center of the universe."

If you go to a restaurant–visitor center on Second Mesa on the Hopi Mesas you can buy a T-shirt or hat that reads, "Hopi Center of the Universe." It's tongue in cheek, but not really. This is Hopi humor, where every joke tells a story. Their mesas are considered, at least among Hopi people, to be the mythical center-place, the circle bisected into quarters that Loma'omvaya drew into the sand with a reed stick.

At this spiral site in the caprock, we were relatively near to Hopi, the mesas stacked a hundred miles out on the horizon. It looks like the center-place may have moved from here to there, Thybony said. "You go into the pueblos along the Rio Grande, or Acoma, they have a plaza there, and they have a shrine that represents the center," he said. "Of course, if they abandon it and have to move somewhere else, they'd have to animate a new center."

I wondered if this spiral and sundial had been the animation of a core, not just a YOU ARE HERE sign, but YOU ARE AT THE MIDDLE OF EVERYTHING. The petroglyph site looks across fields of rubble mounds, thousands of rooms collapsed into themselves. In its day, this was a city, a shining nucleus of the Pueblo world. The period between 1200 and 1400 AD was a time of extraordinary aggregation, populations massing across the Southwest, and this was one of the big ones, drawing in clans and lineages like arrows to a bull's eye. They must have claimed centrality in their day, putting down their mark. How long did it last? If Chris Lewis is right about the number of spiral rings, it may have been only thirteen years. When it's time, the center swiftly moves.

◆

At the edge of his corn plot at Zuni, Jim Enote set up rocks as solar markers. He told me the act, both for himself and for the larger culture, is about maintaining cosmological process. I explained that I observe my own solstice markers at home and I don't know why I do it, it just seems like the right thing to do. I said, "The sun keeps hitting here again and again, I should mark that."

Enote replied that it's just something that happened for him, as if he couldn't avoid observing the alignments. "The day I started making my markers, it really just fell out of me," he said. "It wasn't a plan or a method."

Placing his sunrise alignment stones began as a conversation with one of his young nieces. He told her the days would be growing long, and then they'd start to shorten. She asked how he knew this. "It's a good question," he said. "Because we don't have the sensation of moving. This whole world, we don't have the sensation that we're flying through space, yet we're moving. Everything moves, whether we're talking about atoms or sheep. Everything moves, everything vibrates."

While a spiral and a sundial may indicate sanctified centrality to one person, to another, like Enote, it points to a process, becoming aware of where, and when, you are.

Enote and his niece went into the field and put a rock down to line up with sunrise. The next day they got up early and put another rock down to show where the sun moved to a new point on the horizon. "So really, it was a teaching tool for my niece," he said. "I told her we'd come back in a couple of months and the sun will be over here when it comes up." They camped at the field and he woke her up, saying the sun's coming up. The girl was groggy and she grumbled getting up to watch the sunrise. "I said there's our rock and now the sun's over there," he said. "And she said, oh yeah."

His niece asked, are we moving or is the sun moving? He

told her it doesn't matter. "Everything moves, even that rock," he said. "In time it is going to become sand."

Enote and I were on-screen when we talked, and our conversation seemed divorced from time and place, the enemy of the very thing we were discussing. We looked at each other through boxes. What did this have to do with the sun, or days, or seasons? We were unmoored from our customary references. At the same time, this medium kept us together. How isolating the world of ideas would have been without being able to see each other's faces from hundreds of miles apart. Any way possible, we were looking for contact.

◆

Catch it for an instant. The light will be gone before you know it. You see through the gaps into the turning heart of the machine, the opening and closing petals of a flower. Marking celestial motion with a petroglyph is an act of testimony, a way of saying, *I am paying attention.* This image placed on stone is a memory aid, an activated history, so you know what to do or what happened here. Hays-Gilpin told me, "Rock art fixes people in a historical sense. It's pinning place and time so that the meaning of this place will persist through time." It is also a captured moment, and it turns with the light. This is a reason to call it art, when no single definition will do.

This spiral site may have had monumental beginnings, a spiral and a sundial consecrating a pueblo where thousands lived, or it may have been farmers teaching their children about seasons and the sun. Feeling down the rope of the human chronicles, you come to knots that people tied along the way, knots of spirals and thunder-beings, handprints on walls, wild sheep pecked with cloven hooves and rainbow-curled horns. You pause at each node, some showing conflict, others birth.

As light spread, the moon turned to ash and faded into the blue of the sky before it set. The air felt renewed, all of us looking

at each other and the shadowlands and mesas around us as if we'd woken from a needed rest.

Talking returned to sunrise levels, stories starting up again but with a little more vigor, spun faster by the sundial. It wasn't a competition of who had seen what, but a comparison of notes, one panel to another. Winters in New Mexico, summers in Colorado, each place came with a tale. I remembered light surrounding a petroglyph, or a pictograph emerging from the dark. They used rock art to position themselves, triangulating between time, space, and an image on stone. Which season was it, which century, which millennia?

Jado climbed around the side of a boulder to where I hadn't moved in the last half hour. I was watching the spiral, which had filled with light. He seemed to be enjoying the whole show. I thought he would. No one could walk away from this without a secret grin.

"Let's come back next year and do it again," he said. It probably wouldn't happen, but I said sure, that would be great. Between now and then we'd get lost in our lives, but I knew how he felt. I wanted this event to repeat itself, but not for another year. Time is needed to digest. The experience would stay with us like a small, polished stone carried in a pocket. As he scrambled away, Jado said to me and anyone within earshot, "Everything in life is gray space until this happens again."

About the Author

Craig Childs has published more than a dozen critically acclaimed books, including *Virga and Bone, The Secret Knowledge of Water, Atlas of a Lost World,* and *House of Rain.* He has won the Orion Book Award, the Sigurd F. Olson Nature Writing Award, the Galen Rowell Art of Adventure Award, and the Spirit of the West Award for his body of work. He is a contributing editor at *Adventure Journal Quarterly* and his work has appeared in the *Atlantic, New York Times,* and *Los Angeles Times.* He lives in southwest Colorado.

About the Art

Gary Gackstatter is an artist, conductor, and composer. Using a vintage crow quill nib dipped into a bottle of ink, he layers thousands of what he calls ghost lines—nearly invisible lines—to achieve a sense of texture, depth, and detail, expressing a relationship between stone and art that goes beyond photography. The process takes about two hours per square inch. For Gackstatter, "drawing is meditation, each ghost line adding a layer of meaning. It is a way to show deep respect, a way to connect to a sense of sacred, a way to come as close as I can to the ancient artists' hands."

For more art and music, visit garygackstatter.com.

TORREY HOUSE PRESS

Voices for the Land

The economy is a wholly owned subsidiary of the environment, not the other way around.
—Senator Gaylord Nelson, founder of Earth Day

Torrey House Press publishes books at the intersection of the literary arts and environmental advocacy. THP authors explore the diversity of human experiences with the environment and engage community in conversations about landscape, literature, and the future of our ever-changing planet, inspiring action toward a more just world. We believe that lively, contemporary literature is at the cutting edge of social change. We seek to inform, expand, and reshape the dialogue on environmental justice and stewardship for the human and more-than-human world by elevating literary excellence from diverse voices.

Visit www.torreyhouse.org for reading group discussion guides, author interviews, and more.

As a 501(c)(3) nonprofit publisher, our work is made possible by generous donations from readers like you.

This book was made possible by a generous gift from Susan Markley. Torrey House Press is supported by Back of Beyond Books, the King's English Bookshop, Maria's Bookshop, the Jeffrey S. & Helen H. Cardon Foundation, the Sam & Diane Stewart Family Foundation, the Barker Foundation, Diana Allison, Klaus Bielefeldt, Laurie Hilyer, Shelby Tisdale, Kirtly Parker Jones, Robert Aagard & Camille Bailey Aagard, Kif Augustine Adams & Stirling Adams, Rose Chilcoat & Mark Franklin, Jerome Cooney & Laura Storjohann, Linc Cornell & Lois Cornell, Susan Cushman & Charlie Quimby, Betsy Gaines Quammen & David Quammen, the Utah Division of Arts & Museums, Utah Humanities, the National Endowment for the Humanities, the National Endowment for the Arts, and Salt Lake County Zoo, Arts & Parks. Our thanks to individual donors, members, and the Torrey House Press board of directors for their valued support.

Join the Torrey House Press family and give today at www.torreyhouse.org/give.